GREAT MOMENTS IN
IRISH SPORT

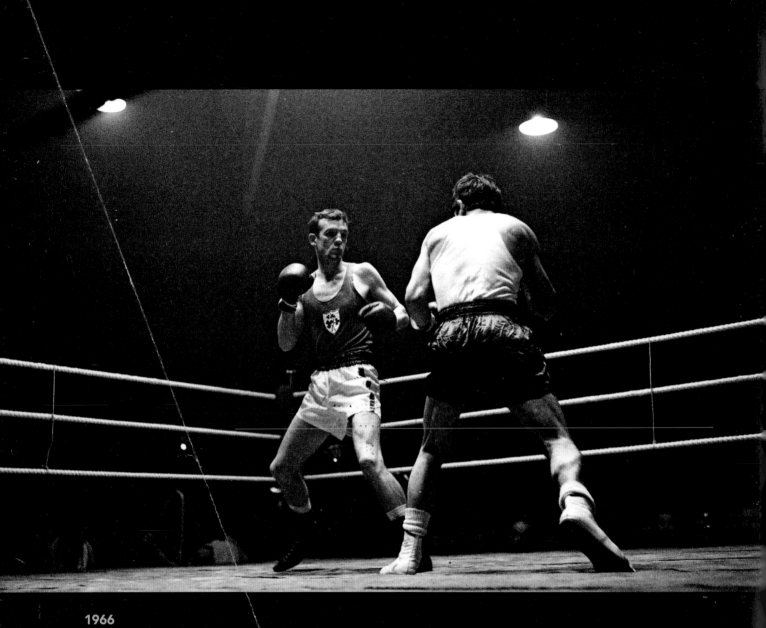

1966

National Boxing Stadium, South Circular Road, Dublin.

Connolly Collection / SPORTSFILE

GREAT MOMENTS IN
IRISH SPORT

from SPORTSFILE

THE O'BRIEN PRESS
DUBLIN

First published 2021 by The O'Brien Press Ltd,
12 Terenure Road East, Rathgar,
Dublin 6, D06 HD27, Ireland.
Tel: +353 1 4923333; Fax: +353 1 4922777
E-mail: books@obrien.ie
Website: www.obrien.ie
The O'Brien Press is a member of Publishing Ireland.

ISBN: 978-1-78849-215-7

Thanks to Oscar Rogan, John Byrne, Nicola Reddy, Seán McGoldrick, Ivan O'Brien for their assistance with captions.

10 9 8 7 6 5 4 3 2 1
25 24 23 22 21

Layout and design by Emma Byrne.
Printed by EDELVIVES, Spain.
The paper in this book is produced using pulp from managed forests

Published in:

DUBLIN
UNESCO
City of Literature

CONTENTS

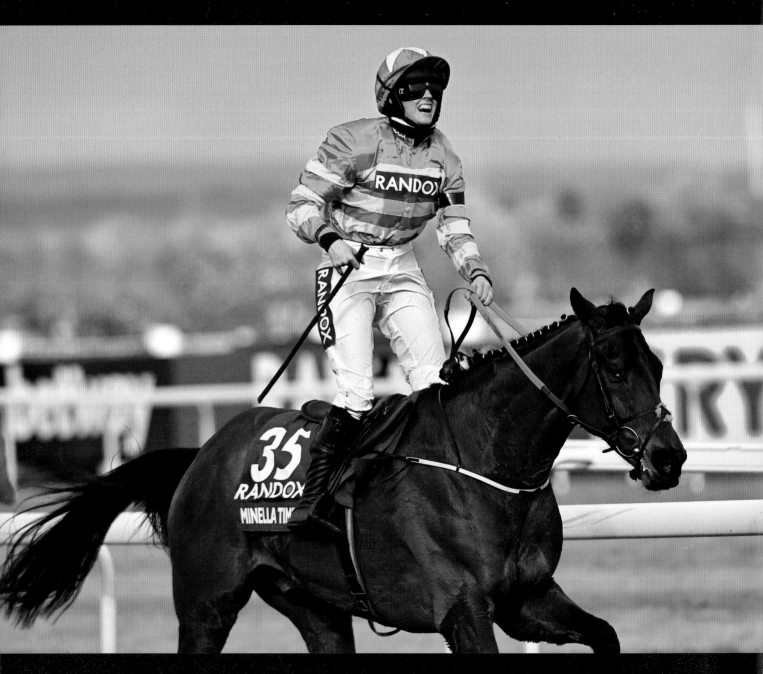

10 April 2020

Rachael Blackmore celebrates on Minella Times after winning the Randox

Grand National at the Aintree Racecourse in Liverpool, England.

INTRODUCTION

My passion for sport was what led me to set up Sportsfile in the early 1980s. From small beginnings, Sportsfile has flourished and become Ireland's number one sports photography agency, with a staff of photojournalists dotted around the island. What has sustained us through the decades, along with our professionalism and skill, is our enthusiasm for and love of sports of every type. The Sportsfile photographers have had the pleasure and privilege of documenting the soaring highs – and some devastating lows – of our Irish athletes both on the world stage and at pitches, boxing rings and athletics tracks around the county.

Assembling this collection of photographs of Ireland's greatest and most memorable sporting moments took me back to a different era of photography, to the days of film where there was a limit to how many shots you could take – a roll of film was thirty-six frames, so you had to make them count. Today, with digital cameras, you'd have that many taken before the event had started! But now, as then, a great photo is often about being in the right place at the right time, reading the game or the race, making sure you're aware of the background and how the athlete will look against it. The times when everything comes together make for some striking images and some great sporting memories.

These photos of national, Olympic and world championships, as well as Gaelic sports, football, cricket, golf, equestrian and much more, showcase the grit and grace of Irish sport, and I'm happy we were there to witness it all; I hope this collection brings you close to the action too.

Ray McManus, 2021

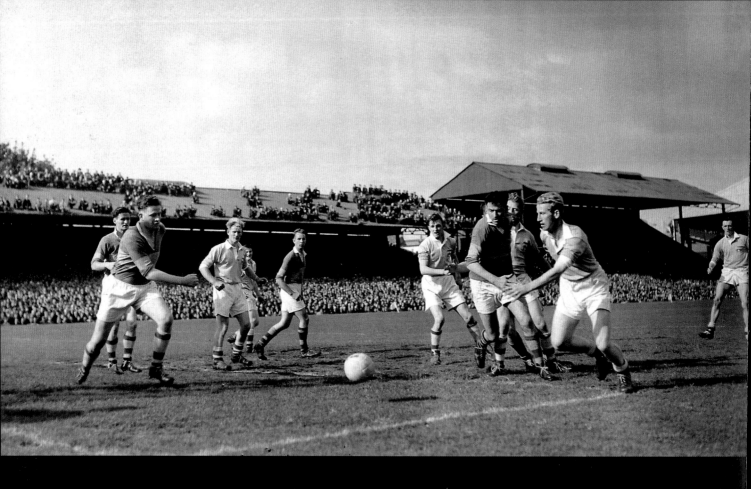

1950s 8

25 September 1955

The 1955 All-Ireland final went down in history as a classic, not least because it marked the arrival of an indigenous Dublin team, many drawn from St Vincent's in Marino; previous Dublin teams had bolstered their ranks with country men, but this new team was Dublin born and played an exciting style of football based around Kevin Heffernan's roving style of play. Kerry were the eventual winners (0-12 – 1-6) in front of a record crowd of over 87,000. All-Ireland Senior Football Championship Final, Dublin v Kerry, Croke Park, Dublin.

1960s

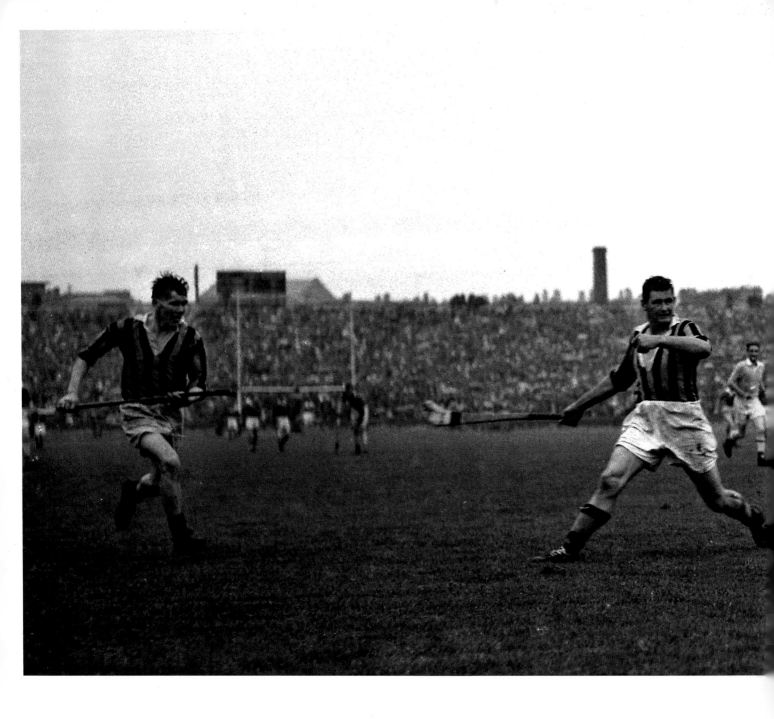

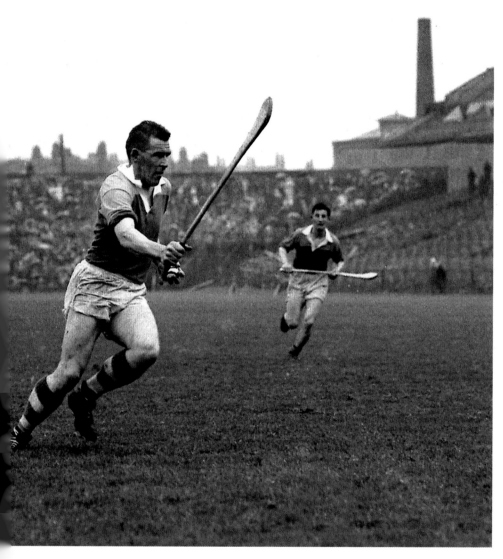

27 July 1958

Two legends of the game, Kilkenny's Link Walsh (second from left) and Padge Keogh of Wexford (second from right) at the Leinster Senior Hurling Championship Final, Kilkenny v Wexford, Croke Park, Dublin. Throughout the 1950s and 1960s, the Leinster Senior Hurling trophy went back and forth between Wexford and Kilkenny, with only Dublin getting a look-in in 1952 and 1961. On this occasion Kilkenny were victorious, 5-12 to 4-9.

Connolly Collection / SPORTSFILE

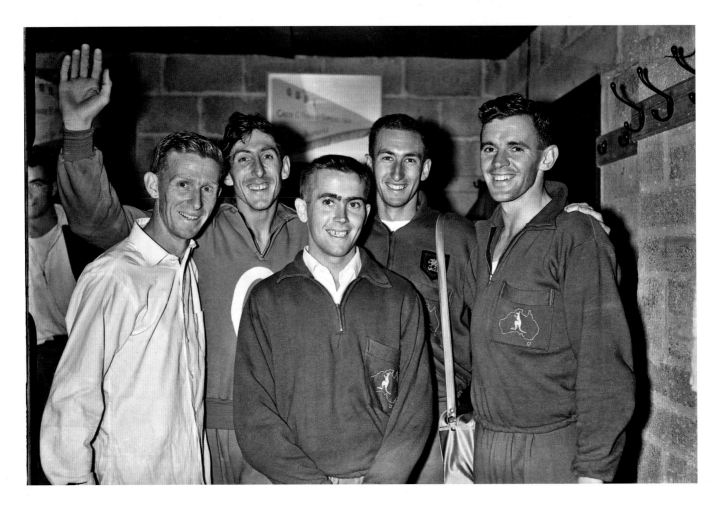

06 August 1958

The Golden Mile in Santry was one of a series of inaugural races on Ireland's first cinder track, built after a year-long fundraising campaign by sports promoter Billy Morton. Olympic 1500m champion Ronnie Delany was a supporter, which resulted in US magazine *Sports Illustrated* flying over to do a story and putting Morton in touch with Bernard P. McDonough, owner of the largest shovel-making factory in the world. McDonough provided a large donation, and a shovel for the ground-breaking ceremony. Ronnie Delany not only broke the first sod for the track, but also agreed to line out against the best milers of the time. The resulting race made headlines around the world as – for the first time in history – five men ran sub-four minutes in the same race. Today, the stadium is named Morton Stadium, in honour of Billy Morton. As well as his Olympic 1500m title in 1956, Delany recorded one of the finest winning streaks in athletics history with forty successive indoor victories in the USA between March 1955 and March 1959.

From left: Murray Halberg, New Zealand; Ronnie Delany, Ireland; Albie Thomas, Herb Elliott and Merv Lincoln, Australia. The finishing times were Herb Elliott 3:54.5 (WR), Merv Lincoln 3:55.9, Ronnie Delany 3:57.5, Murray Halberg 3:57.5, Albie Thomas 3:58.6.

Connolly Collection / SPORTSFILE

23 April 1960

Vincent O'Brien, right, with horse owner and New York businessman Townsend B. Martin at Naas race course, Kildare. O'Brien trained horses for fifty years, retiring in 1994. In his early days, he trained steeplechasers and hurdlers, winning the Grand National three times, the Cheltenham Gold Cup four times and the Champion Hurdle three years running. Even greater successes came when he changed his focus to flat racing – the list of horses trained by him includes Sadler's Wells who won the Beresford Stakes, Irish 2000 Guineas, Eclipse Stakes and Irish Champion Stakes. O'Brien was voted the greatest influence in horse racing history in a worldwide *Racing Post* poll.

Connolly Collection / SPORTSFILE

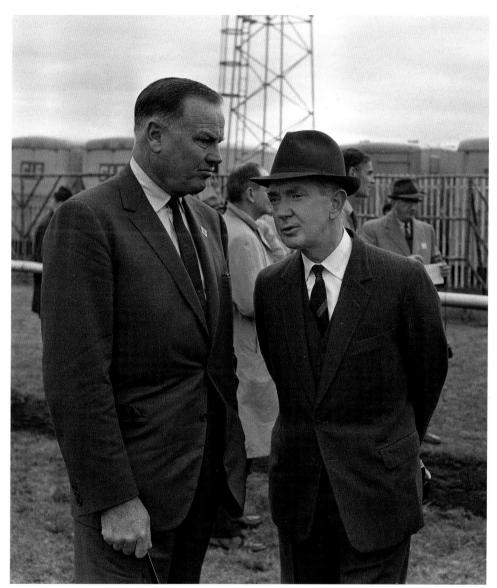

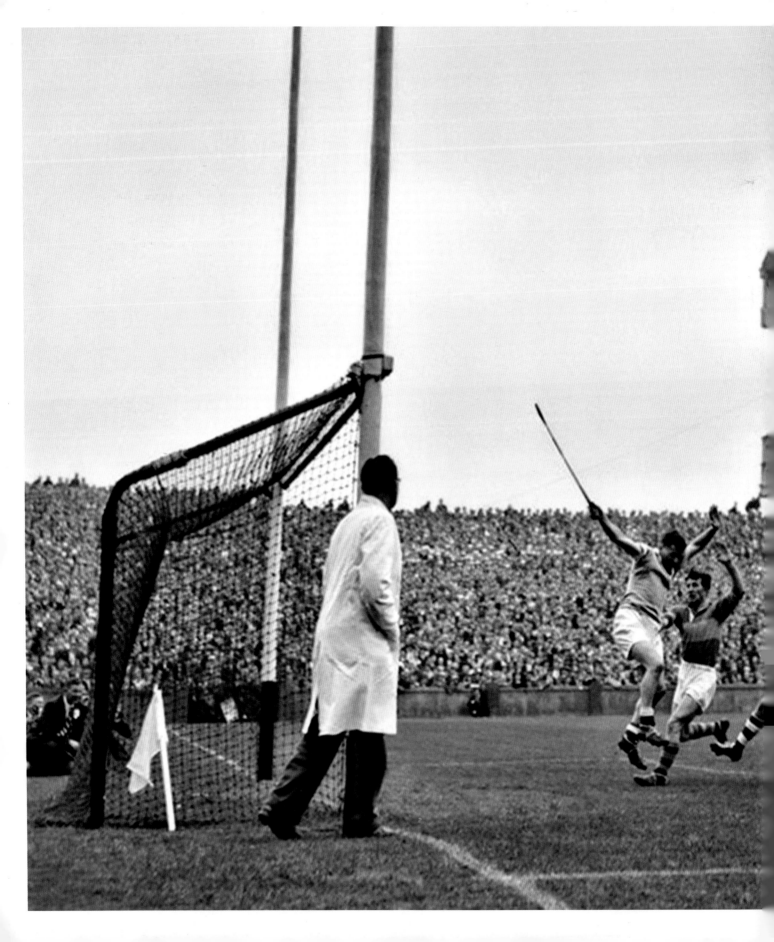

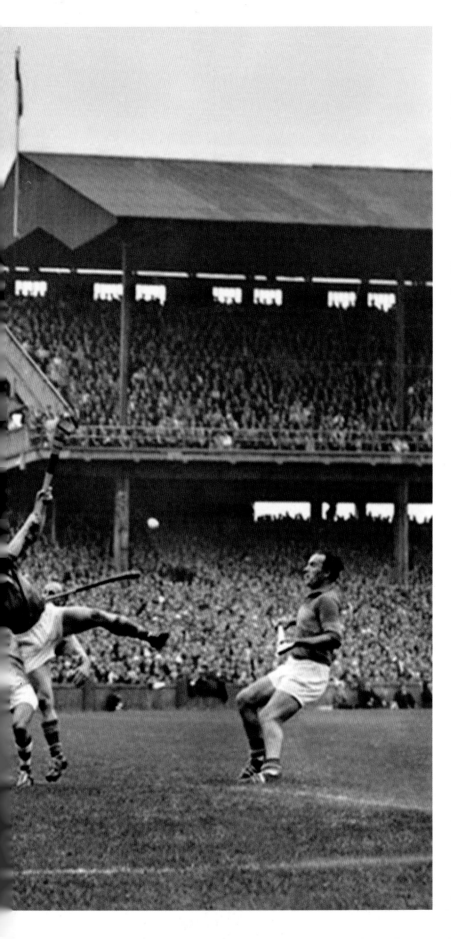

03 September 1961

This Dublin-Tipperary final marks the last time that the Dublin hurlers made it to an All-Ireland Final. Dublin have not won the Liam MacCarthy Cup since 1938. Hurling All-Ireland Senior Championship Final, Dublin v Tipperary, Croke Park, Dublin.

Connolly Collection / SPORTSFILE

24 September 1961

Offaly and Down footballers clash in the All-Ireland Senior Football Championship in Croke Park. Offaly were playing in their first ever final, while for Down it was only their second appearance; Down won 3-6 to 2-8. This was their second of three wins in the 1960s that made them made one of the 'teams of the decade' along with Galway, who also won three titles. This novel pairing of Down and Offaly attracted a crowd of 90,556, which is still a record attendance at a GAA match.

Connolly Collection / SPORTSFILE

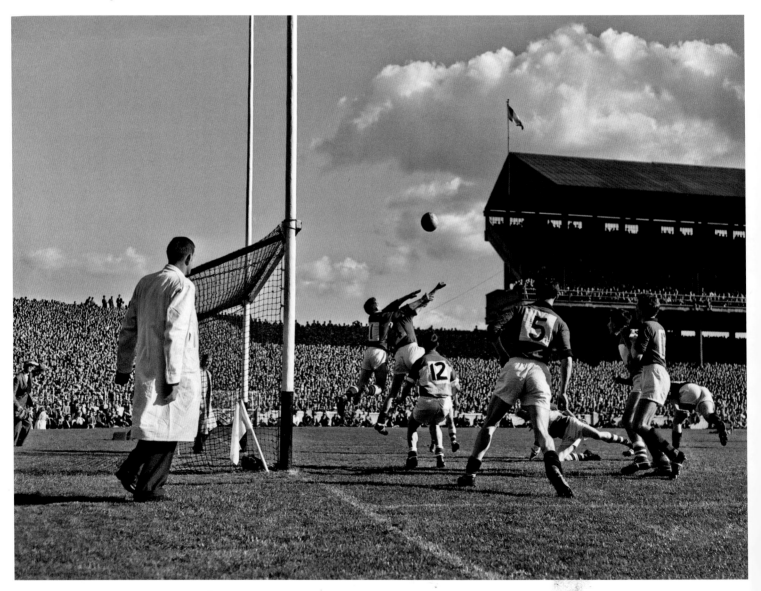

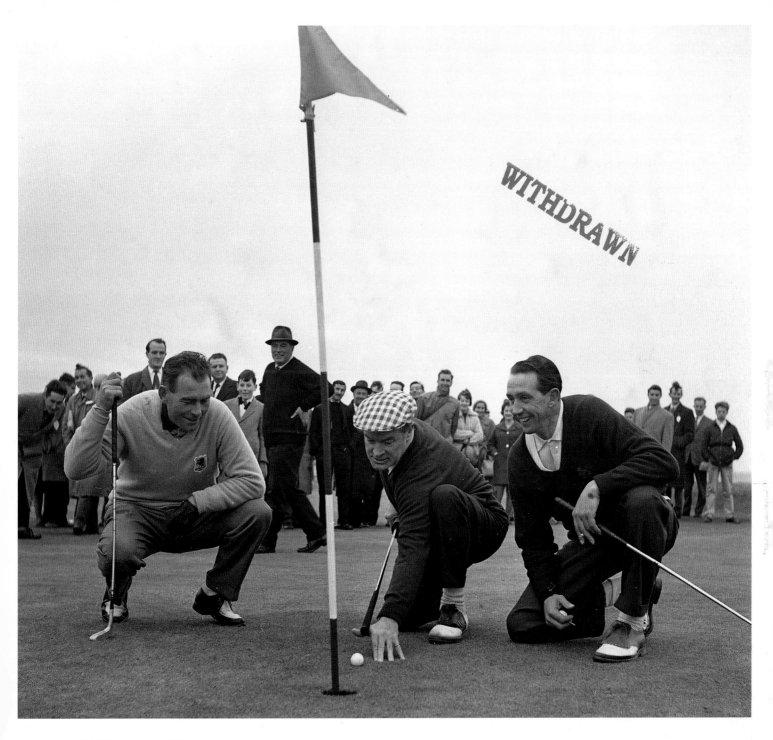

WITHDRAWN

04 November 1961

Irish professional golfer Christy O'Connor Senior, comedian Bob Hope and Irish
amateur golfer Joe Carr at Royal Dublin Golf Club, Bull Island, Dublin.

Connolly Collection / SPORTSFILE

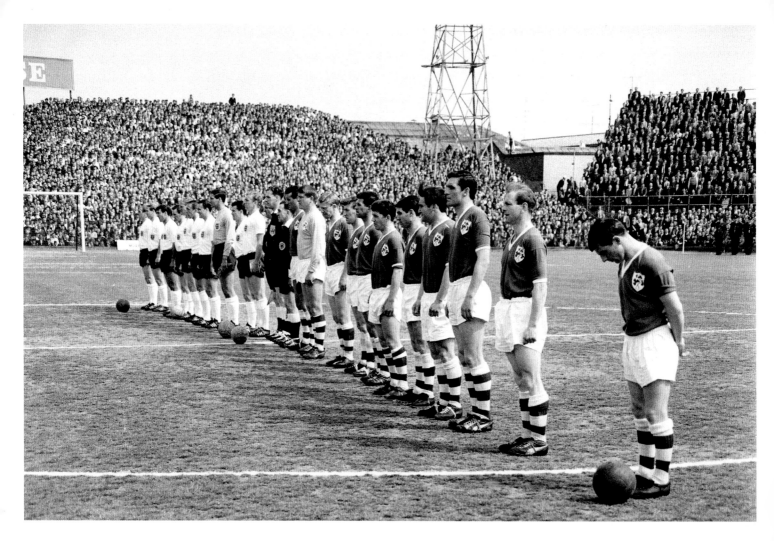

24 May 1964

International friendly: Republic of Ireland players, from right to left, Joe Haverty, Millwall, Paddy Ambrose, Shamrock Rovers, Willie Browne, Bohemians, Eddie Bailham, Shamrock Rovers, Tony Dunne, Manchester United, Johnny Giles, Leeds United, Andy McEvoy, Blackburn Rovers, Mick McGrath, Blackburn Rovers, Fred Strahan, Shelbourne, Noel Dwyer, Swansea Town, and captain Noel Cantwell, Manchester United, stand for the National Anthem before facing England in front of a crowd of 45,000 people. Republic of Ireland v England, Dalymount Park, Dublin.

Connolly Collection / SPORTSFILE

23 January 1965

Ireland's Willie John McBride wins possession for his side in the lineout against France during their opening match of the Five Nations in front an attendance of 55,000. Five Nations Championship, Ireland v France, Lansdowne Road, Dublin.

Connolly Collection / SPORTSFILE

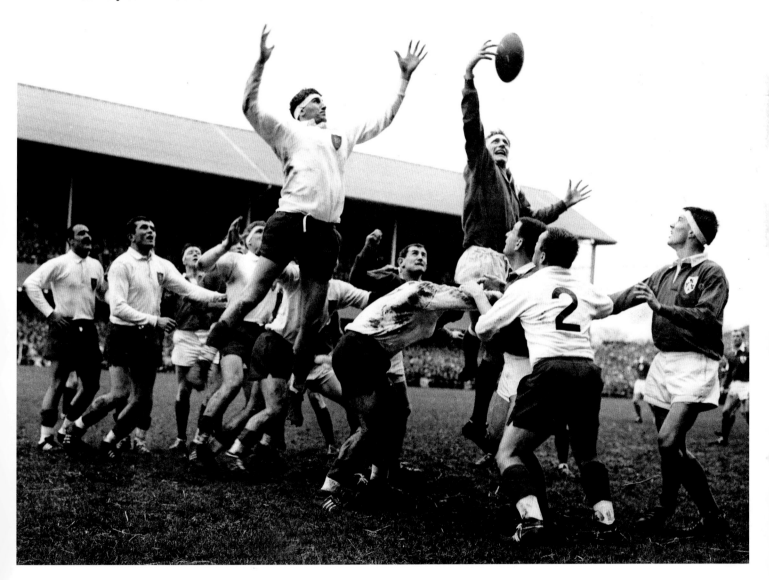

27 February 1965

Arkle, remembered as the greatest steeplechaser of all time, with his owner Anne, Duchess of Westminster. Trained by Tom Dreaper and ridden by Pat Taaffe, Arkle won three Cheltenham Gold cups, the 1964 Irish Grand National and many other major races, often carrying a heavy weight handicap. He retired at the age of nine after an injury. He is commemorated by a bronze statue in his native County Meath; his skeleton can still be seen on display at the National Stud.

Connolly Collection / SPORTSFILE

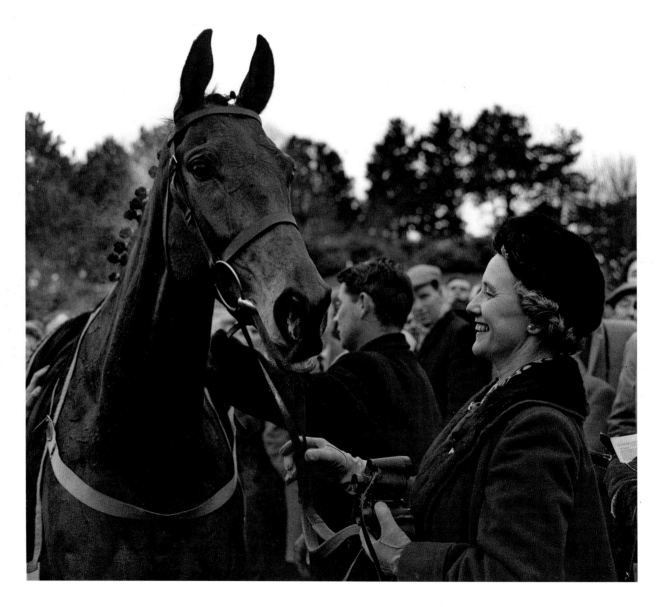

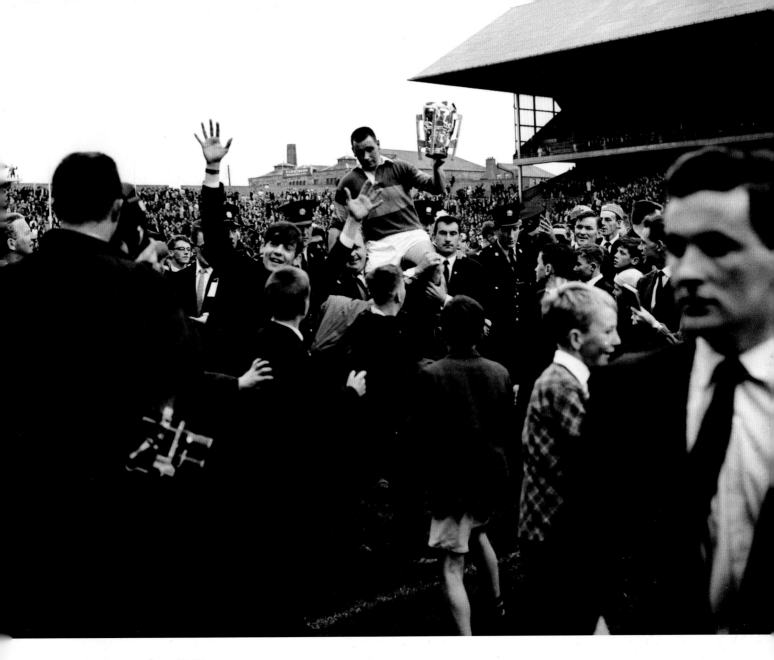

05 September 1965

Legendary Tipperary captain Jimmy Doyle – who, over his career, would win six All-Ireland medals and nine Munster medals – is held aloft by Tipperary supporters after his side's 2-16 to 0-10 victory over Wexford. The Thurles Sarsfields man was chosen as left corner forward on both the GAA Team of the Century in 1984 and the GAA Team of the Millennium in 2000.

Connolly Collection / SPORTSFILE

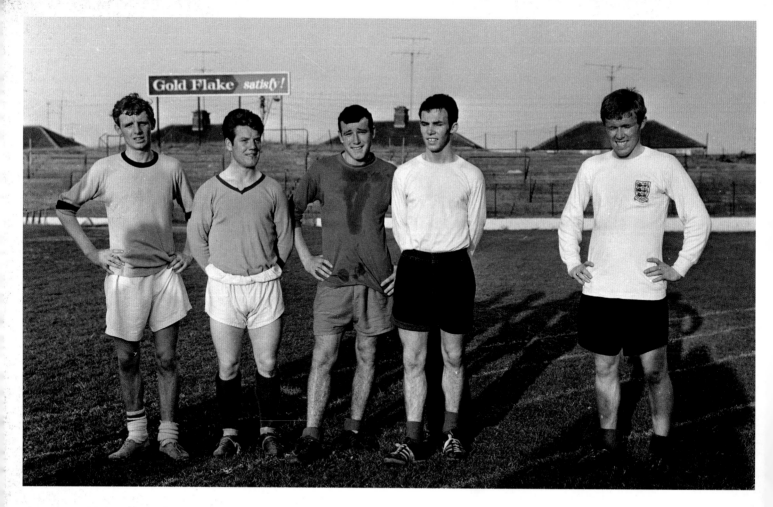

01 January 1966

Members of the Ireland Under 23 squad, including Eamon Dunphy (left), during squad training in Milltown, Dublin.

As a teenager, Dunphy went to Manchester United as an apprentice and went on to play for York City, Millwall, Charlton Athletic and Reading, before coming home to Shamrock Rovers (along with Johnny Giles) in an attempt to revitalise the League of Ireland. In 1978 Dunphy retired from football to concentrate fully on writing; he has been a prolific journalist and sports commentator ever since.

Connolly Collection / SPORTSFILE

01 January 1966

Cross country, Gormanston. Tom O'Riordan (leading the field) went to the US on an athletics scholarship in 1957, where he ran for Idaho State University, winning the NAIA Men's Cross Country Championship in 1959. The Donore Harriers man went on to represent Ireland in the 5,000m at the 1964 Olympics in Tokyo.

Connolly Collection / SPORTSFILE

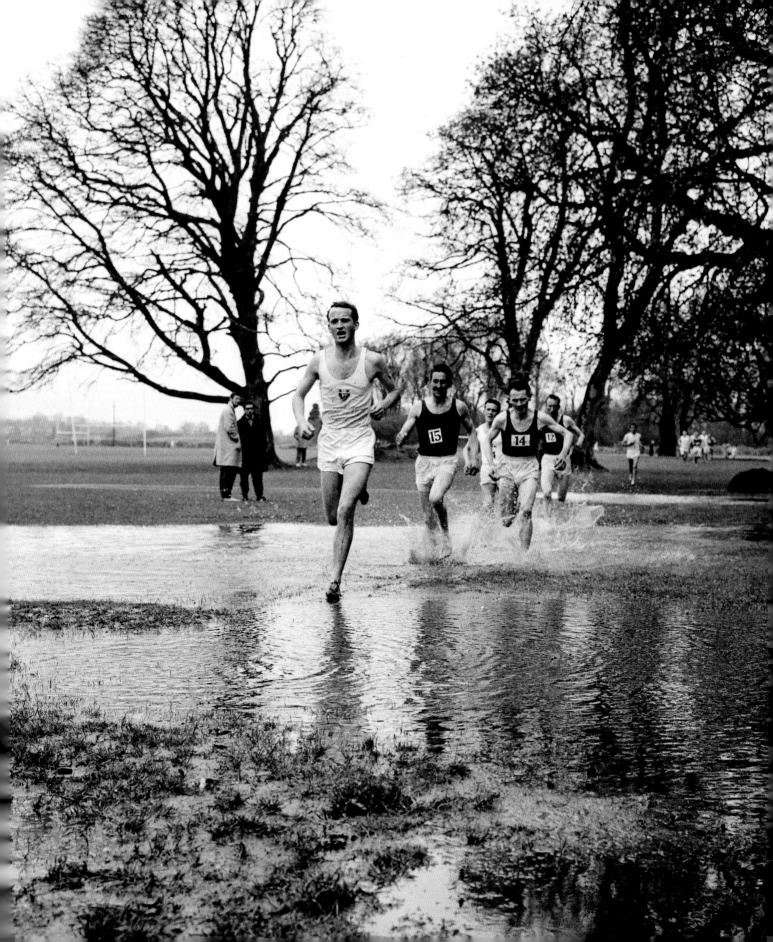

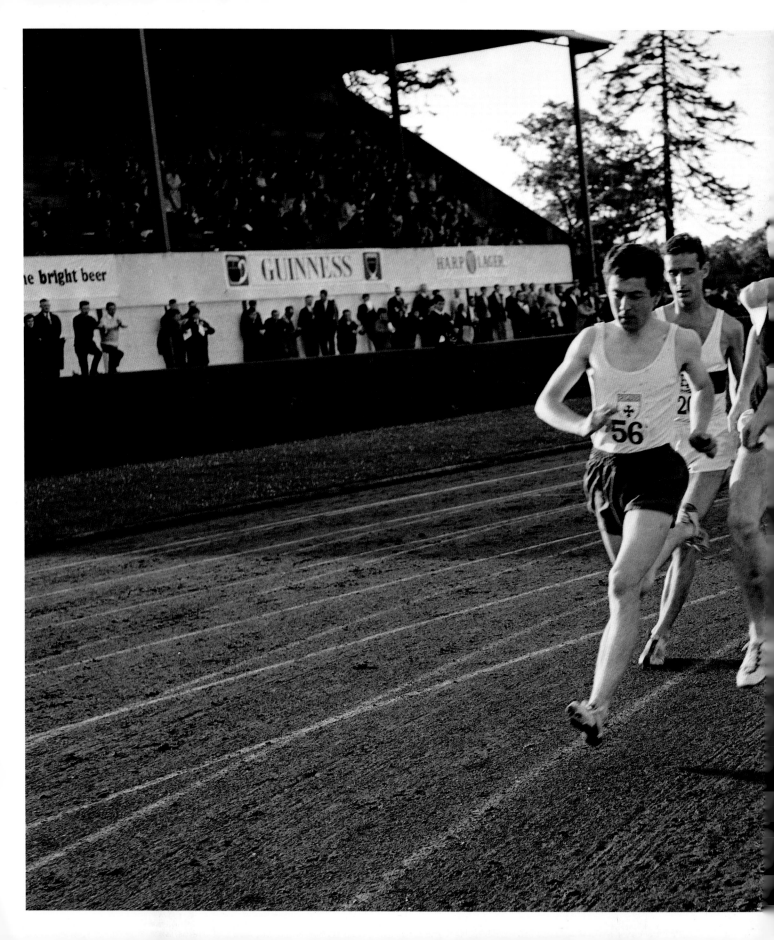

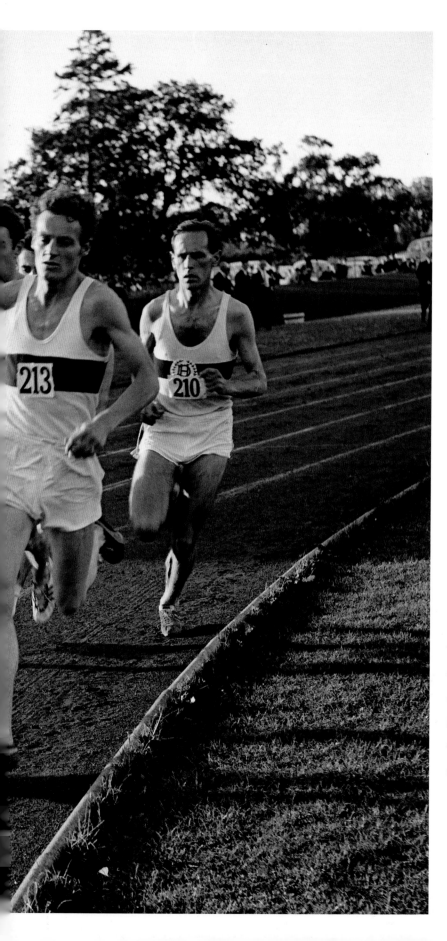

01 January 1966

Jim McNamara, 213, leads the field – including Tom O'Riordan, 210, and Frank Murphy, third from right – at the Amateur Athletic Union Championships, Santry, Dublin. McNamara represented Ireland in the marathon at the 1976 Olympics. Throughout the 1960s and 70s, when they won sixteen consecutive All-Ireland Cross Country championships, he and his Donore Harriers teammates were a force to be reckoned with in Irish running.

Connolly Collection / SPORTSFILE

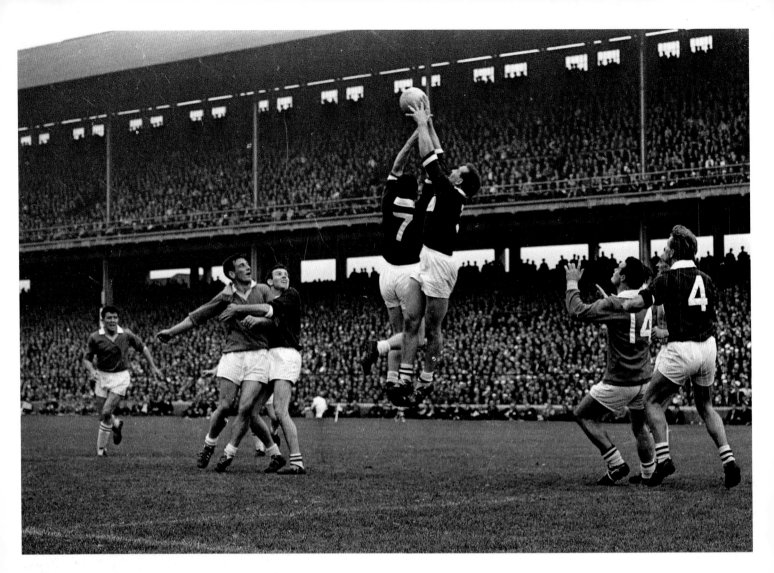

25 September 1966

Noel Tierney, right, and Martin Newell, leap for the high ball in the All-Ireland Senior Football Final against Meath. Galway won 1-10 to 0-07, making this their third consecutive football title. Both Tierney and Newell played on all three winning teams from 1964 until 1966 inclusive. This win made Galway joint team of the decade along with Down, who also won three titles, though not consecutive ones, in the 1960s. All-Ireland Senior Football Final, Galway v Meath, Croke Park, Dublin.

Connolly Collection / SPORTSFILE

22 September 1968

Kerry's Mick O'Connell, known for his skill with the high ball (centre), outfields Down's Sean O'Neill and John Purdy. O'Neill and John Murphy scored the goals as the Mournemen secured their third All-Ireland title in nine years and maintained their unbeaten championship record against Kerry.

Connolly Collection / SPORTSFILE

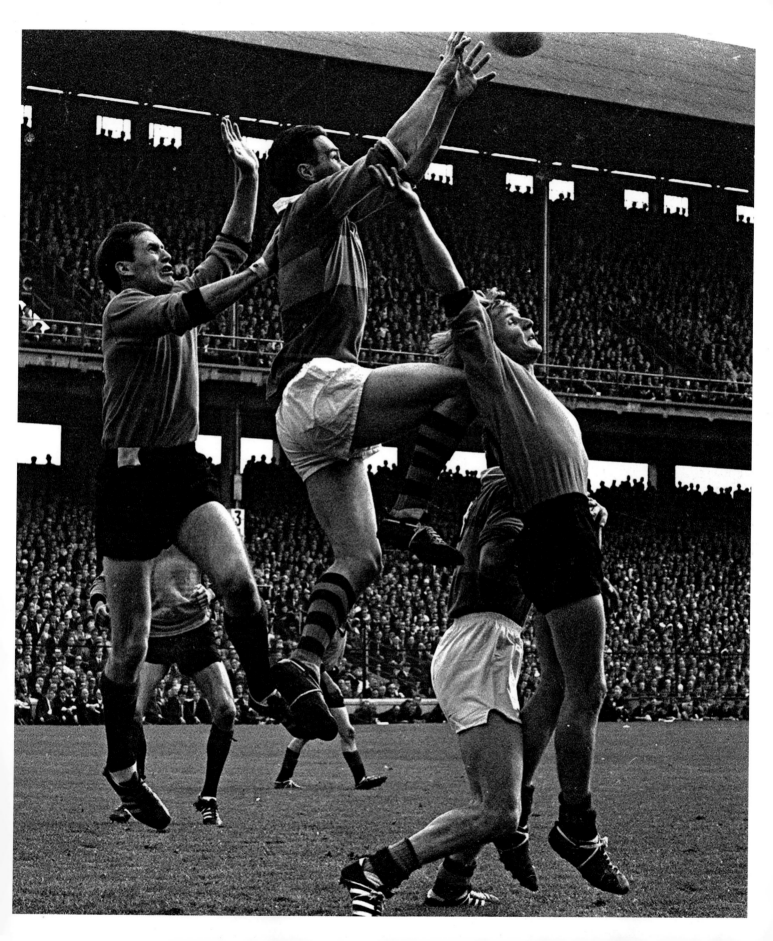

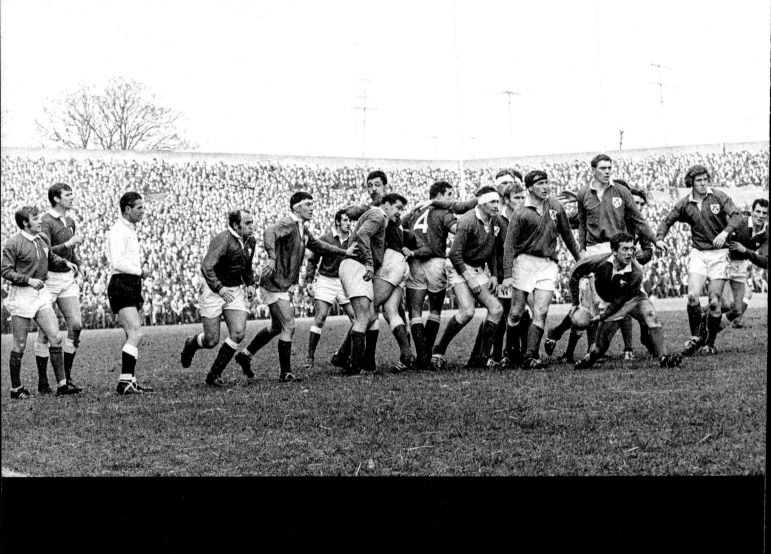

14 March 1970

**Lansdowne Road: In the final game of the 1970
Five Nations, Wales are denied their second
successive Triple Crown by a strong Irish side.
The match ended 14-0 to the home team. Here,
Roger Young of Ireland gets the ball away from a
lineout.**

Connolly Collection / SPORTSFILE

1970s

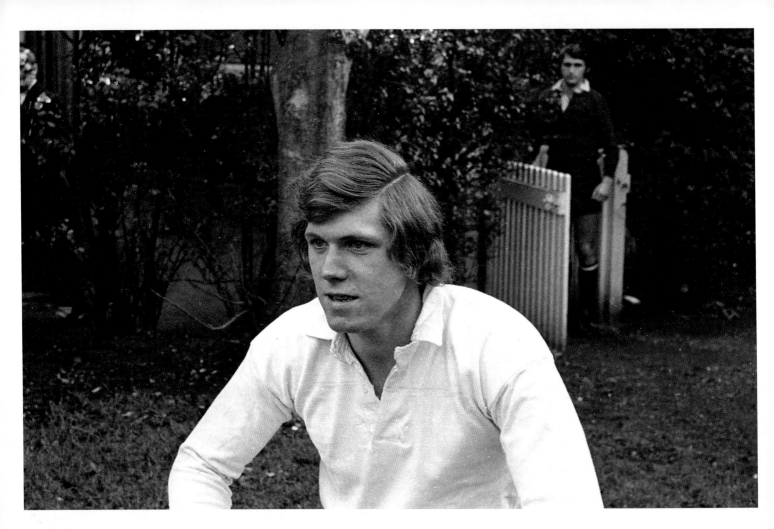

16 January 1971

Ireland's Fergus Slattery, pictured ahead of the 1971 Five Nations in
Lansdowne Road. Just twenty-one, Slattery earned a place on the British
& Irish Lions tour to New Zealand and Australia later that year, which
included an epic series victory over the All Blacks.

Connolly Collection / SPORTSFILE

26 September 1971

Offaly captain Willie Bryan lifts the Sam Maguire Cup after
Offaly's first ever All-Ireland Football Final win. Offaly beat
Galway, who had won three consecutive titles in the 1960s,
1-14 to 2-8 thanks to a Murt Connor goal.

Connolly Collection / SPORTSFILE

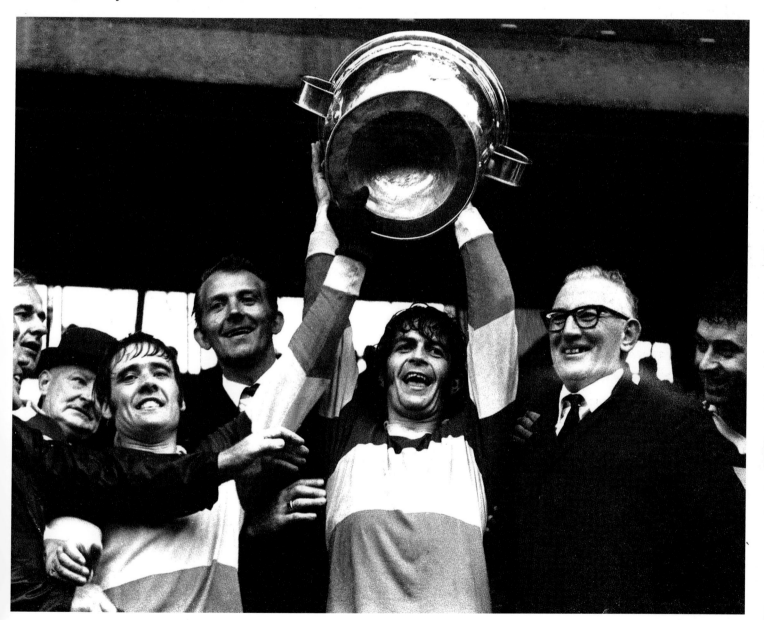

29 April 1972

Ireland's Mike Gibson during an international friendly test match against France at Lansdowne Road, which the home team won by 24-14.

Connolly Collection / SPORTSFILE

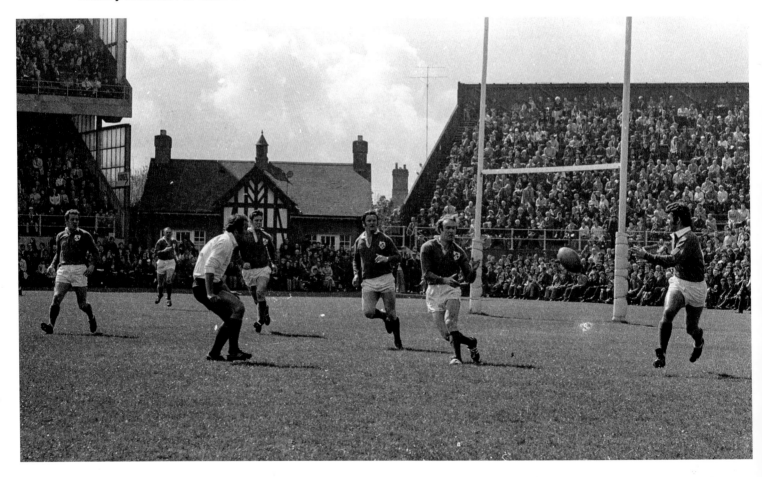

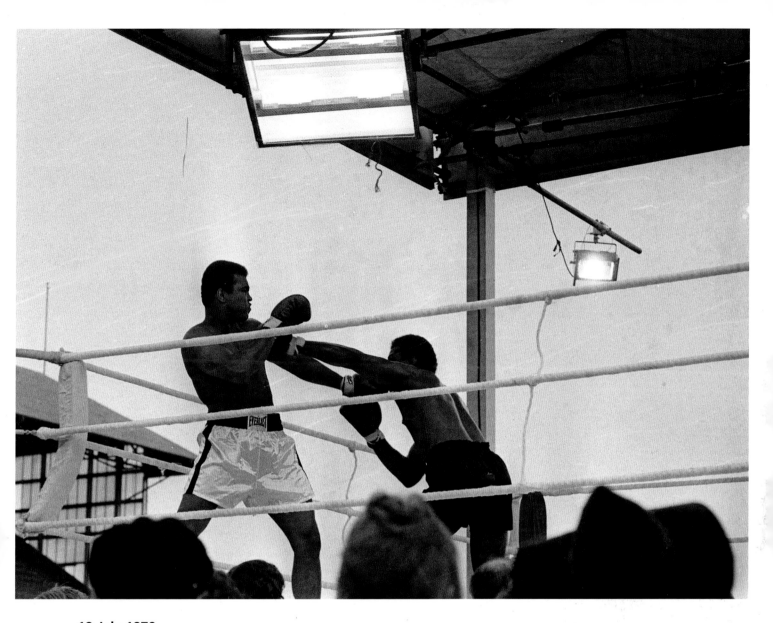

19 July 1972

It was the talk of the nation when Muhammad Ali, 'The Greatest', came to Croke Park to fight Al 'Blue' Lewis in 1972. Ali was making a comeback after a stint in prison for his conscientious objection to the Vietnam War, when Kerryman and former circus strongman Butty Sugrue arranged the bout.

Ali was trailed by adoring fans and crowds came to watch him train and spar in Croke Park every afternoon. As a publicity stunt he was even shown how to use a hurley and sliotar by Kilkenny great Eddie Keher. Ali stopped Lewis in the eleventh round in a technical knockout.

Connolly Collection / SPORTSFILE

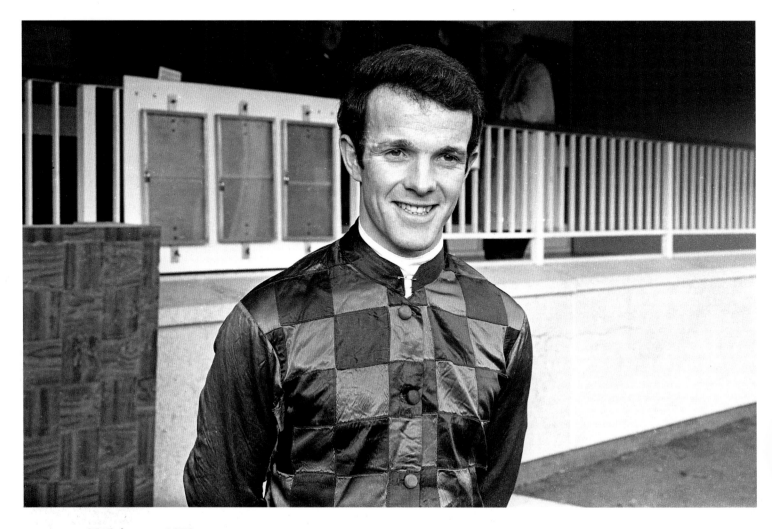

03 February 1973

Jockey Ted Walsh at Leopardstown racecourse, Co. Dublin. More widely known these days for his racing punditry, Walsh previously enjoyed a successful career as a jockey, winning the Irish Amateur Jockey Championship eleven times.

Connolly Collection / SPORTSFILE

10 February 1973

When Ireland beat England 18-9 at Lansdowne Road, Dublin, in 1973, the bigger story was that the match had taken place at all. The previous year had been one of the most violent years of the 'Troubles' in Ireland, with the Bloody Sunday killings in Derry and the burning of the British Embassy in Dublin. Wales and Scotland were both scheduled to play Ireland in Dublin that year, but after players received death threats, purported to come from the IRA, the decision was taken that the teams would not travel to Dublin. So when England turned up to play in 1973 the applause echoed around the stadium for a full five minutes before kick-off. 'We may not be any good, but at least we turn up,' said England captain John Pullin at the post-match banquet.

Connolly Collection / SPORTSFILE

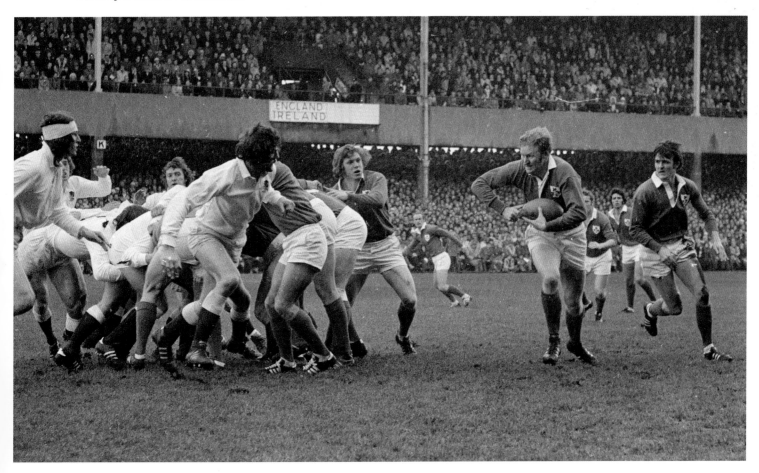

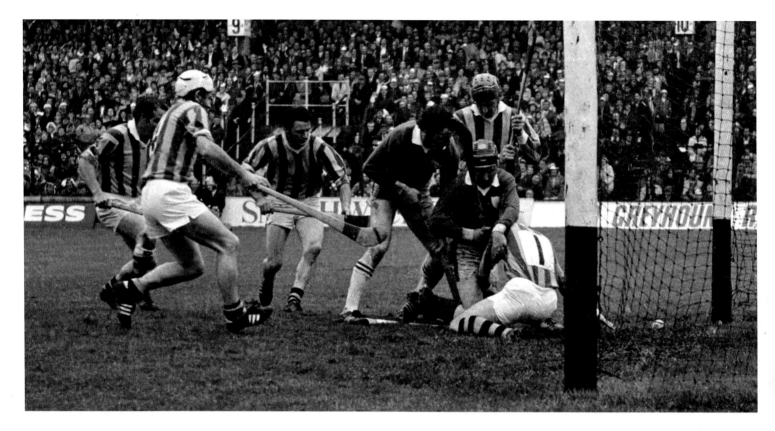

02 September 1973

Mossy Dowling of Limerick scores his side's goal past Kilkenny goalkeeper Noel Skehan during the All-Ireland Hurling Final match between Kilkenny and Limerick at Croke Park in Dublin. Other players include from left, Fan Larkin, Phil Cullen and Nicky Orr of Kilkenny, Ned Rea of Limerick and Pat Henderson of Kilkenny. Though they went in as underdogs, Limerick won the match 1-21 to 1-14.

Connolly Collection / SPORTSFILE

23 September 1973

Billy Morgan, captain of the victorious Cork football team, shakes hands with Galway captain Liam Sammon. This was Cork's first All-Ireland win in twenty-eight years; the match was also notable for the first All-Ireland appearance by nineteen-year-old Jimmy Barry-Murphy, who scored two goals for the Rebels.

All-Ireland Senior Football Final, Cork v Galway, Croke Park, Dublin.

Connolly Collection / SPORTSFILE

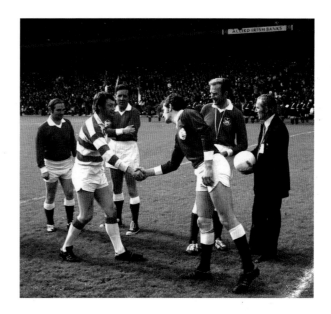

27 December 1973

Trainer Vincent O'Brien and jockey Lester Piggott – two legends of the turf – at the Sweeps Hurdle at Leopardstown race course in Dublin. O'Brien was one of the greatest trainers ever and Lester Piggott remains unchallenged as one of the greatest jockeys ever.

Connolly Collection / SPORTSFILE

22 September 1974

Dublin goalkeeper Paddy Cullen saves a penalty. Dublin, under the management
of Kevin Heffernan, won the game 0-15 to 1-6 to secure their first All-Ireland title
since 1963. Later that year Heffernan became the first non-player to win the Texaco
Footballer of the Year award. All-Ireland Senior Football Championship Final,
Dublin v Galway. Croke Park, Dublin.

Connolly Collection / SPORTSFILE

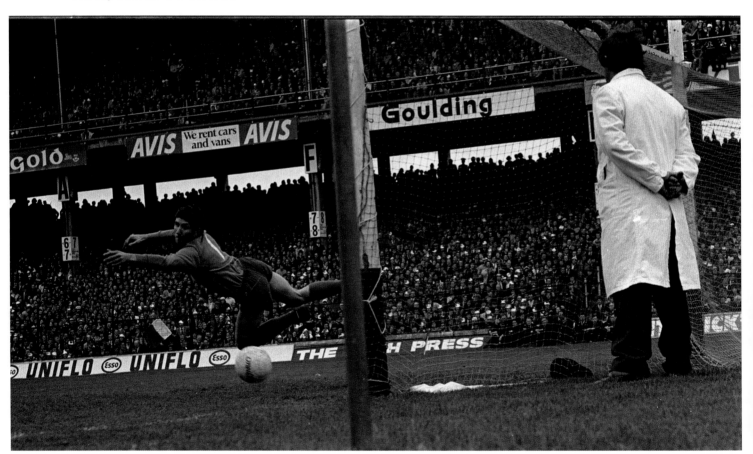

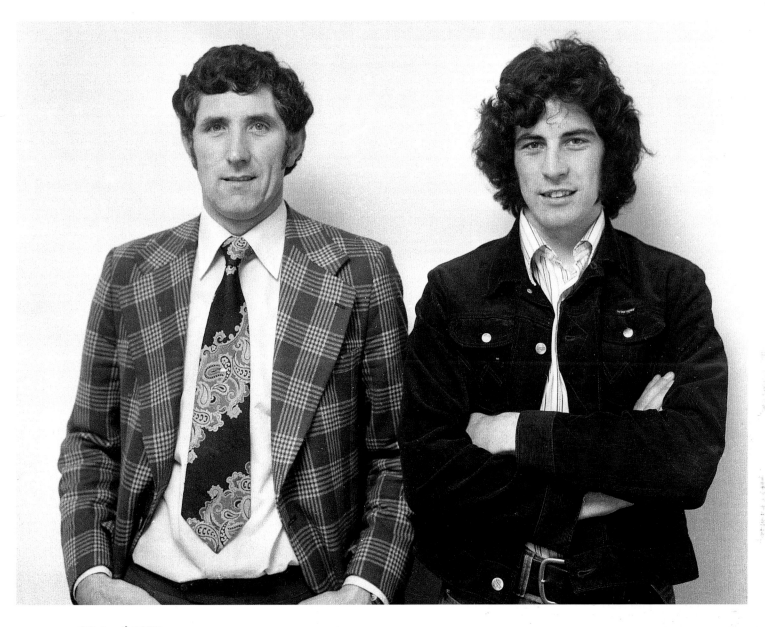

30 April 1975

Dublin footballers Paddy Cullen, left, and Bernard Brogan. Under the reign of Kevin Heffernan, the success of the Dublin team of the 1970s led to a surge in support for the GAA in the capital, with key players such as Cullen and Brogan becoming household names throughout the country.

Connolly Collection / SPORTSFILE

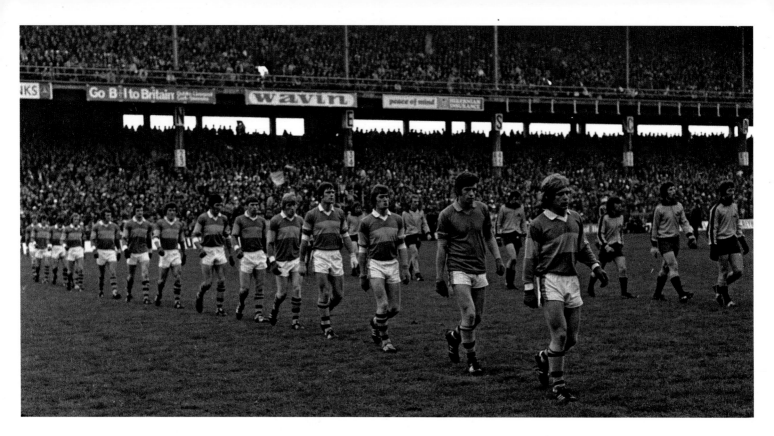

28 September 1975

The Kerry and Dublin teams parade round Croke Park prior to the match. The 1975 Kerry team were the youngest Kerry side to win an All-Ireland. This victory was the start of a journey under Mick O'Dwyer which would result in eight All-Irelands over the following twelve years for the Kingdom. All-Ireland Football Final, Kerry v Dublin, Croke Park.

Connolly Collection / SPORTSFILE

10 August 1977

Shamrock Rovers player/manager John Giles, with Ray Treacy and Eamon Dunphy during a Shamrock Rovers photo call at Glenmalure Park in Milltown, Dublin. Giles had just resigned from West Bromwich Albion to take up a player/manager role at Shamrock Rovers. He sought to turn Rovers into a European force and, as he stated in an interview with *Magill* magazine, he hoped 'Ultimately to win the European Cup with Shamrock Rovers'. In a broader sense, Giles also aimed to revitalise the Irish game, which was stagnating due to increased television coverage of British teams. Giles stressed the importance of keeping Irish talent in Ireland. Treacy and Dunphy were both signed by Giles as they also left England to return home and join his project. Ultimately, it was not to be for Giles at Shamrock Rovers as he departed the club in 1983. In a 2015 interview with the42.ie, he recalled 'it was like trying to climb Everest'.

Connolly Collection / SPORTSFILE

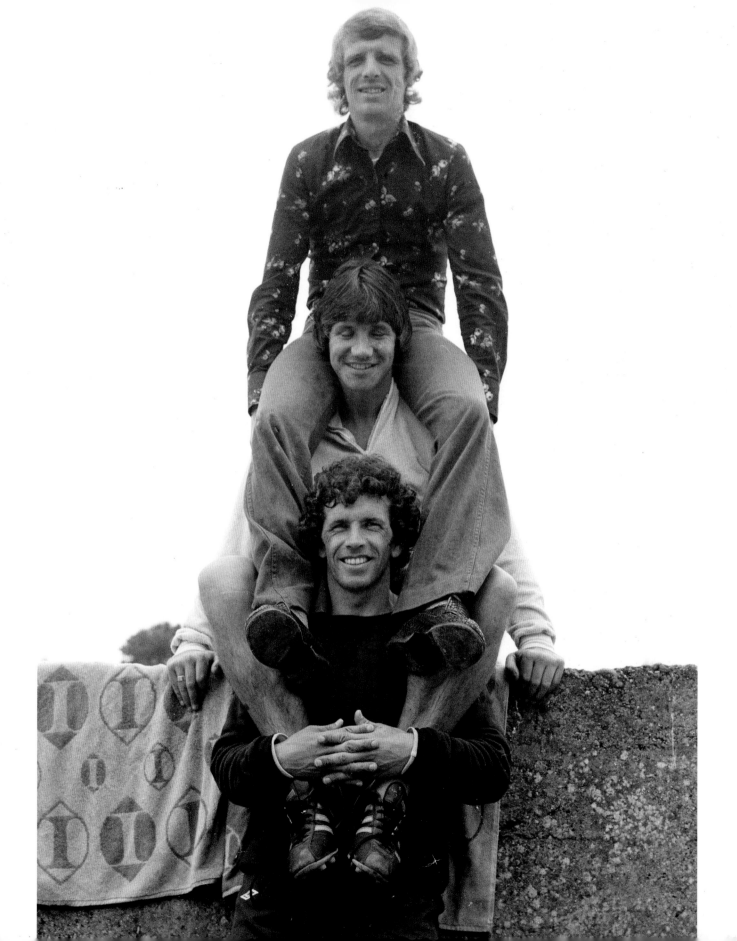

03 September 1978

John Horgan, Cork, in action against Brian Cody, Kilkenny.

Cork won the match 1-15 to 2-8; Corkman Jack Lynch, one of the

all-time greats of hurling and the Taoiseach at the time, was in the

Hogan Stand to congratulate them as they lifted the Liam MacCarthy

Cup. All-Ireland Hurling Final, Cork v Kilkenny, Croke Park, Dublin.

Connolly Collection / SPORTSFILE

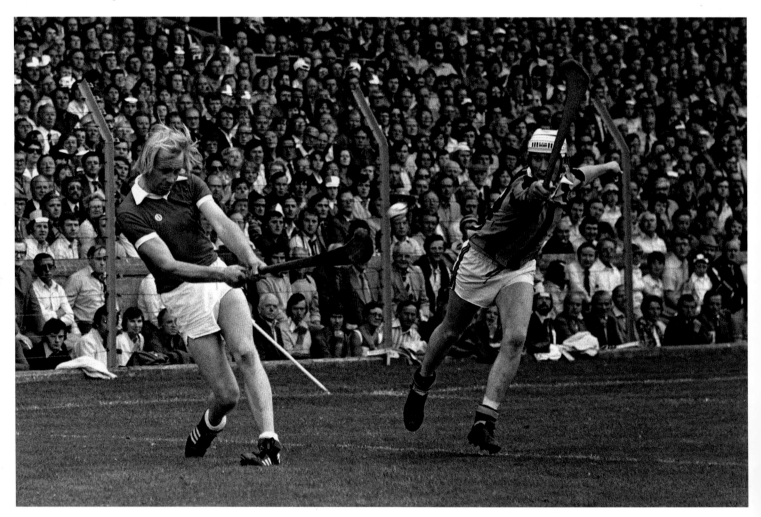

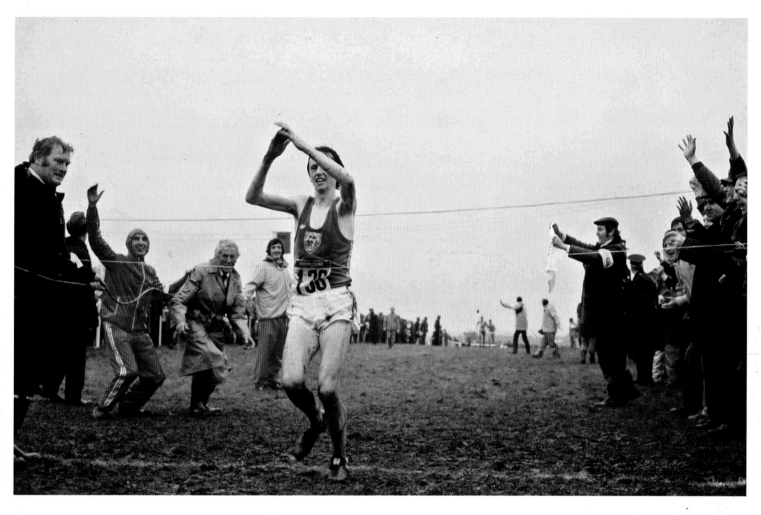

25 March 1979

In front of a huge home crowd who turned out despite the weather
to cheer on 'the mudlark', defending champion John Treacy of
Ireland crosses the line to win the World Cross Country Championship
at Green Park Racecourse in Limerick. In 1984 he went on to win
silver in the Olympic marathon in Los Angeles, earning Ireland's only
Olympic medal at the marathon distance.

Ray McManus / SPORTSFILE

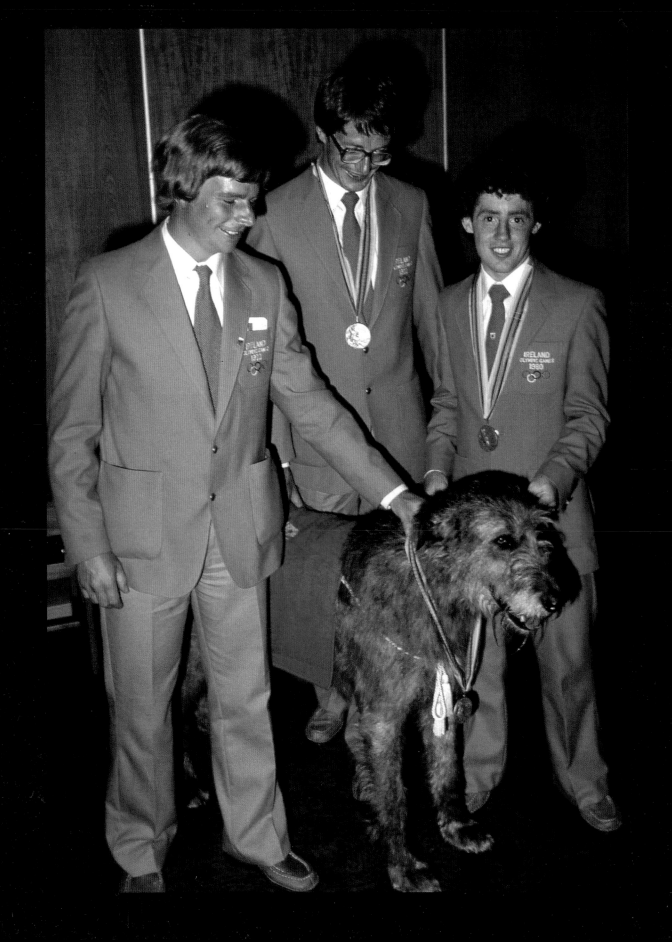

04 August 1980

Flyweight bronze medallist Hugh Russell, right, with *Flying Dutchman* silver medal crew David Wilkins, left, and James Wilkinson at the Irish Olympic team homecoming in Dublin Airport from the 1980 Summer Olympics held in Moscow, Soviet Union.

Ray McManus / SPORTSFILE

1980s

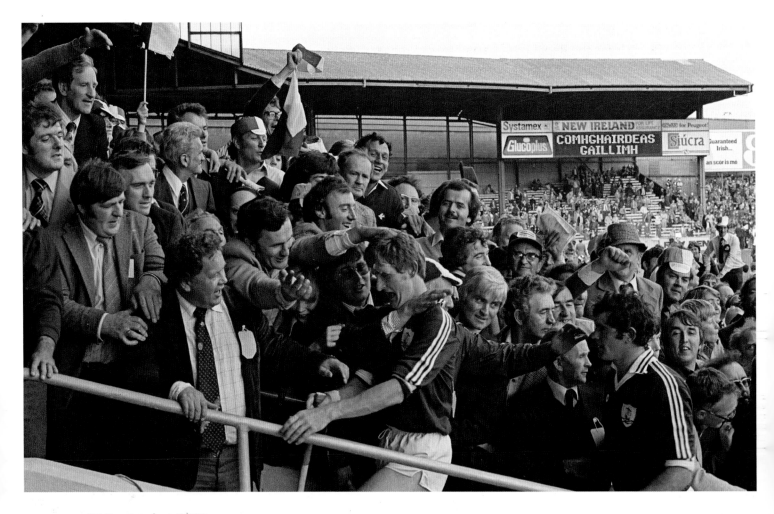

07 September 1980

Noel Lane, left, and Steve Mahon of Galway are engulfed by jubilant fans as they make their way up the steps of the Hogan Stand after the All-Ireland Hurling Final against Limerick in Croke Park, Dublin. Galway, who had lost to Kilkenny in 1979, won out 2-15 to 3-9 this year. Immortalised by captain Joe Connolly's famous speech and Joe McDonagh's rendition of 'The West's Awake', this win was the first time since 1923 that the Liam MacCarthy Cup would head to the western province.

Ray McManus / SPORTSFILE

25 March 1981

Liam Brady leads the Republic of Ireland team out against Belgium ahead of the Fifa World Cup Group 2 Qualifying match between Belgium and Republic of Ireland at Heysel Stadium in Brussels. It was a game dominated by two controversial decisions by referee Raul Nazaré. Frank Stapleton managed to put the ball in the back of the Belgian net, only for the goal to be bizarrely disallowed by Nazaré. In the dying moments of the game, Belgium were awarded a free kick for a contentious foul on Eric Gerets, which led to the match-winning goal. Many would regard this Irish team as the greatest to never qualify for a World Cup.

Ray McManus / SPORTSFILE

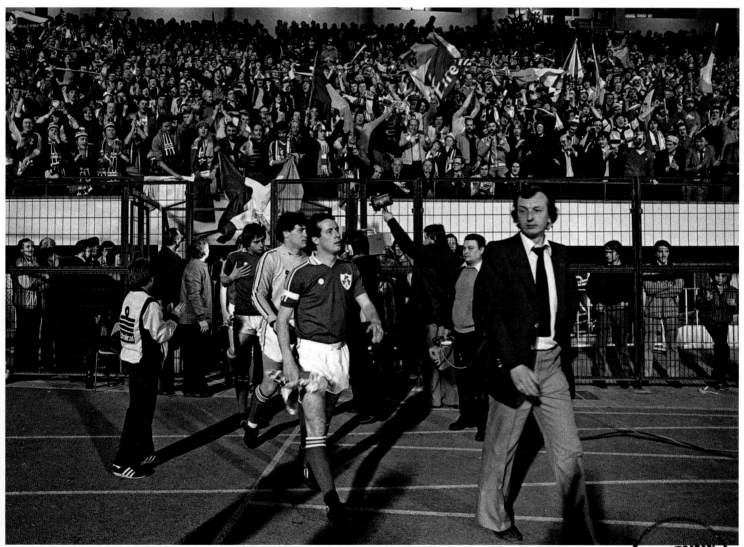

06 September 1981

Offaly players and supporters celebrate their first ever All-Ireland hurling win at the final whistle of the All-Ireland Senior Hurling Championship Final match between Offaly and Galway at Croke Park in Dublin.

Ray McManus / SPORTSFILE

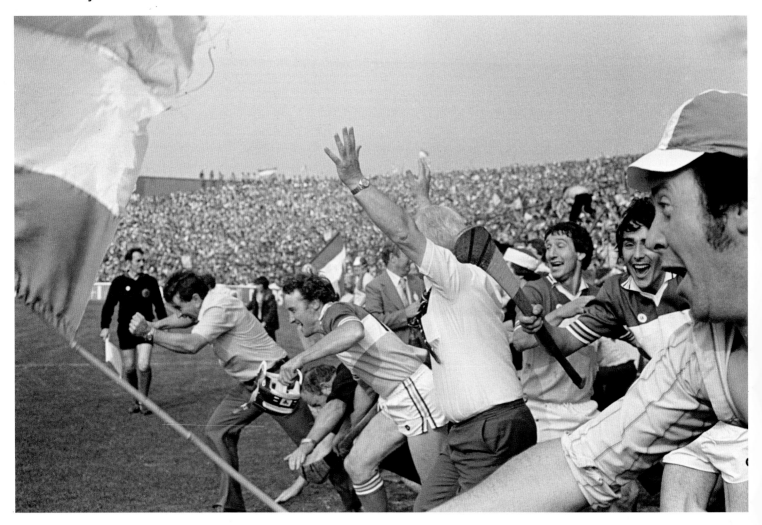

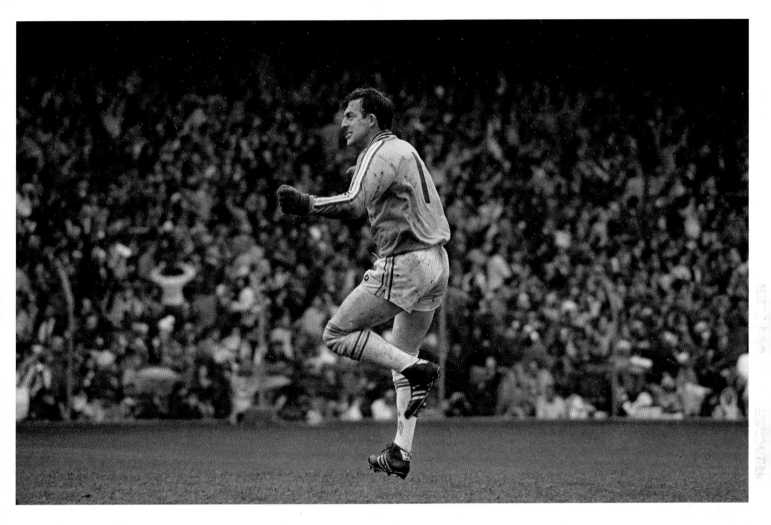

19 September 1982

Kings of September! Offaly goalkeeper Martin Furlong celebrates after Seamus Darby scored a late goal – which denied Kerry five All-Ireland Football titles in a row. All-Ireland Senior Football Final, Kerry v Offaly, Croke Park.

Ray McManus / SPORTSFILE

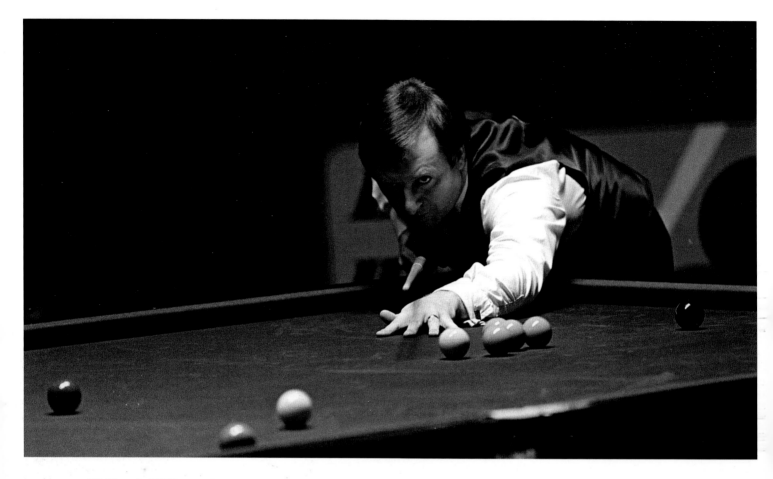

22 March 1983

Dennis Taylor of Northern Ireland in action during the Benson &
Hedges Irish Masters Round 1 match against Jimmy White at Goffs In
Naas, Kildare. Taylor went on to become World Snooker Champion in
1985.

Ray McManus / SPORTSFILE

04 May 1983

Eight of the Irish members of the 1983 British & Irish Lions party:
from left, Hugo MacNeill, David Irwin, Ollie Campbell, captain Ciaran
Fitzgerald, team manager Willie John McBride, Michael Kiernan, John
O'Driscoll and Trevor Ringland. Also on their way to New Zealand
were Donal Lenihan and Gerry McLoughlin.

Jim O'Kelly / SPORTSFILE

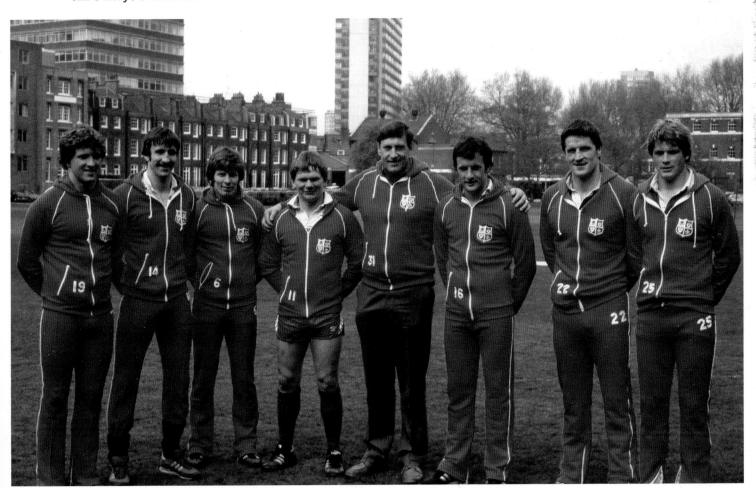

18 September 1984

Glasgow Rangers supporters clash with Gardaí during the UEFA Cup First Round 1st Leg between Bohemians and Glasgow Rangers at Dalymount Park in Dublin. Despite Garda presence in the stadium, as well as newly-built steel fences in the stands, riots broke out between the two sets of fans. Rangers manager Jock Wallace regarded the events that night as 'a disgrace to football'. While headlines were dominated by the events on the terraces, on the pitch, goals from Rocky O'Brien and Gino Lawless helped Bohemians to a 3-2 victory.

Ray McManus / SPORTSFILE

05 February 1985

Fans stand on the roof of one of the terraces as the Republic of Ireland line up a free kick. Friendly International, Republic of Ireland v Italy, Dalymount Park, Dublin. Only 1,600 tickets were issued for the game, while other spectators would pay at the turnstiles. The FAI severely underestimated how large the crowd would be. It is estimated that there were 40,000 people inside Dalymount that night. This fixture is also notable as it marked Paul McGrath's first international cap.

Ray McManus / SPORTSFILE

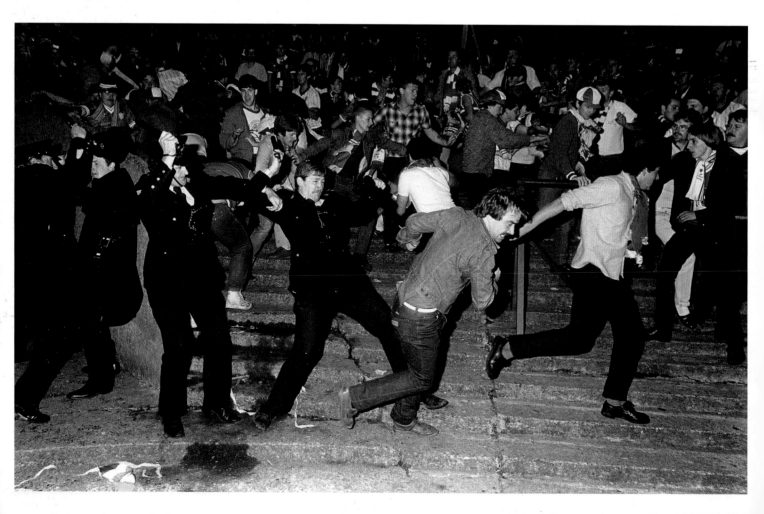

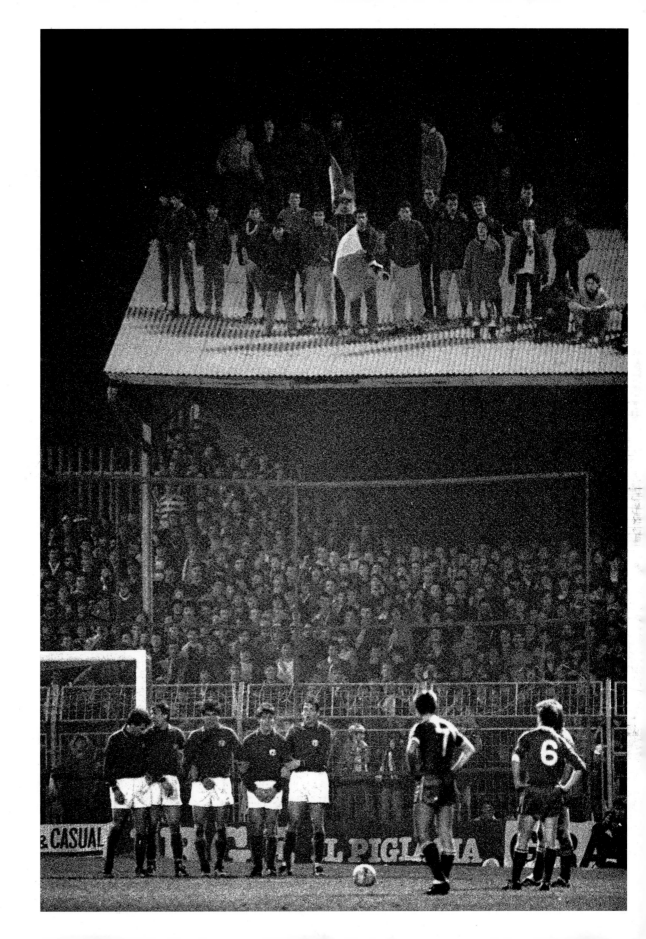

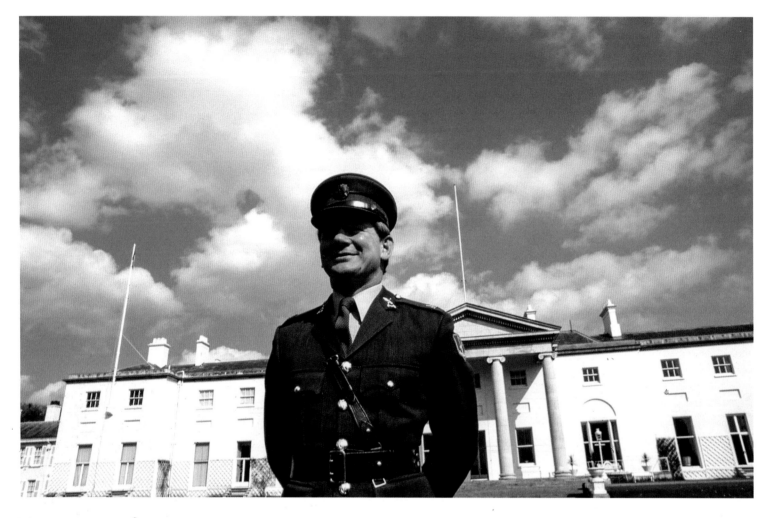

25 March 1985

Ireland rugby captain and aide-de-camp to President Patrick Hillery, Ciaran Fitzgerald, poses for a portrait at Áras an Uachtaráin in Dublin. Fitzgerald captained Ireland to the Triple Crown in 1982 and 1985, and the British & Irish Lions on their 1983 tour. After his days as a player, he became the coach of the national team.

Ray McManus / SPORTSFILE

30 March 1985

In Lansdowne Road Ireland's Michael Kiernan
(number 12) watches as his drop goal goes over to
seal Ireland's victory over England and give them
the Triple Crown.

James Meehan / SPORTSFILE

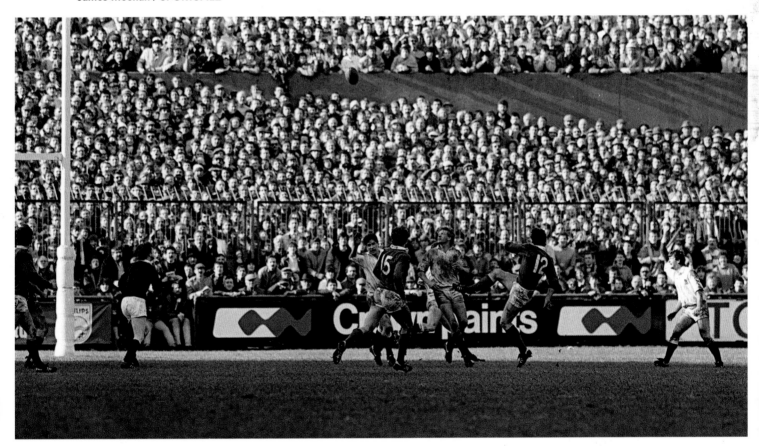

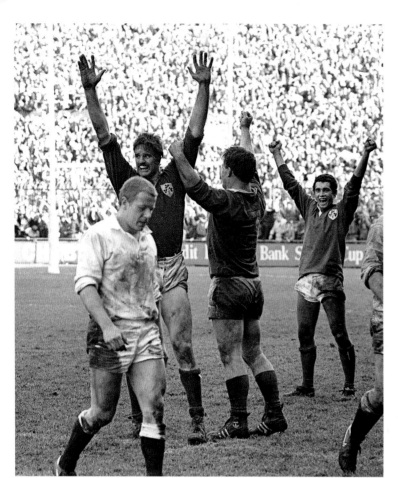

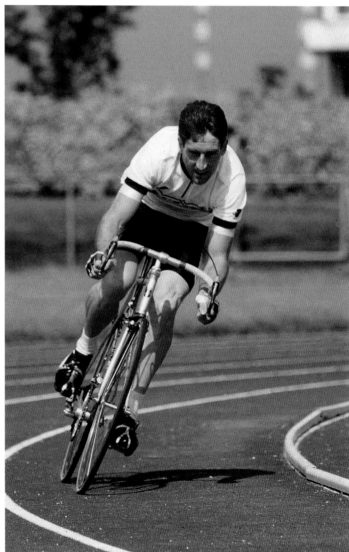

31 July 1985

Sean 'King' Kelly from Carrick-on-Suir was probably the leading road racing cyclist of his generation: when world rankings were introduced in 1994 he was the first at number 1, a position he held for a remarkable five years. His toughness was legendary, and his 193 professional wins included sprints, mountains and one-day 'classics', as well as five consecutive editions of the week-long Paris-Nice race.

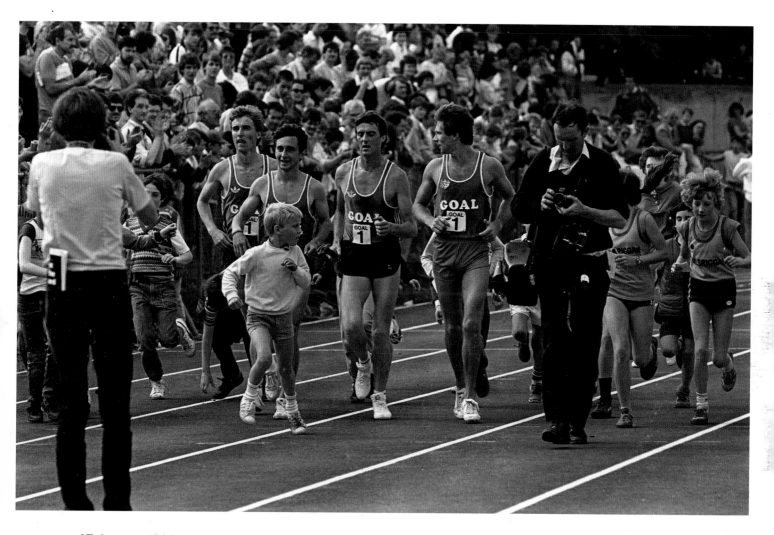

17 August 1985

In 1985 John O'Shea of GOAL was determined to stage some sort of sporting event to raise money for famine-stricken Ethiopia. He had the idea to recruit some of the finest Irish milers of all time for a record attempt. And so, in front of an enthusiastic crowd on the old Belfield track at UCD, Eamonn Coghlan, Marcus O'Sullivan, Frank O'Mara and Ray Flynn set the world outdoor record for the 4 x 1 mile relay. There was no entry fee, but O'Shea recalled, 'We had our "Goalies" going around with buckets, taking donations, and by the end of the night had collected around £25,000, with more coming in afterwards.' The record time – 15:49:08 – still stands today.

Ray McManus / SPORTSFILE

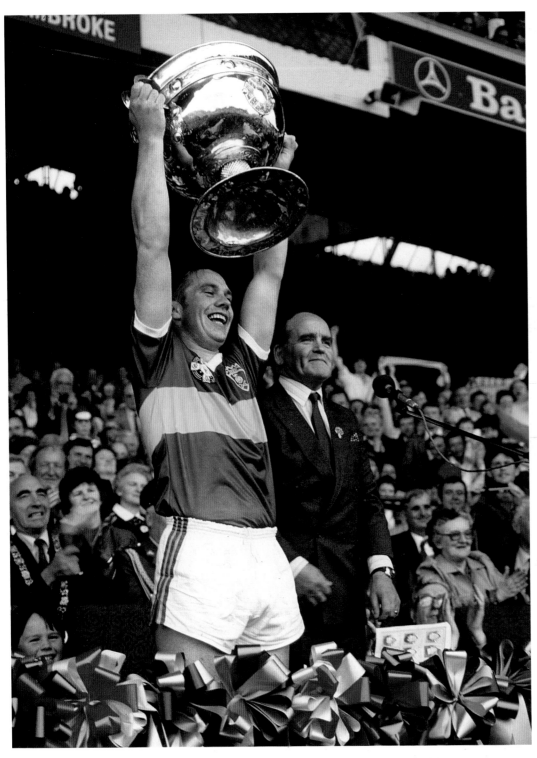

22 September 1985
Legendary Kerry captain Páidí Ó Sé lifts the Sam Maguire in the company of Dr Mick Loftus, President of the GAA, after Kerry's 2-12 to 2-8 victory over Dublin. All-Ireland Football Final, Kerry v Dublin, Croke Park.

Ray McManus /
SPORTSFILE

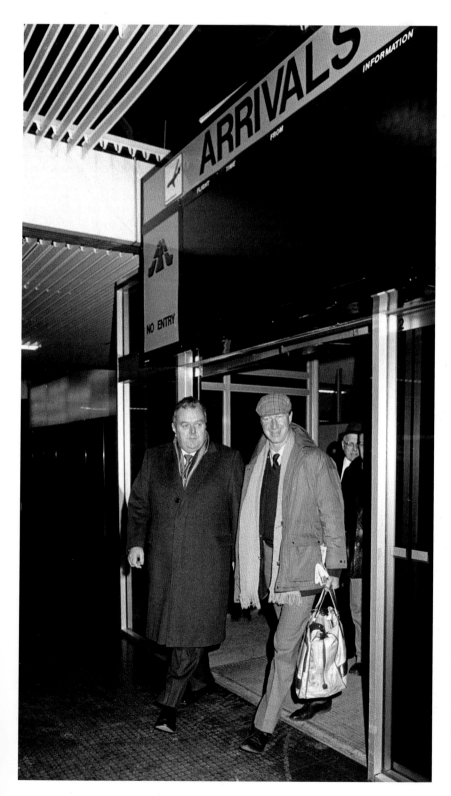

11 February 1986

Jack Charlton, accompanied by Joe Delaney, assistant honorary treasurer of the FAI, arrives at Dublin airport four days after his appointment as Republic of Ireland manager. A World Cup winner in his playing days, 'Big Jack' is undoubtedly one of the most influential men in Irish sporting history. Charlton was the first non-Irish manager of the national team. He led the country to qualification for the European Championships in 1988, as well as back-to-back World Cup qualifications in 1990 and 1994. A notable theme of Charlton's reign was his utilisation of what many refer to as the 'granny rule'. This was the practice of players declaring for a country other than the one they were born in, usually because of some familial tie to that country. John Aldridge, Ray Houghton and Tony Cascarino are examples of how Charlton used this rule to strengthen his Irish squad. Many of the most iconic and unforgettable moments in Irish football came during Charlton's ten-year spell at the helm of the national team. Often, it was these non-Irish players that Charlton had so shrewdly recruited that were at the forefront of these famous moments.

Ray McManus / SPORTSFILE

15 February 1986

Barry McGuigan, left, in action against Danilo Cabrera during their WBA World Featherweight Title Fight at the RDS in Dublin. The Clones Cyclone, the defending champion, stopped the Dominican challenger in the 14th round. McGuigan, from County Monaghan, was an incredibly popular sportsman and a symbol of hope and unity during the Troubles, as he drew a mixed audience to his fights; he regularly filled the King's Hall in Belfast. In an interview with Donald McRae in *The Guardian* newspaper in 2011, McGuigan said, 'You know that line [in 'Danny Boy'] my father used to sing? "I'll be there in sunshine or in shadow …" Well, the shadows ran deep. And my fights felt a little like sunshine. Both sides would say: "Leave the fighting to McGuigan" – people loved to forget the Troubles a while.'

Ray McManus / SPORTSFILE

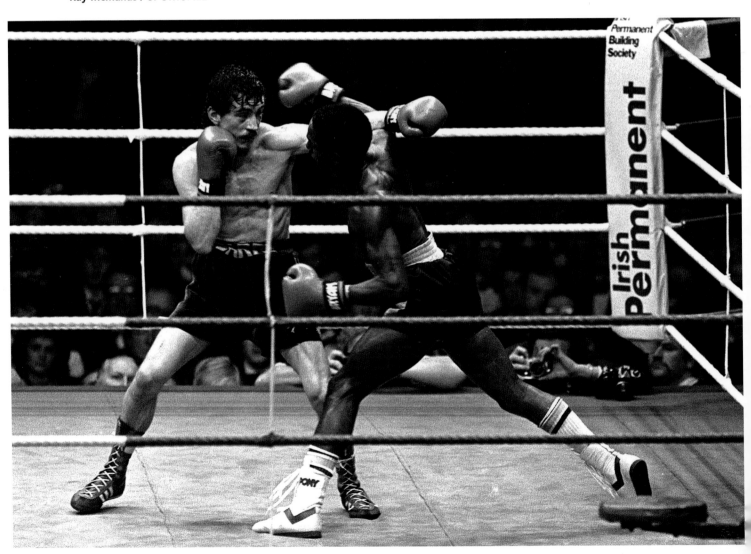

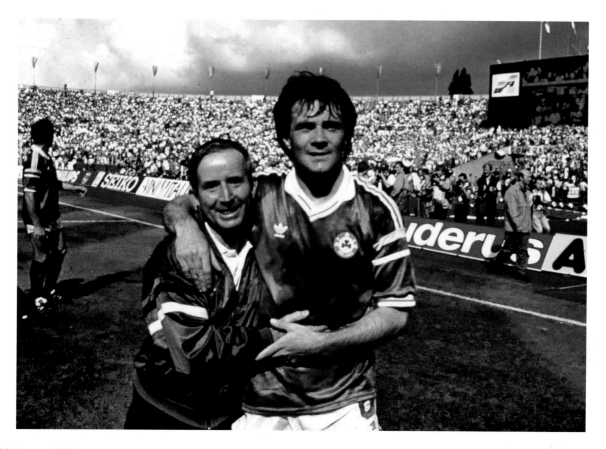

12 June 1988

Republic of Ireland's Charlie O'Leary, left, and Ray Houghton celebrate after defeating England. One of the games that immediately comes to mind when you think of Irish football, this was Ireland's first game at a major tournament and is still one of the most unforgettable. Glasgow-born Ray Houghton was the hero as he latched onto a header from Liverpool teammate John Aldridge to loop a header over Peter Shilton in the English goal. A courageous, driven performance by the team, epitomised by Packie Bonner in goal, saw Ireland hold out for a famous victory. Speaking after the game, Jack Charlton said 'Somebody once told me fortune favours the brave and God, our lads were brave'. Unfortunately, this would be the highlight of the tournament for Ireland as a 1-1 draw with the Soviet Union and a 1-0 loss to the Netherlands saw Ireland exit the competition at the group stage.

European Championship Finals 1988, Group B, Republic of Ireland v England, Neckarstadion, Stuttgart, Germany.

Ray McManus / SPORTSFILE

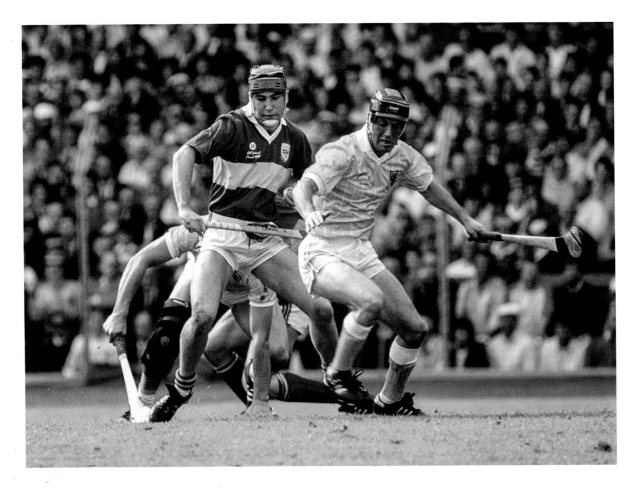

03 September 1989

John Leahy of Tipperary in action during the All-Ireland Hurling Championship Final match between Tipperary and Antrim at Croke Park in Dublin. Tipperary's Nicky English set a new scoring record as he notched up 2-12 in his team's 4-24 to 3-9 victory.

Ray McManus / SPORTSFILE

15 November 1989

Paul McGrath, left, and Kevin Moran of Republic of Ireland celebrate after a John Aldridge brace secured Ireland's qualification for their first ever World Cup in the FIFA World Cup Qualifying match between Malta and Republic of Ireland at the Ta'Qali Stadium in Valetta, Malta.

Ray McManus / SPORTSFILE

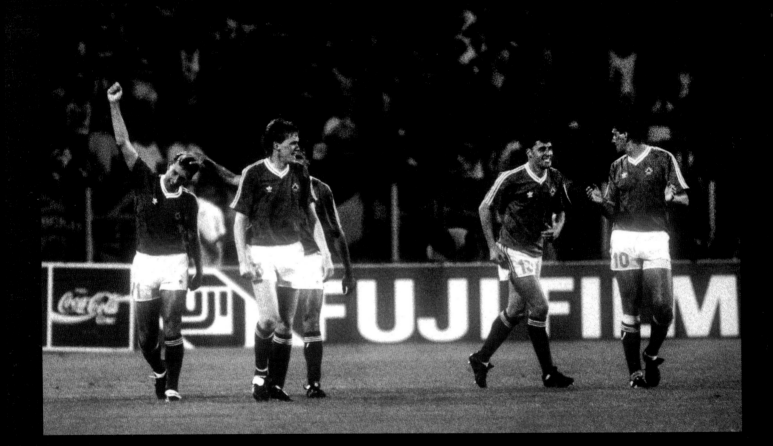

11 June 1990

Kevin Sheedy of Republic of Ireland, left, celebrates with team-mates Steve Staunton, Andy Townsend and Tony Cascarino after scoring his side's goal. Just like two years prior at their first ever European Championships, Ireland faced England in the opening game of their first ever World Cup. Sheedy's strike cancelled out a Gary Lineker opener to secure a point in a 1-1 draw. FIFA World Cup 1990 Group F match between England and Republic of Ireland at Stadio Sant'Elia in Cagliari, Italy.

Ray McManus / SPORTSFILE

1990s

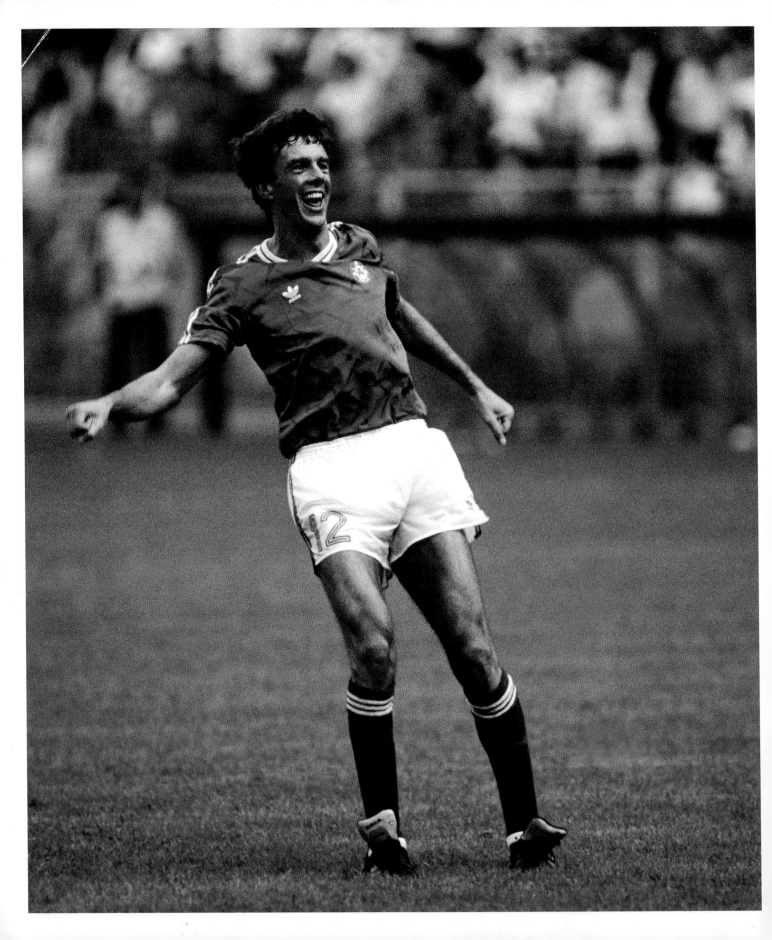

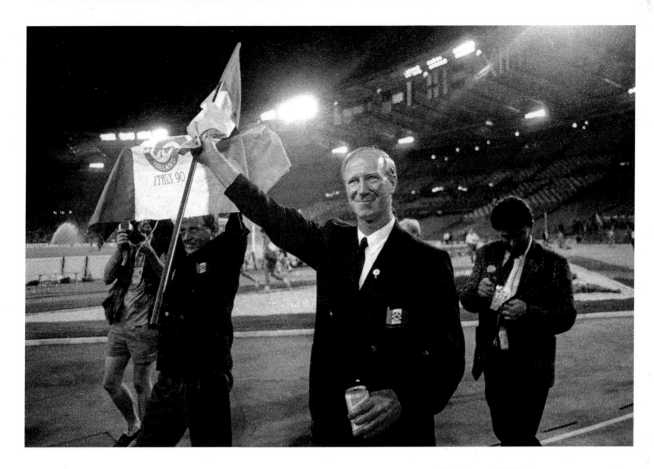

25 June 1990

The nation was no longer holding its breath, it was screaming in ecstasy and disbelief. David O'Leary of Republic of Ireland celebrates after scoring the winning penalty to send Ireland through to the quarter finals. The game remained locked at 0-0 after extra time and a penalty shootout was required to decide a victor. After Packie Bonner denied Daniel Timofte of Romania, the responsibility fell on the shoulders of defender David O'Leary. A player who had worked his way back into the international setup after being frozen out of the Ireland squad for a number of years stepped up to deliver what many would regard as the greatest moment in Irish sporting history. FIFA World Cup 1990, Republic of Ireland v Romania at the Stadio Luigi Ferraris in Genoa, Italy.

Ray McManus / SPORTSFILE

30 June 1990

Republic of Ireland manager Jack Charlton waves to the supporters following the end of Ireland's heroic Italia 90 run. Despite a valiant effort, Ireland's exit came at the hands of the hosts, Italy, spearheaded by 'Toto' Schillaci. Schillaci scored the only goal of the game in a 1-0 win for the Italians. Italy v Republic of Ireland at the Stadio Olimpico in Rome, Italy.

Ray McManus / SPORTSFILE

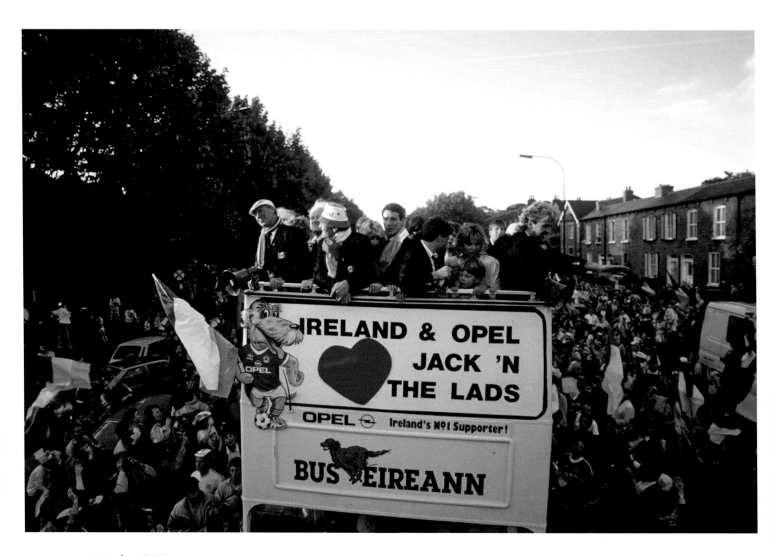

01 July 1990

The Republic of Ireland squad are cheered by supporters as they are brought by open top bus from Dublin Airport to College Green in Dublin city centre for a reception on their arrival home from Italia 90. Some 500,000 people lined the streets of Dublin to welcome home Ireland's heroes. While they may have come home empty handed, 'Jack's Army' had succeeded in bringing the country together and inciting a real excitement around Irish football.

Ray McManus / SPORTSFILE

23 September 1990

Angela Downey, right, celebrates with Kilkenny team-mate Breda Holmes after scoring the game's only goal two minutes from the end. Kilkenny defeated Wexford 1-14 to 0-7. All-Ireland Senior Camogie Championship Final match between Kilkenny and Wexford at Croke Park in Dublin.

Ray McManus / SPORTSFILE

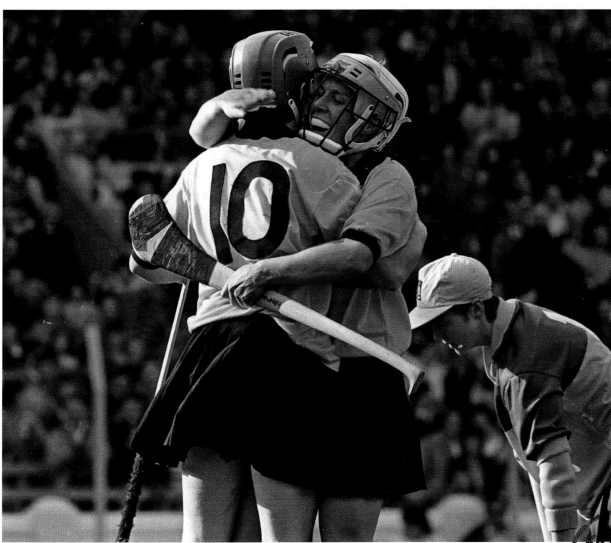

15 September 1991

Down substitutes celebrate at the final whistle as Down beat Meath 1-16 to 1-14 in the All-Ireland decider. Note photographer Cyril Byrne, then of the *Irish Press*, almost getting knocked over in the rush.

Ray McManus / SPORTSFILE

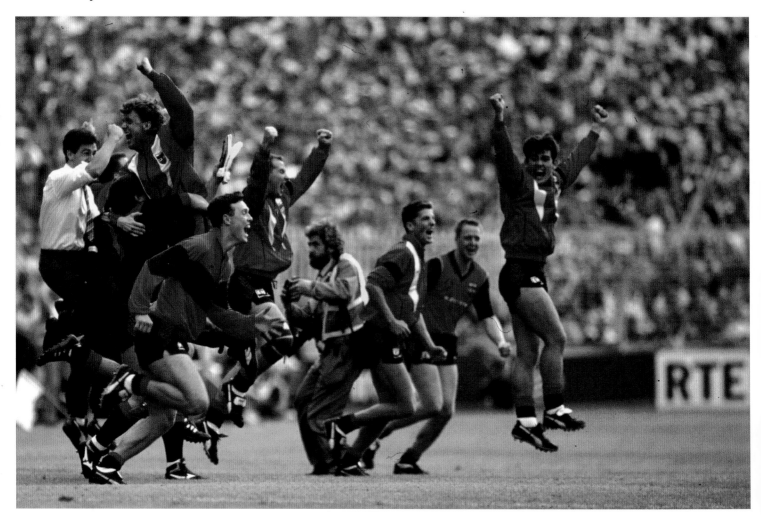

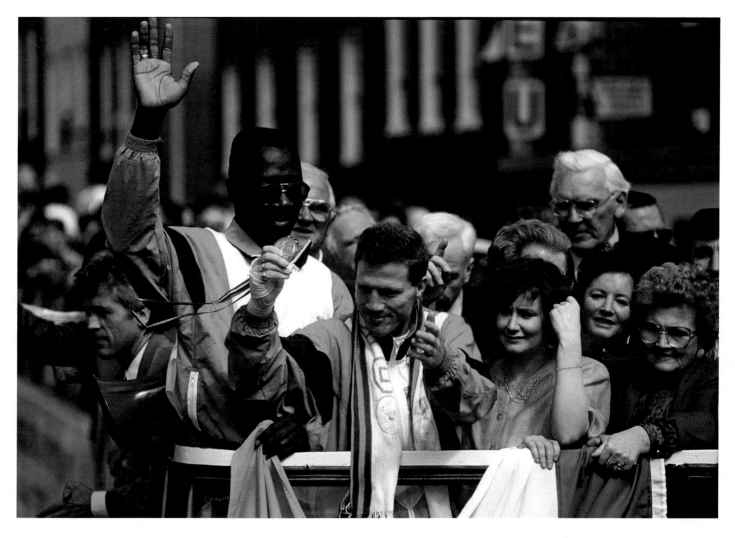

11 August 1992

Olympic champion boxer Michael Carruth, holding his gold medal, accompanied by his wife Paula and coach Nicholas Cruz, on board the bus which drove them through the streets of Dublin during the Irish Olympic team's homecoming from the 1992 Olympic Games in Barcelona, Spain. This was Ireland's first Olympic gold in thirty-six years.

David Maher / SPORTSFILE

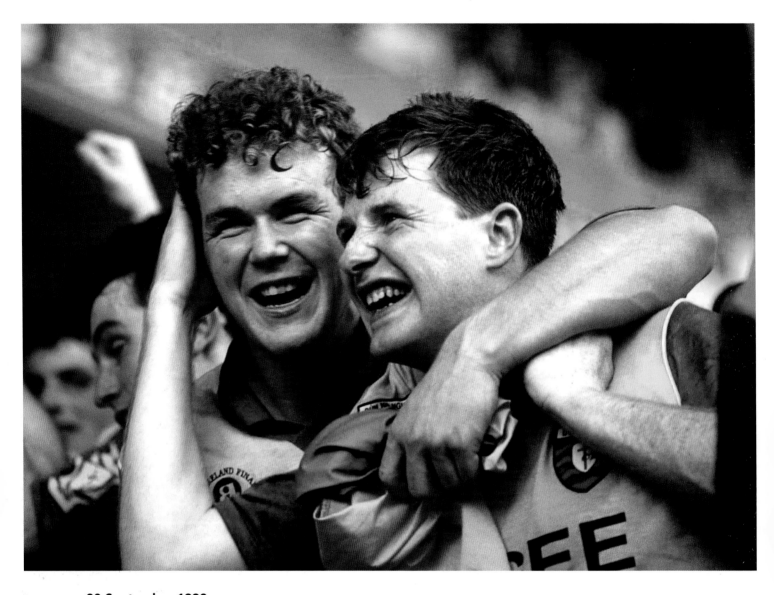

20 September 1992

Donegal's Tony Boyle, left, and Manus Boyle celebrate their surprise triumph over pre-match favourites Dublin. The Ulster team won 0-18 to 0-14, with nine of their points scored by man of the match Manus Boyle. All-Ireland Football Championship Final, Dublin v Donegal, Croke Park, Dublin.

Ray McManus / SPORTSFILE

26 October 1992

Jerry Kiernan winning the Dublin Marathon for the second time. One of the golden-age Irish marathoners of the seventies and eighties, Kiernan represented Ireland in the 1984 Los Angeles Olympics in the marathon, where he finished 9th, as well as competing in seven world cross-country championships and winning national titles in distances ranging from the 1,500m to the marathon; in 1976 he was the seventh Irishman to break the four-minute mile when he ran 3:59.2 in London. The Clonliffe Harriers man went on to become a well-known athletics commentator for RTÉ and a coach to middle-distance runners including Joe Sweeney and Ciara Mageean.

Ray McManus / SPORTSFILE

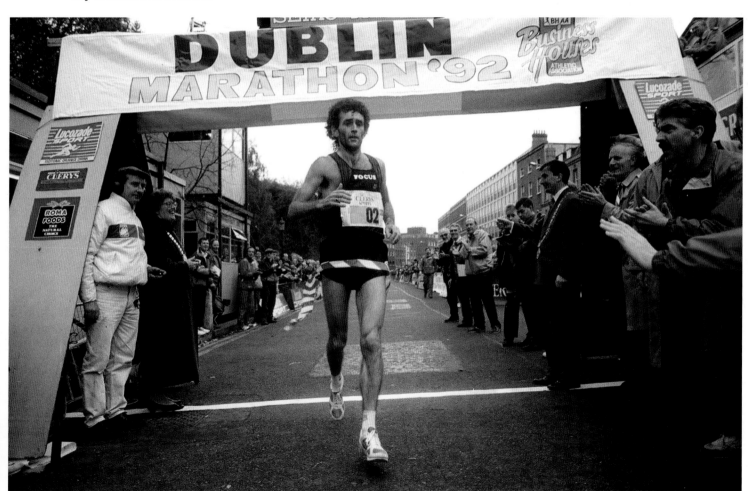

22 August 1993

Derry manager Eamonn Coleman celebrates his side's victory over Dublin at Croke Park.
Derry went on to beat Cork in the final and secure their first (and so far only) All-Ireland
success. All-Ireland Football Semi-Final, Derry v Dublin.

Ray McManus / SPORTSFILE

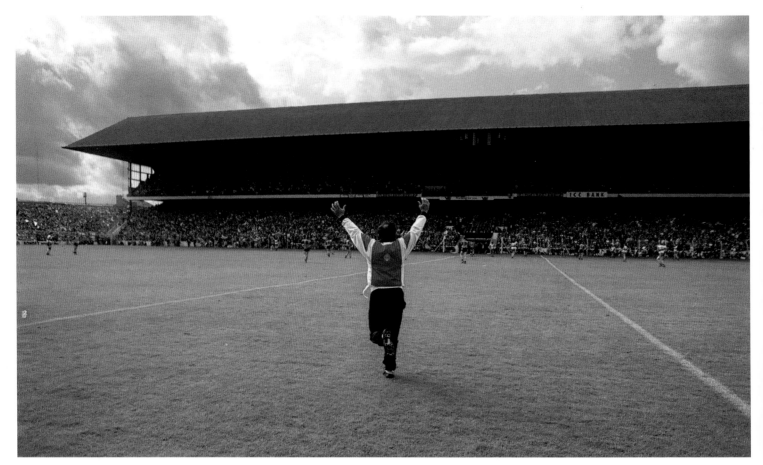

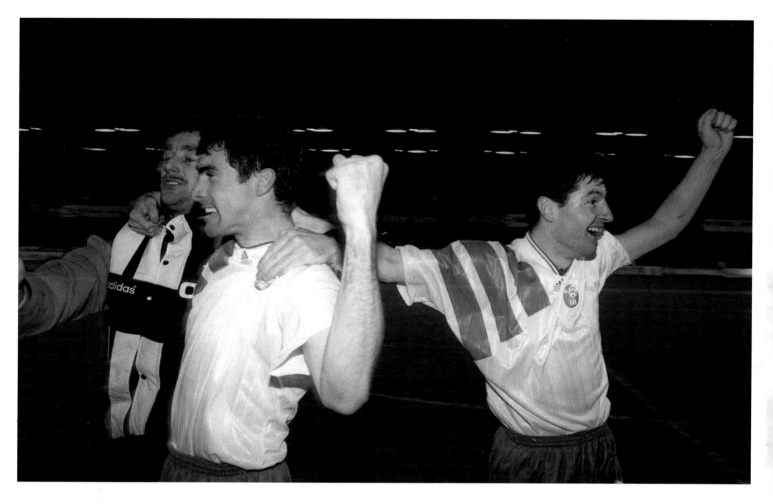

17 November 1993

Republic of Ireland players, from left, John Aldridge, Alan McLoughlin and Denis Irwin celebrate their qualification for the 1994 World Cup after a 1-1 draw with Northern Ireland in Windsor Park in Belfast. The game was shrouded in tension, not only for the high-stakes nature of the match, with Ireland needing a result to qualify, but also due to the horrific violence on the streets of Belfast at that time. No Republic of Ireland fans were permitted at the game, and the squad flew to Belfast from Dublin due to safety concerns. On the pitch, an Alan McLoughlin goal was enough to secure a vital point which saw Ireland qualify for the World Cup.

David Maher / SPORTSFILE

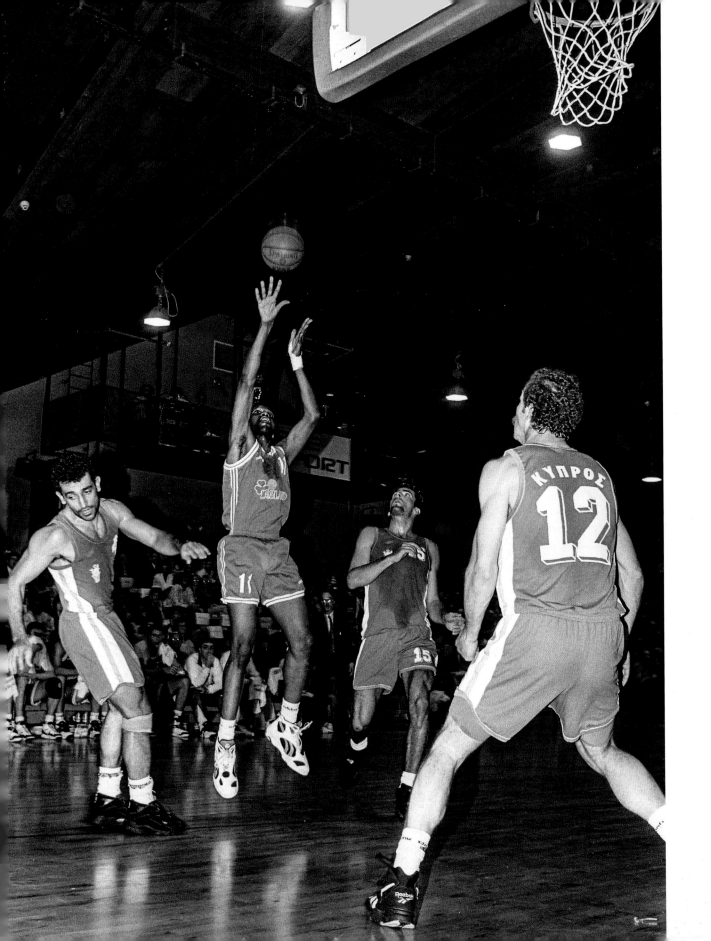

08 June 1994

Jerome Westbrooks of Ireland during the 1994 Promotions Cup Final match between Ireland and Cyprus at the National Basketball Arena in Tallaght, Dublin. Born and raised in Chicago, Westbrooks came to Dublin in 1981 to play for Dublin team, Killester. The 80s were a boom time for Irish basketball, and Westbrooks wasn't the only American player on an Irish team. Others like Jasper McElroy, Ray Smith, Kelvin Troy, Mario Elie and Deora Marsh also played on teams around the country and became household names. After retiring from the National League, Westbrooks moved on to coaching; the north Dublin school teams he coaches have been consistent high performers in the National League. All five of his children have represented Ireland in basketball.

Ray McManus / SPORTSFILE

18 June 1994

Ray Houghton of Republic of Ireland scores in spectacular fashion to give Ireland an early lead against Italy. Ireland's opener at the 1994 World Cup was a repeat of the heartbreaking 1990 quarter final. An imperious display from an injured Paul McGrath, who tormented Roberto Baggio and Giuseppe Signori, helped Ireland to cling on and claim revenge against the Italians. Ireland successfully navigated the group stages, but were knocked out of the tournament by the Netherlands in the Round of 16. FIFA World Cup 1994 Group E match between Republic of Ireland and Italy at Giants Stadium in New Jersey, USA.

David Maher / SPORTSFILE

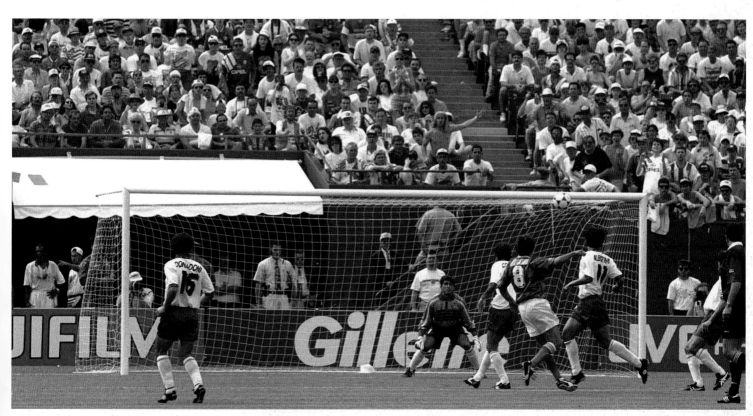

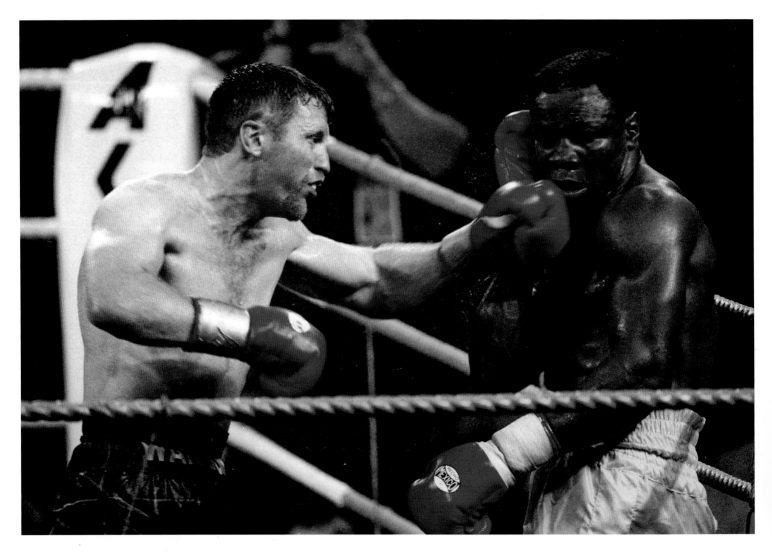

18 March 1995

Steve Collins lands a left on Chris Eubank's chin.
Collins defeated Eubank to win the WBO World
Super-Middleweight Title in Millstreet, Co. Cork.

David Maher / SPORTSFILE

03 September 1995

Clare goalkeeper Davy Fitzgerald celebrates his side's victory over Offaly in the Guinness All-Ireland Senior Hurling Championship Final at Croke Park in Dublin. This was Fitzgerald's first of two All-Ireland wins with Clare. Considered to be the best goalkeeper of his generation, he made 148 National League and Championship appearances and went on to become a successful manager with Waterford, Clare and Wexford.

David Maher / SPORTSFILE

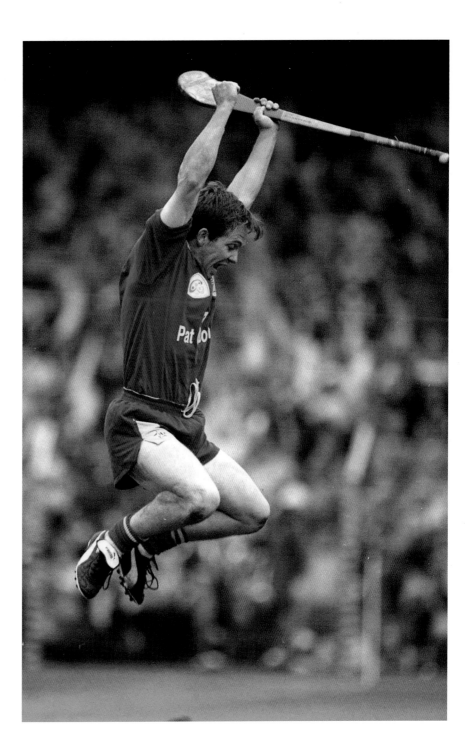

22 September 1996

Galway captain Imelda Hobbins in action against Sandie Fitzgibbon, left, and Therese O'Callaghan, Cork. Playing in front of a then-record attendance at a camogie match, Galway went on to earn their first ever All-Ireland win, on a score of 4-8 to 1-15. All-Ireland Senior Camogie Championship Final, Cork v Galway, Croke Park, Dublin.

Ray McManus / SPORTSFILE

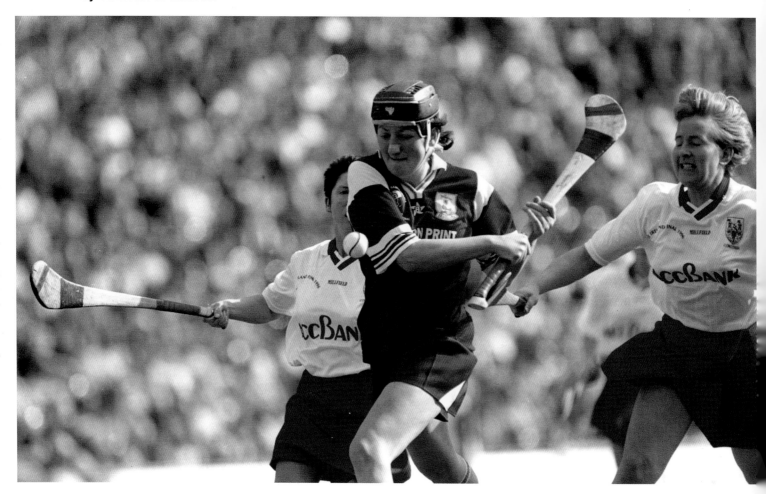

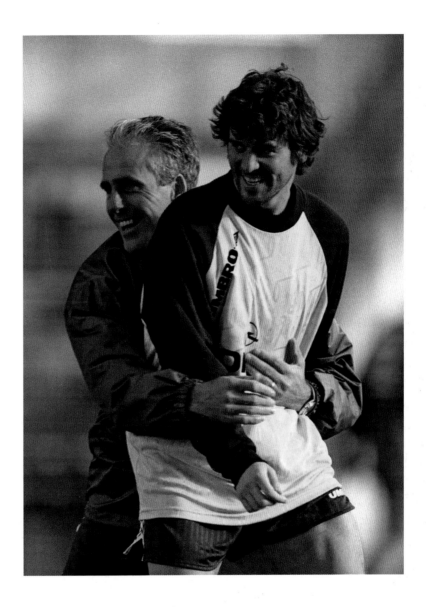

09 November 1996

Republic of Ireland manager Mick McCarthy tackles Roy Keane during a squad training session at Lansdowne Road in the early days of the McCarthy era. The photo is particularly strange to look at now, given what lay ahead for McCarthy and Keane.

Ray McManus / SPORTSFILE

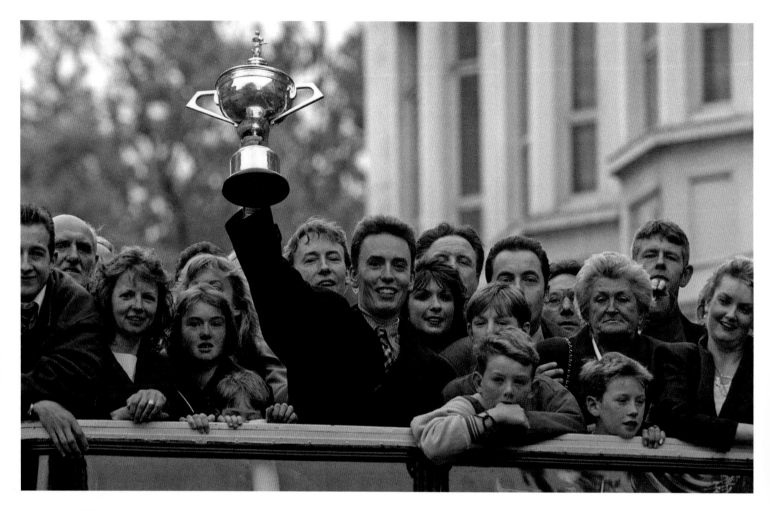

07 May 1997

1997 Embassy World Snooker Champion Ken Doherty from Ranelagh, Dublin, pictured with the trophy at a homecoming reception held at the Mansion House in Dublin. Doherty's career-defining 1997 win is the most recent time an Irishman has been the snooker world champion.

David Maher / SPORTSFILE

28 September 1997

Maurice Fitzgerald of Kerry fixes the collar of his jersey in the pre-match parade before the Bank of Ireland All-Ireland Senior Football Championship Final between Kerry and Mayo at Croke Park. Kerry would end their eleven-year run of losses with a three-point victory over Mayo.

Brendan Moran / SPORTSFILE

12 October 1997

Monaghan Captain Angela Larkin jumps for joy as her team beat Waterford 2-15 to 1-16 in the All-Ireland Ladies Football Final. Larkin was one of the stars of a Monaghan team considered to be Ulster's best ever ladies' football side, winning back-to-back titles in 1996 and 1997.

Matt Browne / SPORTSFILE

18 March 1998

Charlie Swan celebrates on Istabraq as they enter the parade ring after winning the Smurfit Champion Hurdle Challenge race during day two of the Cheltenham Racing Festival at Prestbury Park in Cheltenham, England.

Matt Browne / SPORTSFILE

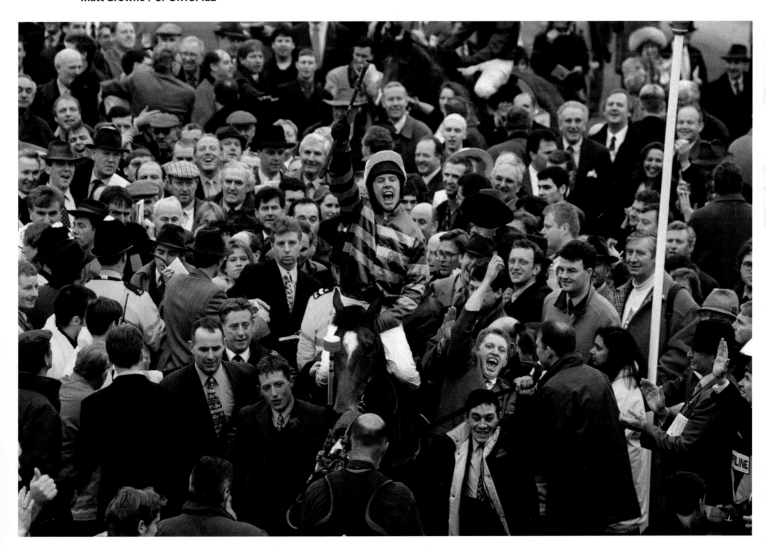

13 April 1998

Paul Carberry and Bobbyjo celebrate with owner Bobby Burke
after they won the Irish Grand National Steeplechase during
the Fairyhouse Easter Festival day at Fairyhouse Racecourse in
Ratoath, Meath. Bobbyjo was trained by Paul's father, Tommy
Carberry, who won the Irish national and the Grand National
at Aintree as a jockey and as a trainer. Bobbyjo went on to win
the Grand National at Aintree in 1999.

Matt Browne / SPORTSFILE

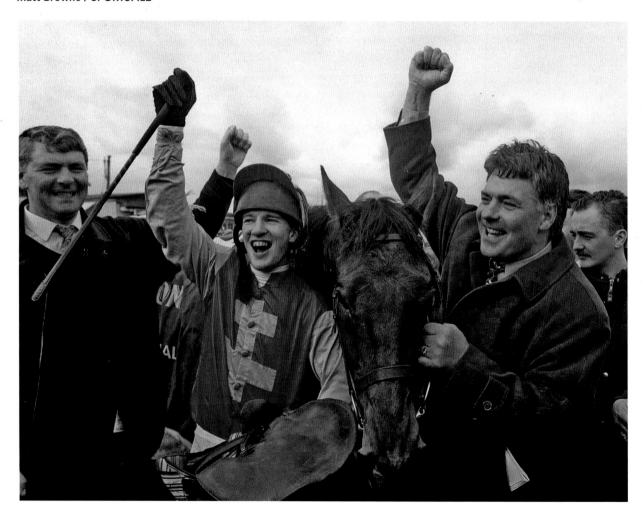

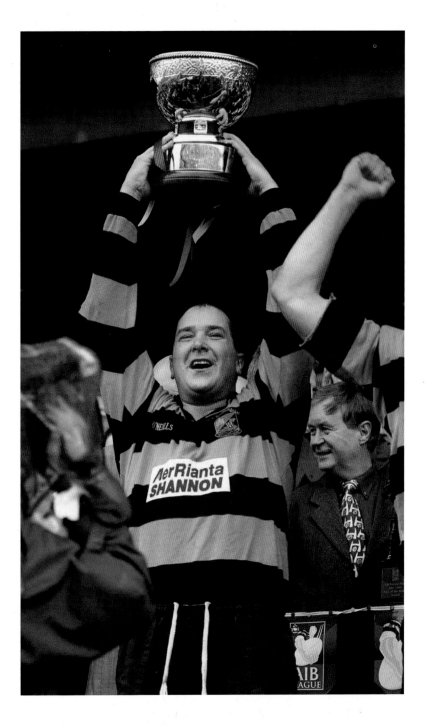

25 April 1998

Anthony Foley of Shannon
lifting the cup following the AIB
All-Ireland League Division 1
final between Garryowen and
Shannon on 25 April 1998 in
Lansdowne Road. Foley, known
as 'Axel', went on to play for
and captain both Munster
and Ireland, and to coach the
Munster team. The night before
Munster were due to play Racing
92, Foley died in his sleep in
the team hotel in Paris, on 16
October 2016, aged 42. He was
posthumously inducted into the
Munster Hall of Fame.

Ray McManus / SPORTSFILE

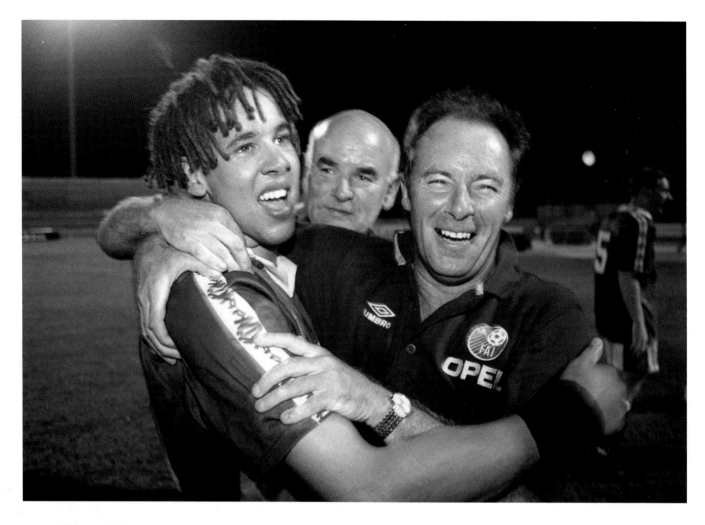

26 July 1998

Liam George of Republic of Ireland celebrates with Republic of Ireland manager Brian Kerr, right, and assistant coach Noel O'Reilly following the UEFA European Under-18 Championship Final win. While the senior team had failed to qualify for the 1998 World Cup, Brian Kerr's Under-18 squad picked up the slack that summer by beating Germany on penalties to win the European Championships. Kerr's squad included Robbie Keane and Richard Dunne, two players who would be ever-present on the international scene for the next fifteen years. Germany v Republic of Ireland at GSZ Stadium in Larnaca, Cyprus.

David Maher / SPORTSFILE

22 August 1998

Offaly supporters protest on the pitch at the Hurling Senior Championship Semi-Final Replay in Croke Park. Clare were leading by 1-16 to 2-10 when Galway referee Jimmy Cooney blew the full-time whistle with two minutes left on the clock. Offaly fans took to the pitch and refused to move for an hour and a half, meaning the next match, an U21 final, had to be called off. A refixture was arranged for the following week; Offaly won by 0-16 to 0-13 and went on to beat Kilkenny in the final

David Maher / SPORTSFILE

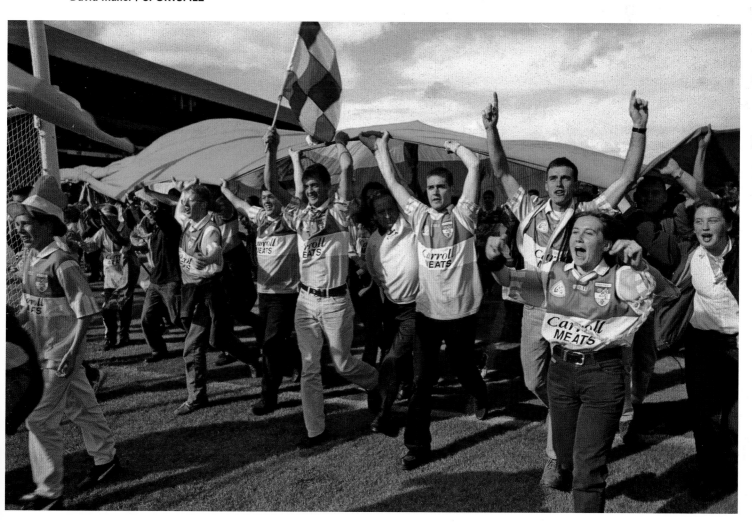

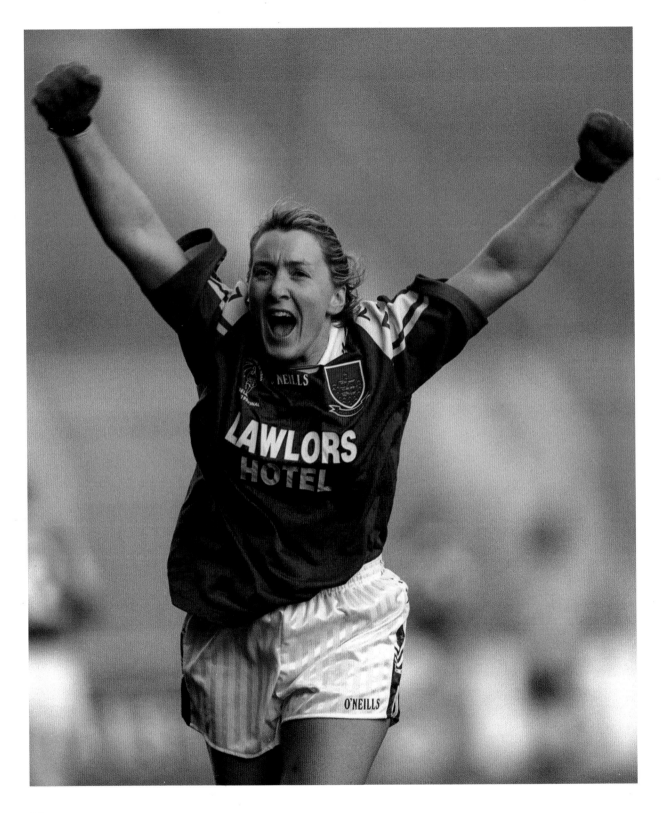

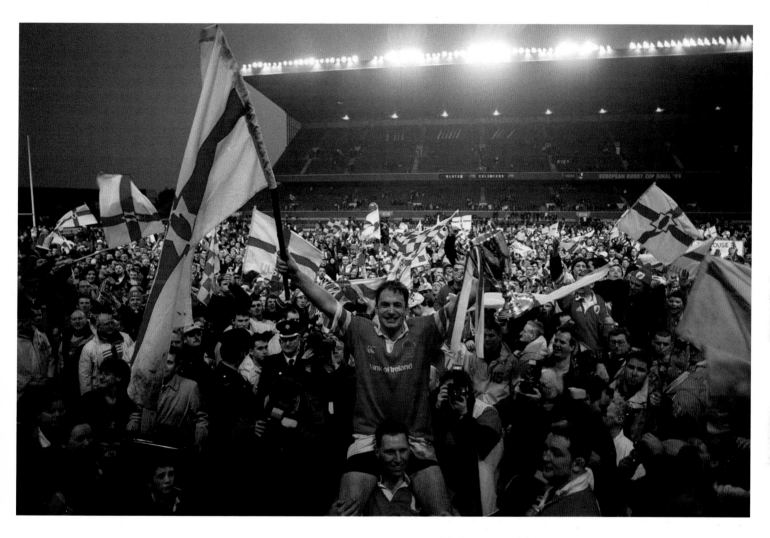

30 January 1999

Ulster captain David Humphreys is lifted by his teammates after they trounced Colomiers of France in the 1999 Heineken Cup final, becoming the first Irish side to win the European crown.

Brendan Moran / SPORTSFILE

25 October 1998

Áine Wall of Waterford celebrates after the All-Ireland Senior Ladies Football Championship Final Replay match at Croke Park in Dublin, where Waterford denied old rivals Monaghan the three in a row, winning 2-14 to 3-8.

Brendan Moran / SPORTSFILE

27 February 1999

Francis 'Francie' Barrett of Olympic Boxing Club prepares in the dressing room for the first round of the IABA National Boxing Championships at the National Stadium in Dublin. Barrett, who is an Irish Traveller, faced discrimination as he progressed through the ranks of Irish boxing, but in 1996 he made history in Atlanta as the first Traveller to compete for Ireland at the Olympics. Barrett, the youngest member of the team, carried the Irish flag at the opening ceremony of the Atlanta Olympics.

Ray Lohan / SPORTSFILE

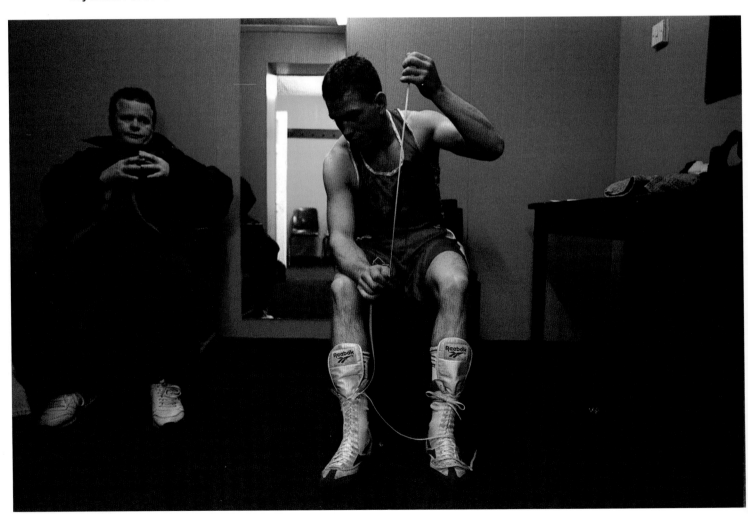

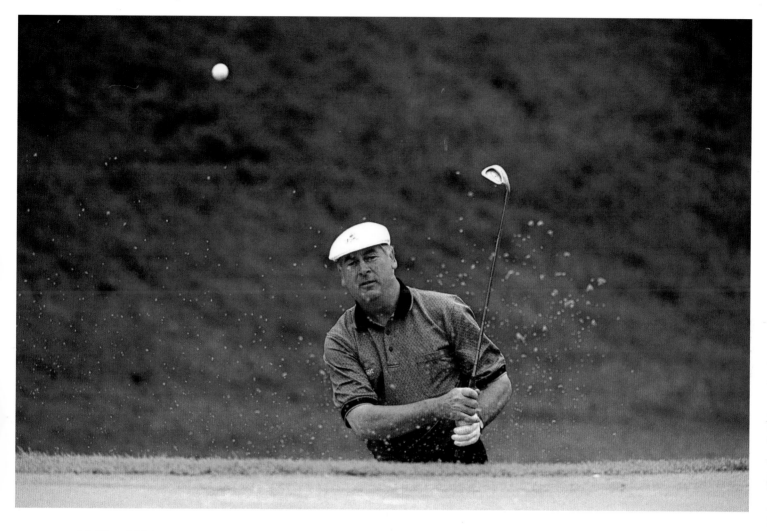

14 May 1999

Christy O'Connor Junior plays a shot from
bunker on the 3rd green during the AIB Irish
Senior Open at Mount Juliet Golf Club in
Thomastown, Kilkenny.

Matt Browne / SPORTSFILE

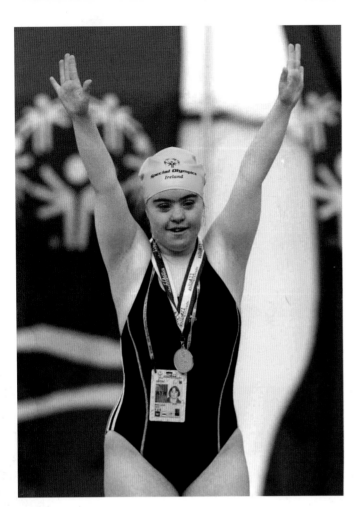

30 June 1999

Bríd Lynch from Dublin celebrates with her gold medal after she won the 100 metres Freestyle during the 1999 Special Olympics World Summer Games in Raleigh, North Carolina, USA.

Ray McManus / SPORTSFILE

12 September 1999

Cork manager Jimmy Barry-Murphy shows off the Liam MacCarthy Cup to Cork supporters on Hill 16 following the Guinness All-Ireland Senior Hurling Championship Final between Cork and Kilkenny at Croke Park in Dublin.

David Maher / SPORTSFILE

26 September 1999

The last final of the century! Meath manager Sean Boylan lifts the Sam Maguire Cup following his team's 1-11 to 1-8 victory over Cork in the Bank of Ireland All-Ireland Senior Football Championship Final at Croke Park in Dublin.

Ray McManus / SPORTSFILE

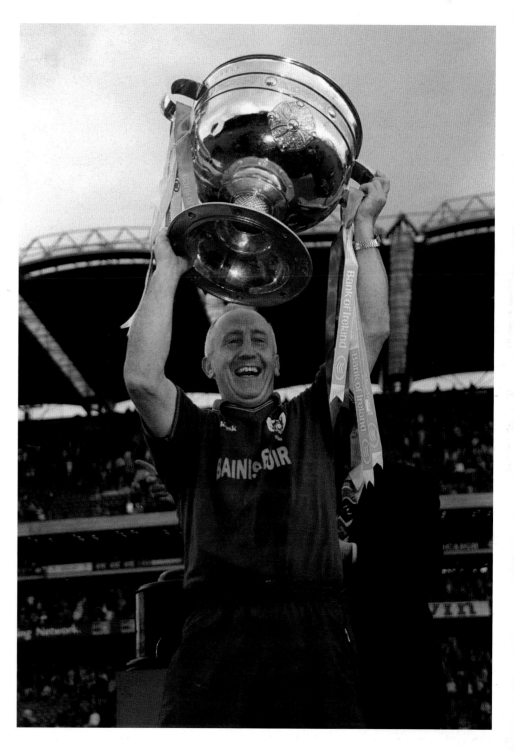

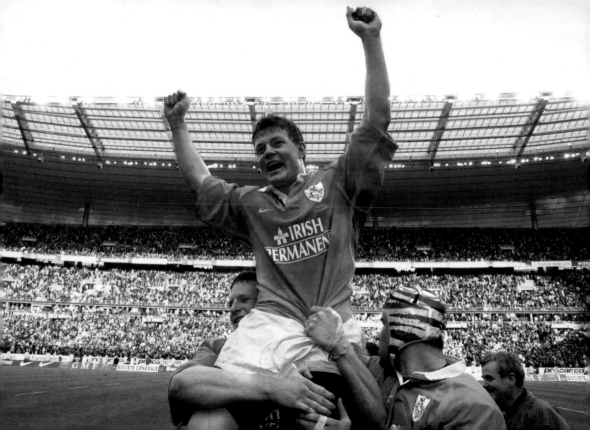

19 March 2000

In the Stade de France on 19 March 2000,
21-year-old Brian O'Driscoll announced himself
to the world by scoring three tries in this breath-
taking Six Nations battle, which was decided
in the 78th minute with a penalty by David
Humphreys. It was Ireland's first win over France
in seventeen years, and their first in Paris in
nearly three decades.

Matt Browne / SPORTSFILE

2000s

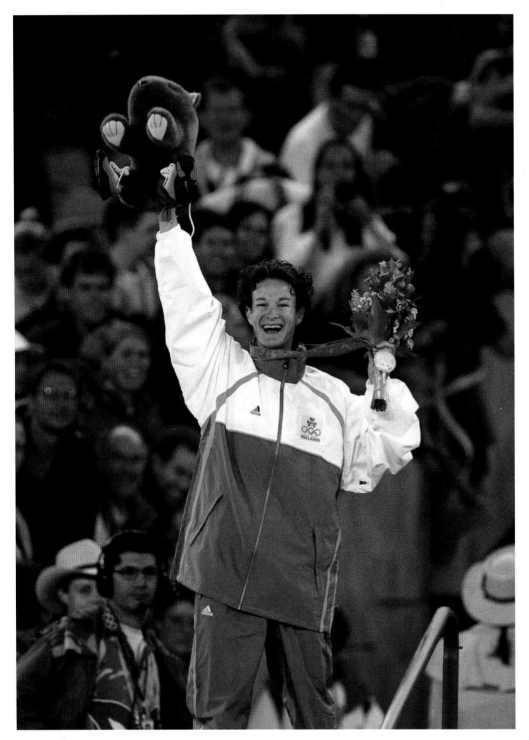

25 September 2000

A delighted Sonia O'Sullivan waves to supporters after winning silver in the women's 10,000 final at the Sydney Olympics.

This medal, the only Olympic athletics medal ever won by an Irishwoman, was a fitting cap to a career that had huge highs alongside devastating lows. One of the greatest Irish sportspeople ever, the Corkwoman – known across Ireland simply as 'Sonia' – has represented Ireland at four Olympics, held four world records and won three World Championship golds and three European Championship golds. She has held the Irish record in nine events from the 800m to the half marathon; in 2019, on her fiftieth birthday, Sonia was inducted into Irish Athletics Hall of Fame.

Brendan Moran / SPORTSFILE

01 October 2000

Mayo's Cora Staunton (yellow gloves) and Diane O'Hora celebrate after the final whistle. Mayo v Waterford, Ladies All-Ireland Senior Football Final, Croke Park, Dublin. Staunton is one of the most successful GAA players ever, winning four All-Irelands and eleven All Stars, and going on to play Australian Rules for the Greater Western Sydney Giants.

Aoife Rice / SPORTSFILE

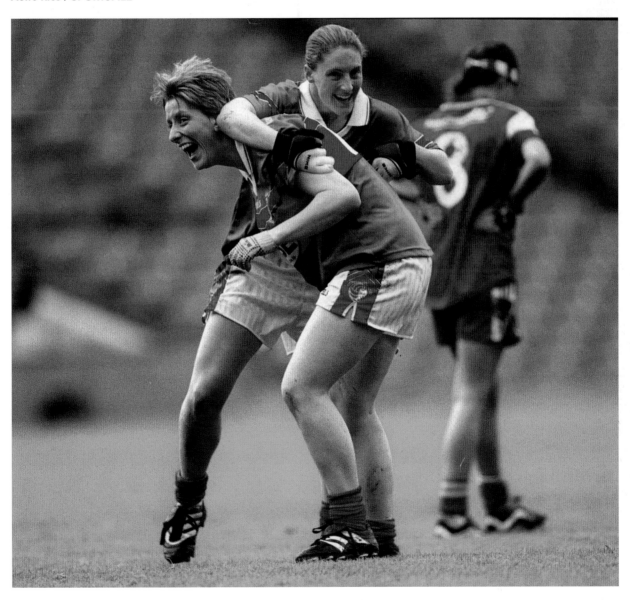

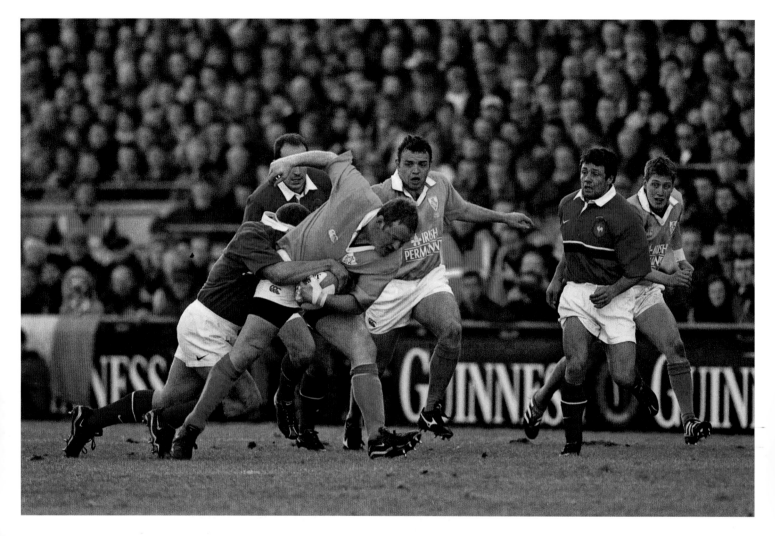

17 February 2001

Mick Galwey of Ireland is tackled by Pieter de Villiers of France during a Six Nations battle at Lansdowne Road on 17 February 2001. A dramatic try by Brian O'Driscoll and the unerring accuracy of Ronan O'Gara secured Ireland's first home victory against Les Bleus in eighteen years.

Matt Browne / SPORTSFILE

01 July 2001

Mick Kinane on Galileo waves to the crowd after winning The Budweiser Irish Derby at The Curragh, Co. Kildare. Since retiring to stud Galileo has been a champion sire and has bred five Derby winners.

Ray Lohan / SPORTSFILE

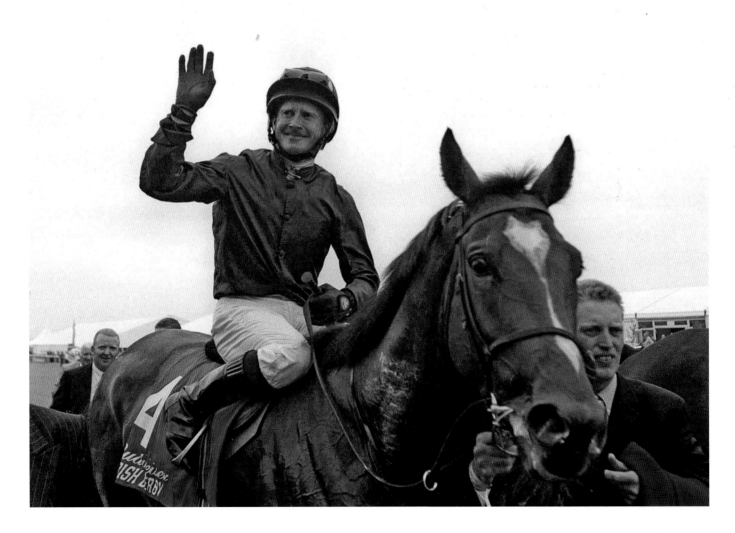

25 August 2001

Ireland's Mike Mitchell hangs from the basket after a slam-dunk during the European Basketball Championships Qualifier match between Ireland and Switzerland at the National Basketball Arena in Tallaght, Dublin.

Brendan Moran / SPORTSFILE

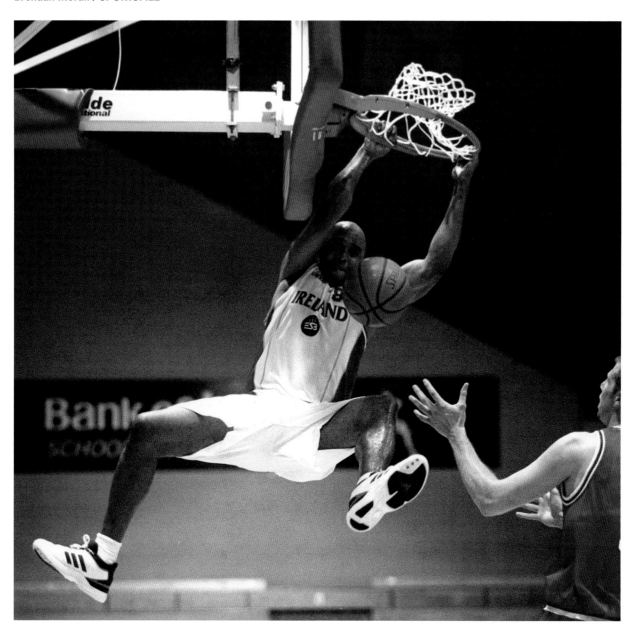

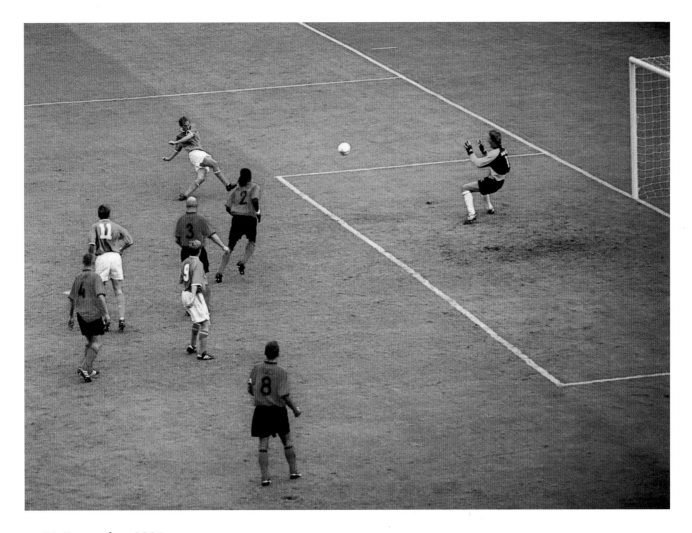

01 September 2001

Jason McAteer scores the Republic of Ireland's goal. One of the great games to be played at Lansdowne Road, and one of the most memorable goals. Despite a penalty appeal, a red card for Gary Kelly and massive chances for Patrick Kluivert, Bolo Zenden and Ruud Van Nistelrooy, the Dutch could not find a way through. The only goal of the game coming as McAteer powerfully swept home a left-footed Steve Finnan cross. On commentary, George Hamilton described the game as 'one of the most courageous, the most brave, the most committed, and ultimately the most effective of Irish performances that we've ever seen'. World Cup Qualifier, Republic of Ireland v The Netherlands, Lansdowne Road, Dublin.

Aoife Rice / SPORTSFILE

22 May 2002

Republic of Ireland manager Mick McCarthy, left, and captain Roy Keane during a Republic of Ireland squad training session. As an Irish football fan, it is difficult to think of the island of Saipan without immediately thinking of the infamous public disagreement that took place there between Mick McCarthy and Roy Keane. Keane publicly delivered a fierce and scathing criticism of the training facilities on the island, and of FAI decision-making. Tempers flared, tensions boiled over and Keane was sent home. The eventual 'Genesis Report' into the incident was in line with many of Keane's criticisms of the FAI as an organisation. The Saipan Incident is certainly one of the most infamous and defining moments in recent Irish sporting memory. ·

David Maher / SPORTSFILE

05 June 2002

Robbie Keane, Republic of Ireland, celebrates after scoring a stoppage time equaliser against Germany. A long ball from Steve Finnan was flicked down wonderfully by Niall Quinn. Keane was quickest to react, took the ball in his stride, evaded the last ditch challenge from Carsten Ramelow and drilled the ball past Oliver Kahn. This Keane strike was the only goal Germany conceded on their way to the final. FIFA World Cup Finals, Group E, Republic of Ireland v Germany, Ibaraki Stadium, Japan.

David Maher / SPORTSFILE

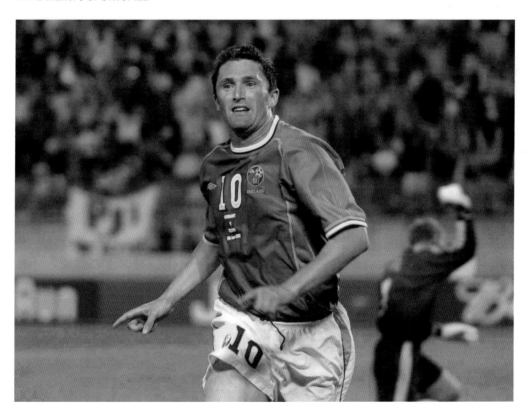

22 September 2002

A riot of Kerry and Armagh colours in Croke Park at 3.29pm, one minute before the start of the GAA Football All-Ireland Senior Championship Final. It was a historic day for the Ulstermen as Armagh beat Kerry 1-12 to 0-14 in their first – and so far only – All-Ireland win.

Brendan Moran / SPORTSFILE

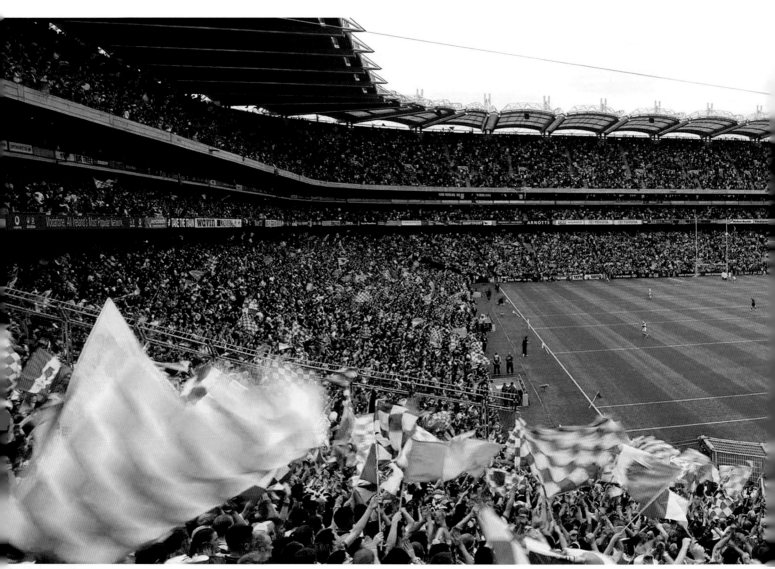

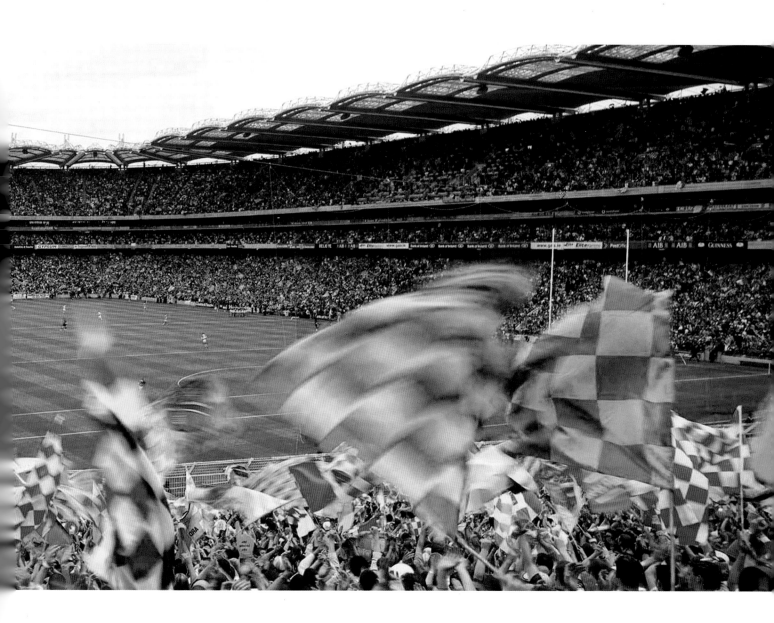

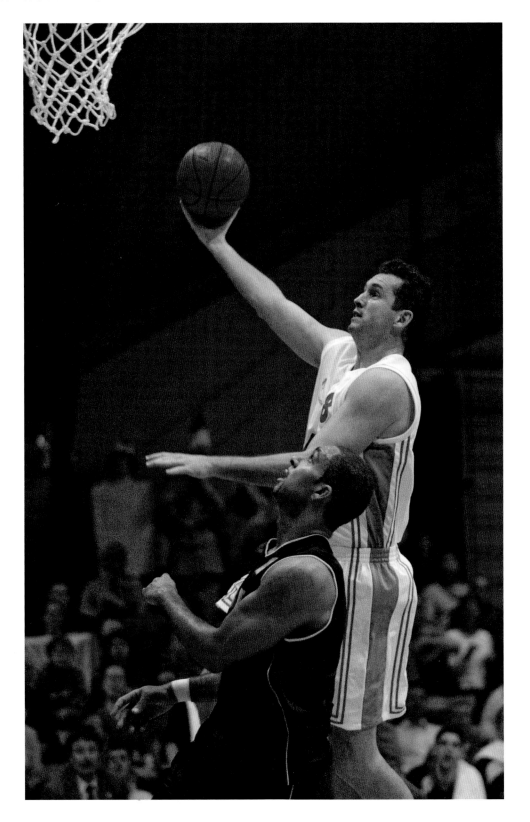

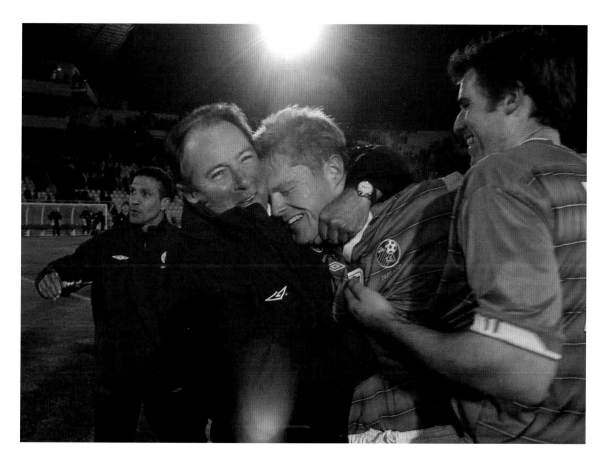

29 March 2003

Republic of Ireland manager Brian Kerr celebrates with Damien Duff and Kevin Kilbane at the end of Kerr's first game in charge of the senior team, which ended in a 2-1 victory. Several players, including Damien Duff, Robbie Keane and John O'Shea, had been managed by Kerr at youth level. 2004 European Championship Qualifier, Georgia v Republic of Ireland, Lokomotiv Stadium, Tbilisi, Georgia.

Damien Eagers / SPORTSFILE

20 November 2002

Marty Conlon, Ireland, in action against Ademola Okulaja, Germany in the European Basketball Championships, Semi-final round, ESB Arena, Tallaght, Co. Dublin.

Brendan Moran / SPORTSFILE

21 June 2003

The Special Olympics World Games, the first to be held outside the USA, lit up the country in 2003, bringing delegations from 180 countries to every corner of Ireland. Nearly 200 towns, cities, villages and offshore islands opened their doors to host athletes, who then travelled to Dublin and Belfast where events were held in venues like Morton Stadium, the RDS and The National Basketball Stadium in Dublin and the King's Hall, Belfast. Thirty thousand volunteers assisted in the running of the games Nelson Mandela officially opened the Games at a ceremony in Croke Park. 75,000 athletes and spectators attended, alongside U2, The Corrs, Arnold Schwarzenegger, Jon Bon Jovi, Roy Keane and special guest Muhammad Ali.

Pat Murphy / SPORTSFILE

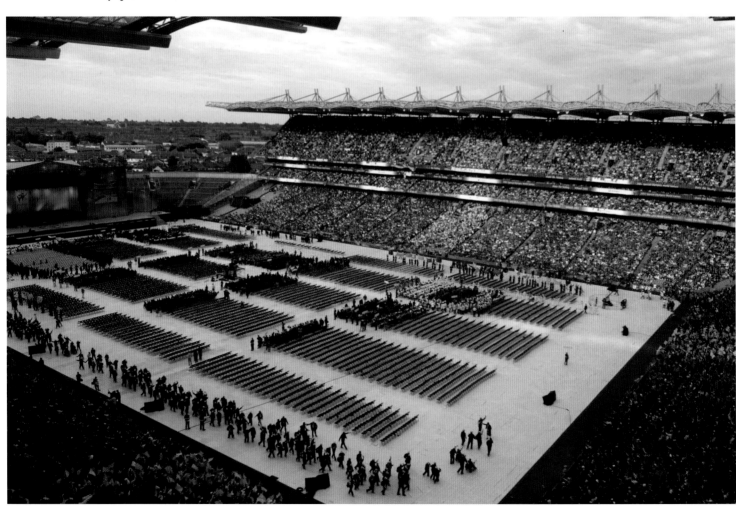

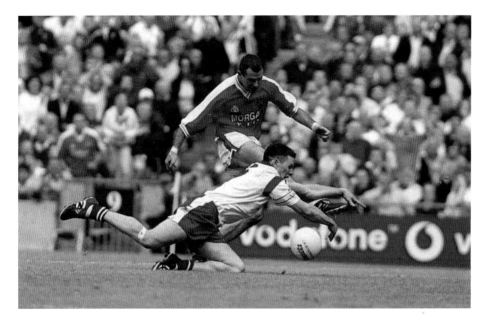

28 September 2003

Tyrone's Conor Gormley blocks a late shot from Armagh's Steven McDonnell. Bank of Ireland All-Ireland Senior Football Championship Final, Armagh v Tyrone, Croke Park, Dublin. For the first time ever – due to the changes in the qualifying system – two counties from the same province met in the final. In this clash between the Ulster counties, Tyrone prevailed over 2002 champions Armagh, 0-12 to 0-9.

Brendan Moran / SPORTSFILE

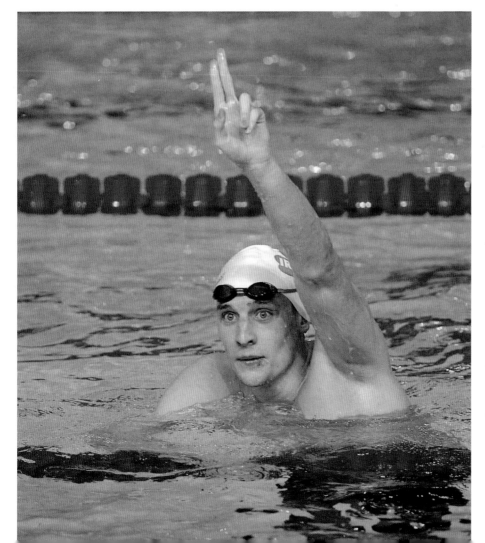

14 December 2003

Ireland's Andrew Bree celebrates winning a Silver Medal in the Men's 200m Breaststroke Final. European Swimming Short Course Championships, National Aquatic Centre, Abbotstown, Dublin.

Brendan Moran / SPORTSFILE

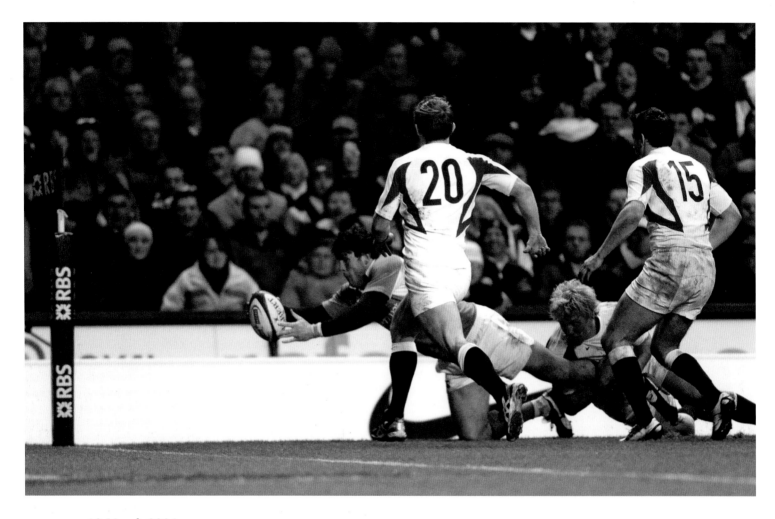

18 March 2006

In Twickenham, against England, Shane Horgan's remarkable, unlikely try in the 78th minute – his second of this Six Nations match – took Ireland ahead, before Ronan O'Gara sealed the deal with a touchline conversion. Ireland had won their second Triple Crown in three seasons.

Brian Lawless / SPORTSFILE

11 August 2006

Derval O'Rourke, Ireland, clears a hurdle during the Women's 100m Hurdles semi-final, where she qualified for the final in a time of 12.94 seconds. SPAR European Athletics Championships, Ullevi Stadium, Gothenburg, Sweden. Considered one of Ireland's greatest athletes, O'Rourke was a world champion and four-time European medallist in the sprint hurdles; she also represented Ireland in the same discipline at three Olympic Games.

Brendan Moran / SPORTSFILE

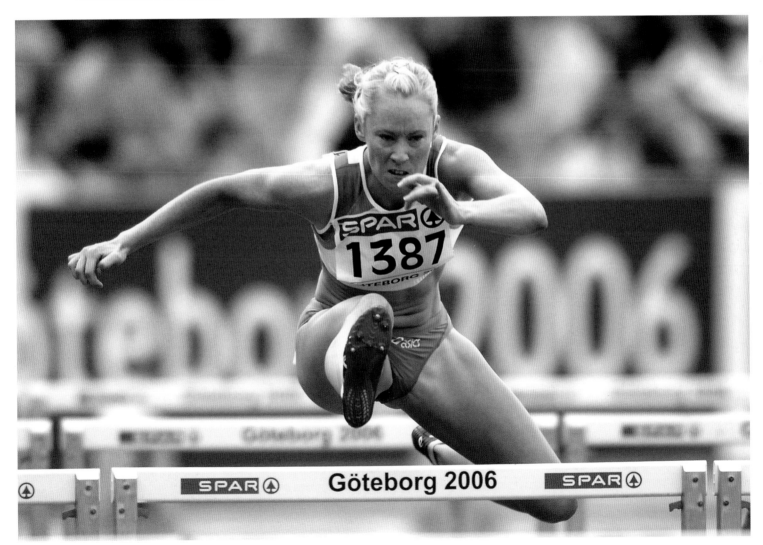

10 September 2006

Cork players, left to right, Elaine Burke, Una O'Donoghue, Mary O'Connor and Briege Corkery, celebrate after their win in the All-Ireland Senior Camogie Championship, Final, Cork v Tipperary, Croke Park, Dublin.

David Maher / SPORTSFILE

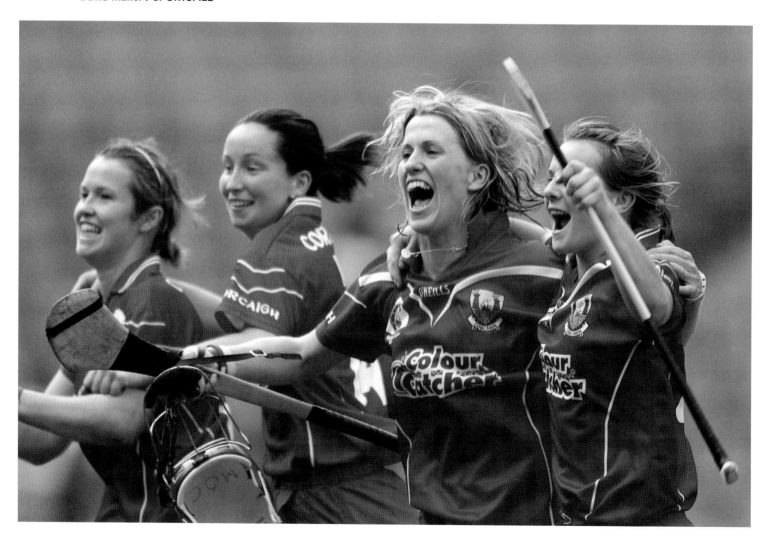

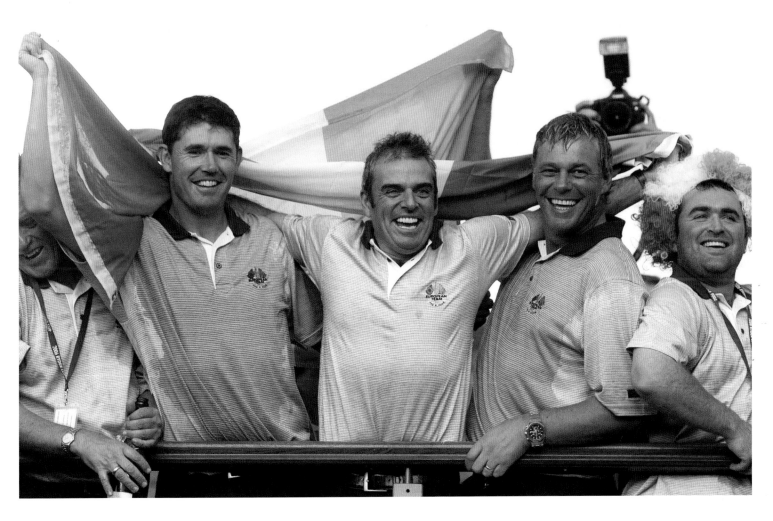

24 September 2006

Team Europe 2006 players Padraig Harrington, Paul McGinley and Darren Clarke celebrate. 36th Ryder Cup Matches, K Club, Straffan, Co. Kildare, Ireland. The Ryder cup was played in Ireland for the first time in 2006 and the European team, which contained three Irish players, won the trophy on a score of 18.5 to 9.5.

Brendan Moran / SPORTSFILE

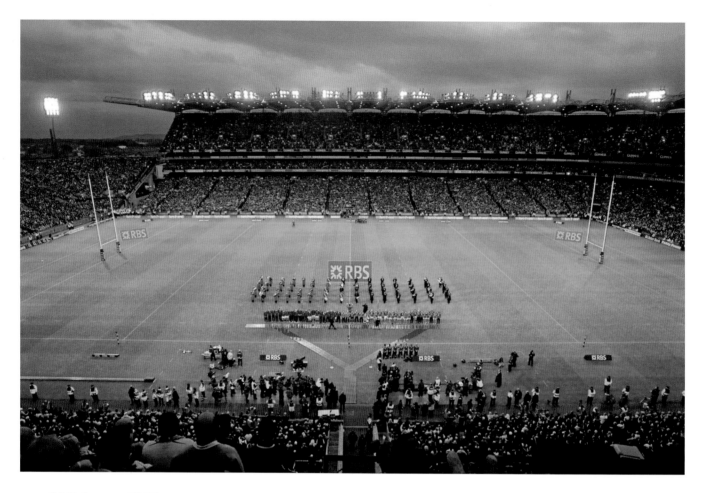

24 February 2007

The day history and sport faced off: an aerial view of Croke Park during the national anthems, as Ireland prepare to take on England in a Six Nations challenge. With Lansdowne Road closed for development, the GAA grounds hosted rugby and football matches for the first time. Emotions ran high as 'God Save the Queen' was played in the place where, on Bloody Sunday in 1920, British soldiers had opened fire on spectators and players at a Gaelic football match, killing fourteen; among them was Tipperary player Michael Hogan, after whom the Hogan Stand is named. The match ended 43-13 for Ireland and included an iconic try by Shane Horgan in the second half.

Brian Lawless / SPORTSFILE

03 March 2007

Ireland's David Gillick celebrates after defending his European title in the 400m Final at the European Indoor Athletics Championships, National Indoor Arena, Birmingham. His time of 45.52 seconds was an Irish record. In 2009, he beat his own record, running 44.77 seconds in Madrid; this record still stands.

Pat Murphy / SPORTSFILE

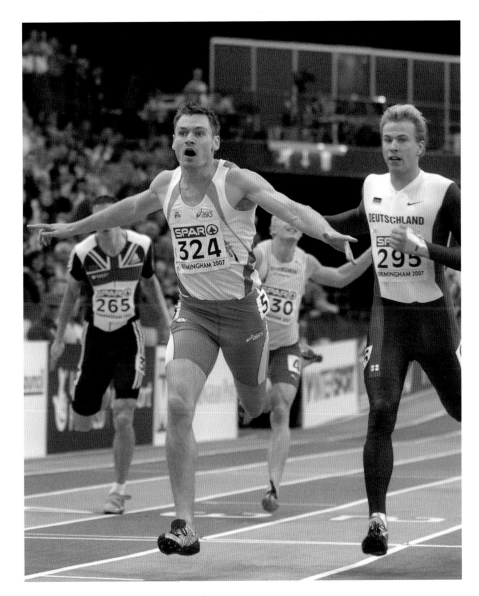

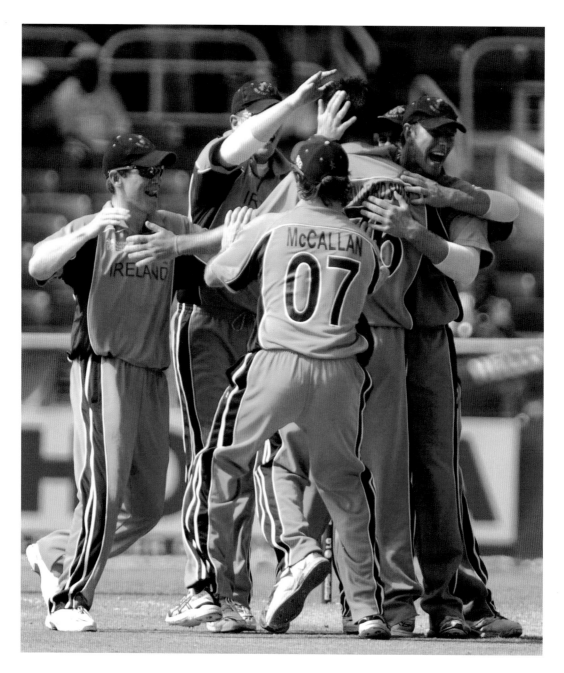

17 March 2007

The Ireland players celebrate with Dave Langford-Smith after he took the wicket of Mohammed Asif, Pakistan, on the way to an historic victory over the world's fourth-ranked team. This fantastic performance was considered 'unthinkable' by the BBC. ICC Cricket World Cup, Kingston, Jamaica.

Pat Murphy / SPORTSFILE

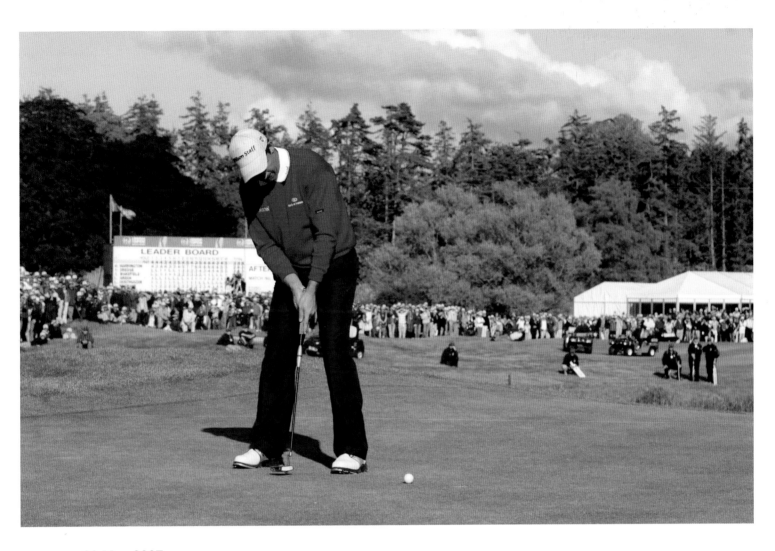

20 May 2007

Padraig Harrington sinks the winning putt during the final round of
the Irish Open Golf Championship, Adare Manor Hotel and Golf
Resort, Adare, Co. Limerick. In winning the tournament, Harrington
became the first Irish winner since John O'Leary in 1982.
Harrington would keep this form going during 2007, as he secured
his first major championship in Carnoustie two months later.

Kieran Clancy / SPORTSFILE

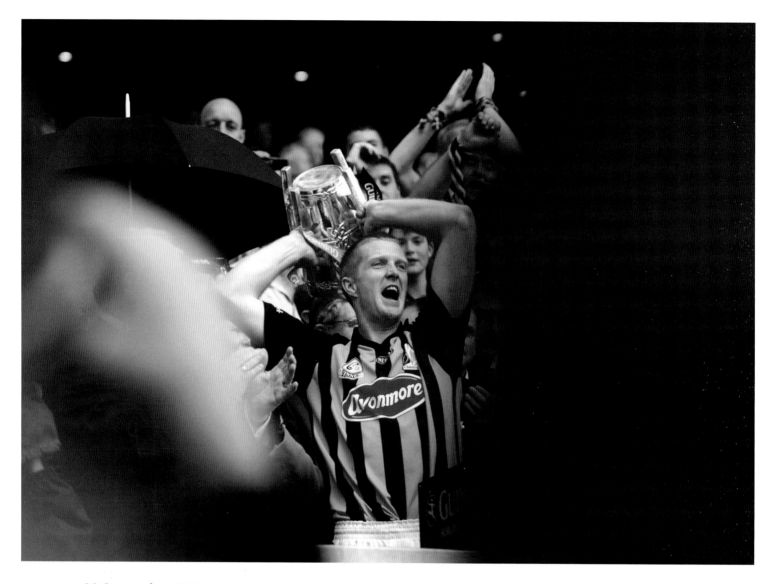

02 September 2007

Kilkenny's Henry Shefflin lifts the Liam MacCarthy Cup. Shefflin is considered to be one of the greatest hurlers of all time. In his career he won eleven All-Stars and is the only player to have been named Hurler of the Year three times. Guinness All-Ireland Senior Hurling Championship Final, Kilkenny v Limerick, Croke Park, Dublin.

Paul Mohan / SPORTSFILE

03 September 2007

John Giles, left, and Eamon Dunphy at a photo call to announce details of RTÉ's extensive soccer coverage for the new season, including over 200 hours of top-quality football available to fans throughout Ireland. This included Ireland's Euro 2008 qualifiers, the Champions League and the Premier League. In addition to this, it was announced that RTÉ had secured the broadcasting rights for Euro 2008, as well as the 2010 and 2014 World Cups. RTE, Donnybrook, Dublin.

David Maher / SPORTSFILE

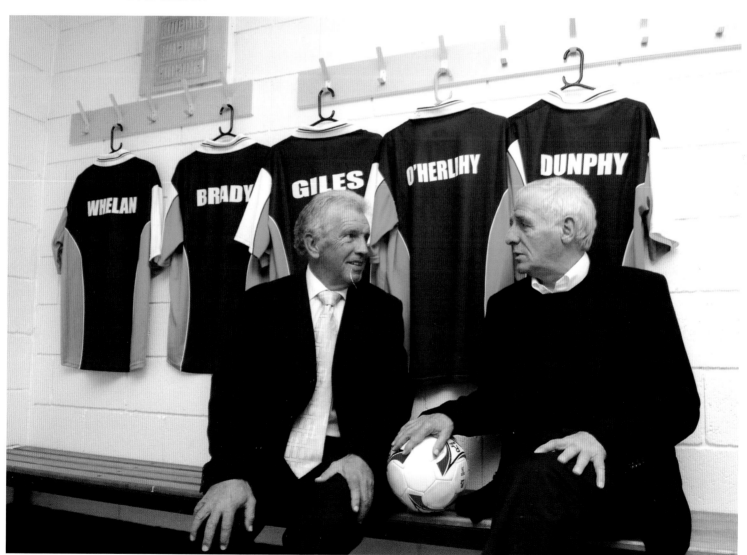

16 September 2007

Kerry's Kieran Donaghy, left, celebrates with team-mate Colm 'Gooch' Cooper after scoring his second and his side's third goal to beat Cork 3-13 to 1-9. Bank of Ireland All-Ireland Senior Football Championship Final, Kerry v Cork, Croke Park, Dublin.

Brian Lawless / SPORTSFILE

24 May 2008

Munster's golden era: Donncha O'Callaghan, Paul O'Connell and Alan Quinlan celebrate their victory over Toulouse in the Millennium Stadium, Cardiff, and the province's second Heineken Cup win.

Oliver McVeigh / SPORTSFILE

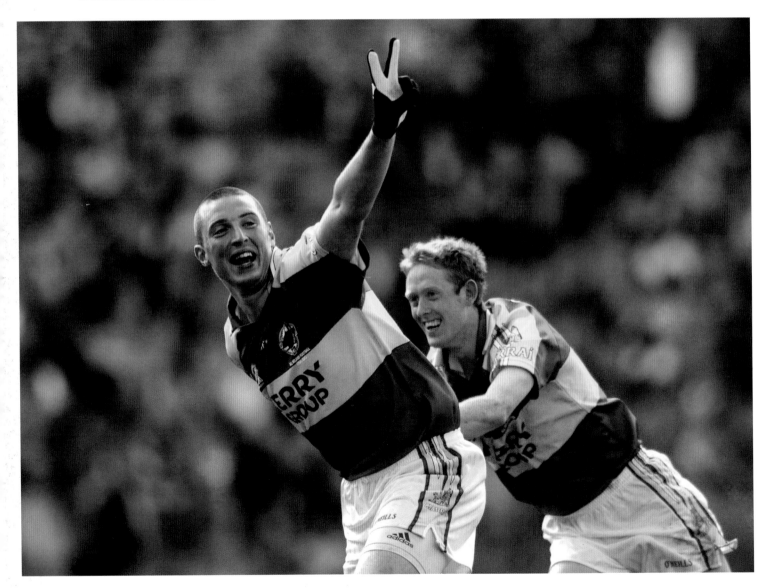

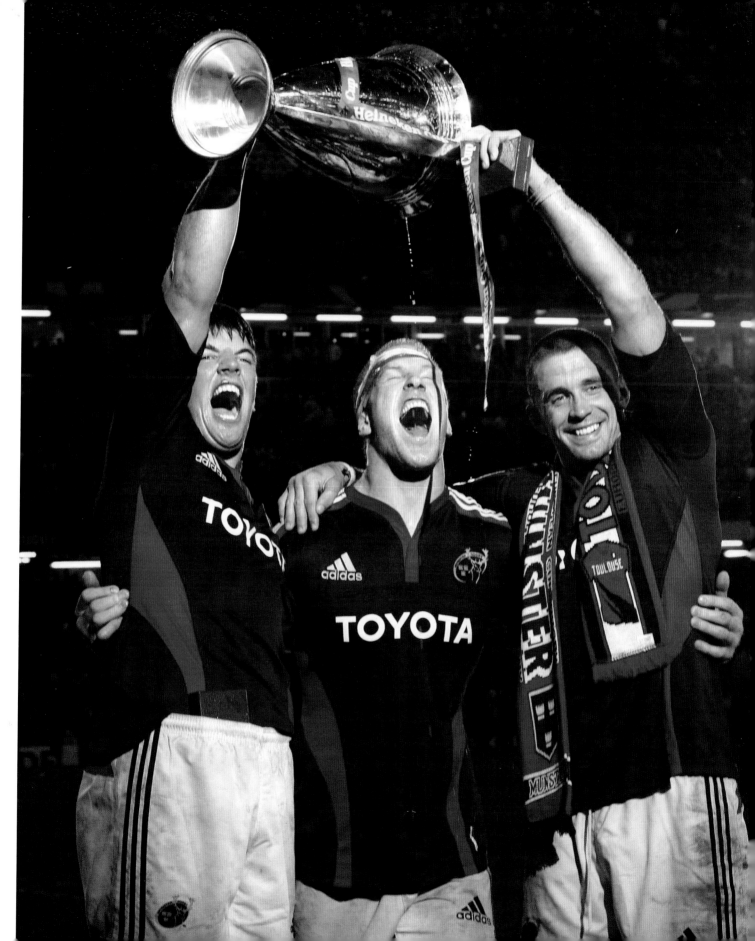

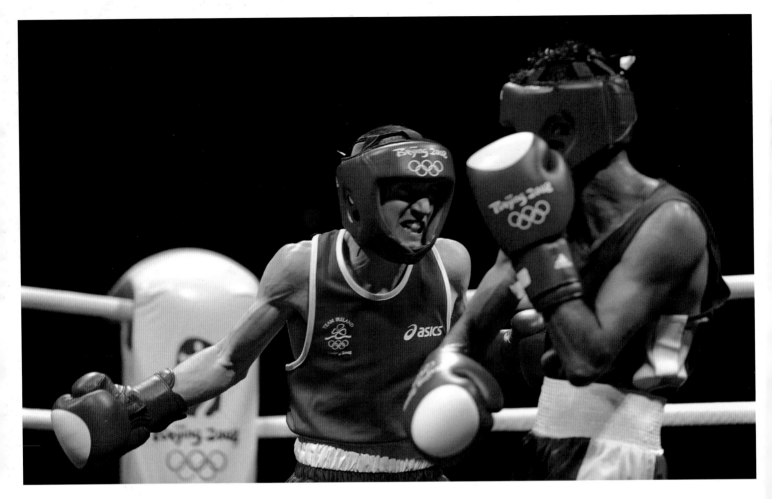

16 August 2008

Paddy Barnes, Ireland, in action against Jose Luis Meza of Ecuador at the Beijing Olympics. Barnes defeated Meza 14–8 and went on to win a bronze medal in his next round – Ireland's first medal of the 2008 Games.

Ray McManus / SPORTSFILE

24 August 2008

Ireland's Kenneth Egan celebrates with his silver medal after the presentation in the Light Heavyweight, 81kg, category at the Beijing Olympics.

Ray McManus / SPORTSFILE

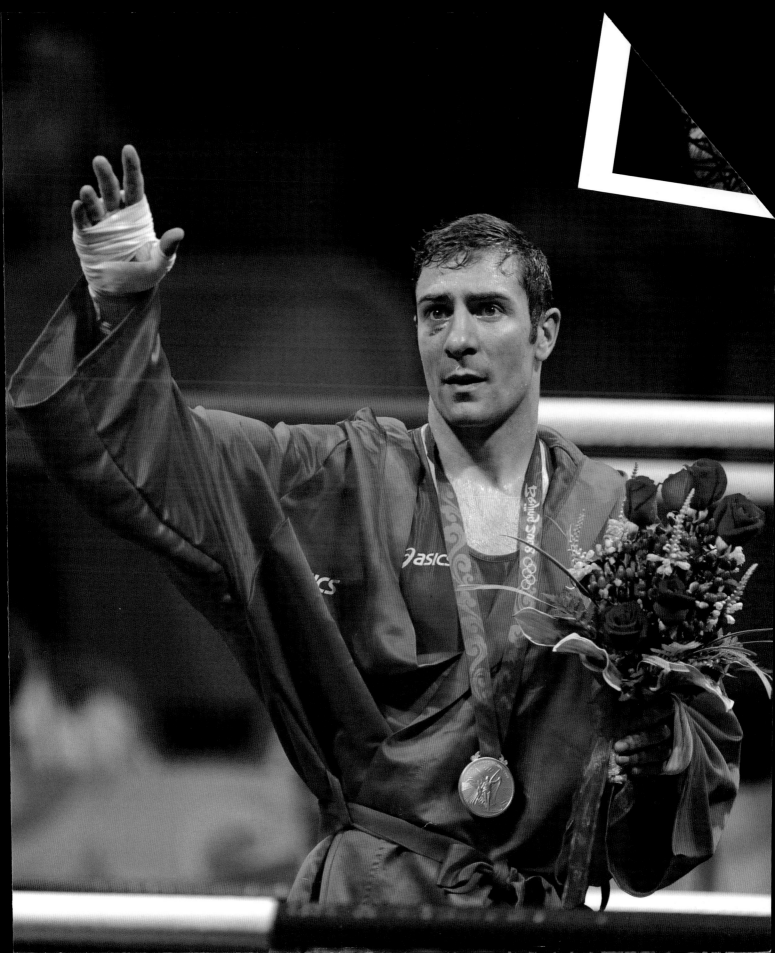

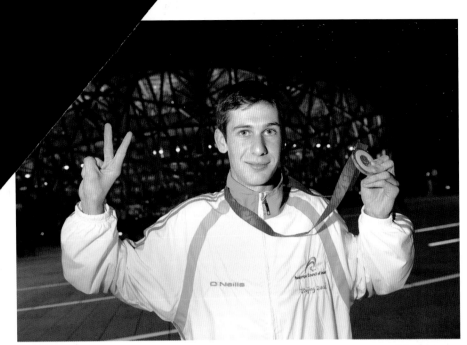

10 September 2008

Ireland's Michael McKillop, from Glengormley, Co. Antrim, celebrates with his gold medal outside the 'Bird's Nest' after winning the Men's 800m-T37 in a world record time of 1:59.39 at the Beijing Paralympic Games.

Brian Lawless / SPORTSFILE

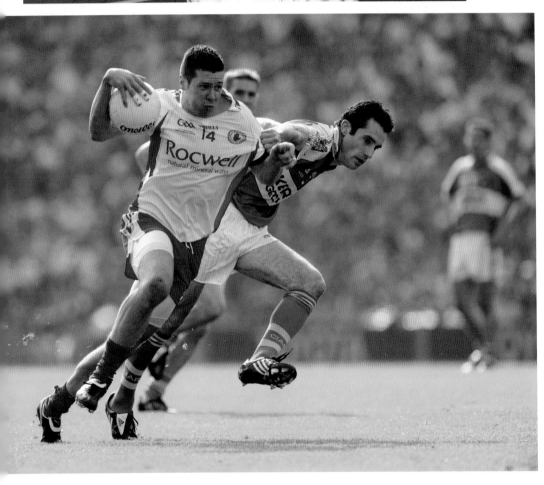

21 September 2008

Top of their game! Sean Cavanagh, Tyrone, is tackled by Tom O'Sullivan, Kerry. All-Ireland Senior Football Championship Final, Croke Park. The two teams had won six titles between them in the previous eight years: 2000, 2004, 2006, 2007 (Kerry) and 2003, 2005 (Tyrone). This time, Tyrone were the eventual winners.

Ray McManus / SPORTSFILE

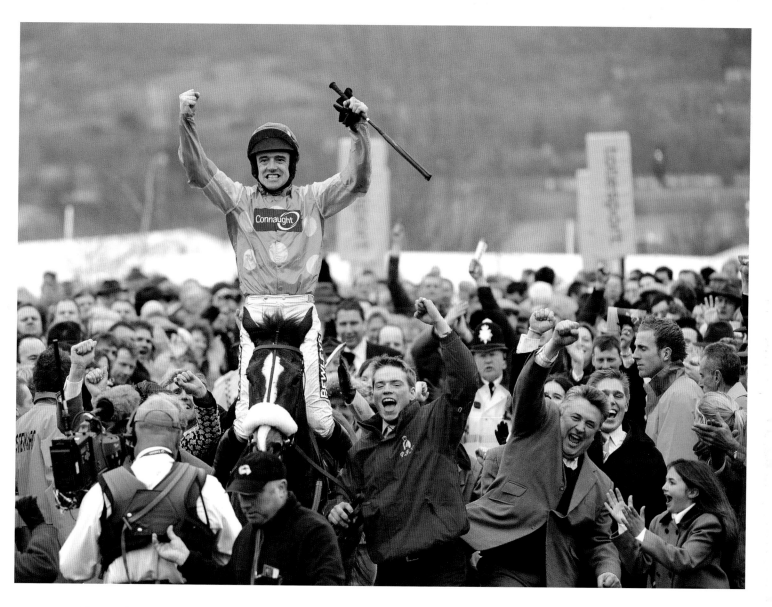

13 March 2009

Jockey Ruby Walsh celebrates with trainer Paul Nicholls, bottom right, after winning the Totesport Cheltenham Gold Cup Steeplechase on board Kauto Star. Kauto Star was considered a very versatile horse; AP McCoy called him 'the most complete chaser of the modern era'. He had already won the Cheltenham Gold Cup in 2007, so this win made him one of the few horses ever to retain the Cup. Cheltenham Racing Festival, Gloucestershire, England.

David Maher / SPORTSFILE

21 March 2009

Ireland's Ronan O'Gara celebrates his match-winning drop goal against Wales in the Millennium Stadium, Cardiff, on 21 March 2009. Three minutes later, Ireland were Grand Slam champions for the second time; the first time was in 1948. RBS Six Nations Championship, Wales v Ireland, Millennium Stadium, Cardiff, Wales.

Brendan Moran / SPORTSFILE

21 March 2009

Hometown hero Bernard Dunne celebrates after defeating defending World Champion Ricardo Cordoba in the eleventh round of their WBA World Super Bantamweight title fight at The O2 in Dublin.

Ray Lohan / SPORTSFILE

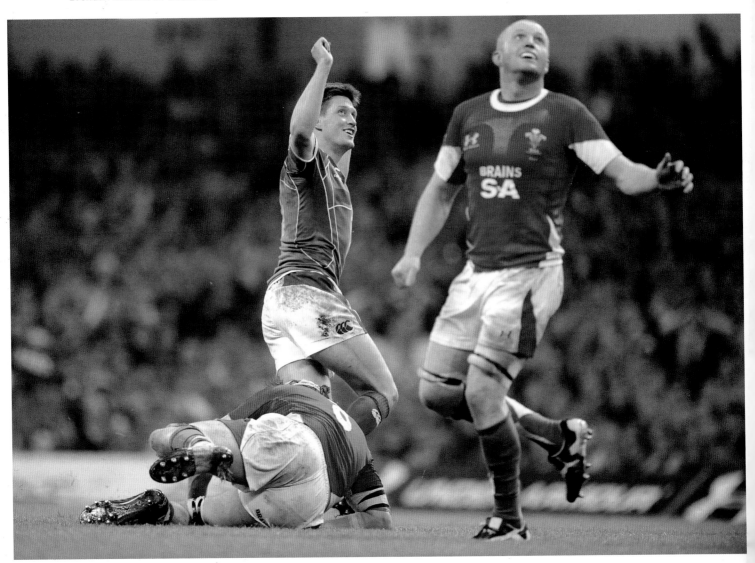

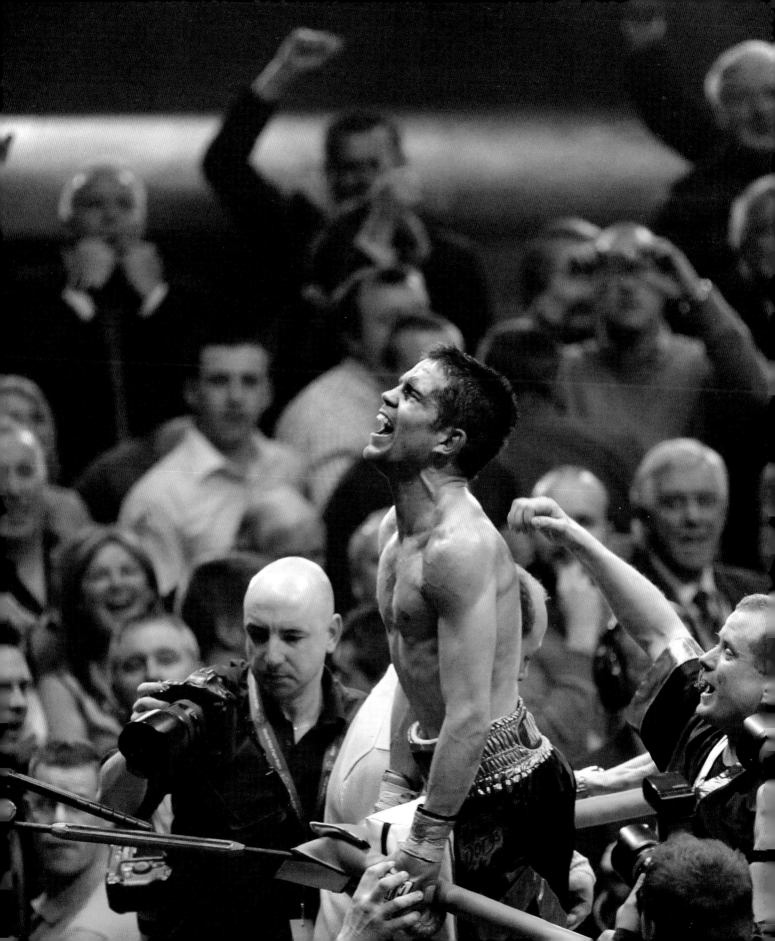

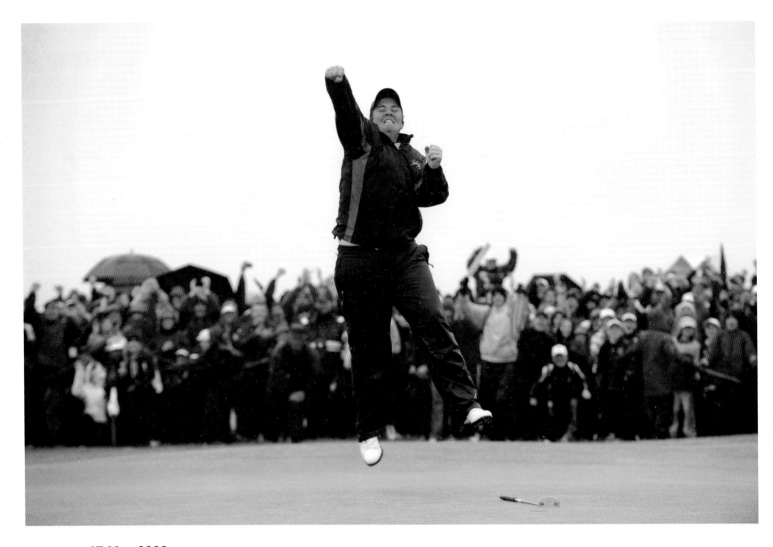

17 May 2009

Shane Lowry celebrates after putting on the 18th, after the third play off, to win the Irish Open. In a landmark victory, Lowry became only the third amateur to win a European Tour event. A decade later in 2019, at Portrush, Lowry would claim victory in the first Open Championship on Irish soil since 1951. The Offaly man has steadily established himself as one of the most popular Irish sportspeople of recent times. Irish Open Golf Championship, Baltray, Co. Louth.

Matt Browne / SPORTSFILE

23 May 2009

Leinster's Gordon D'Arcy, left, and Brian O'Driscoll
celebrate winning the Heineken Cup for the
first time after overcoming Leicester Tigers in
Murrayfield, Edinburgh, on 23 May 2009. This was
a brilliant year for Leinster, who had begun their
ascent to the top of the European rankings, and for
Irish rugby. Heineken Cup Final, Leinster v Leicester
Tigers, Murrayfield Stadium, Edinburgh, Scotland.

Matt Browne / SPORTSFILE

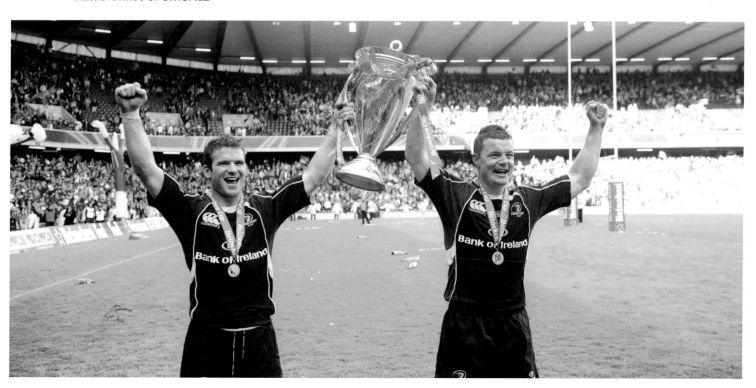

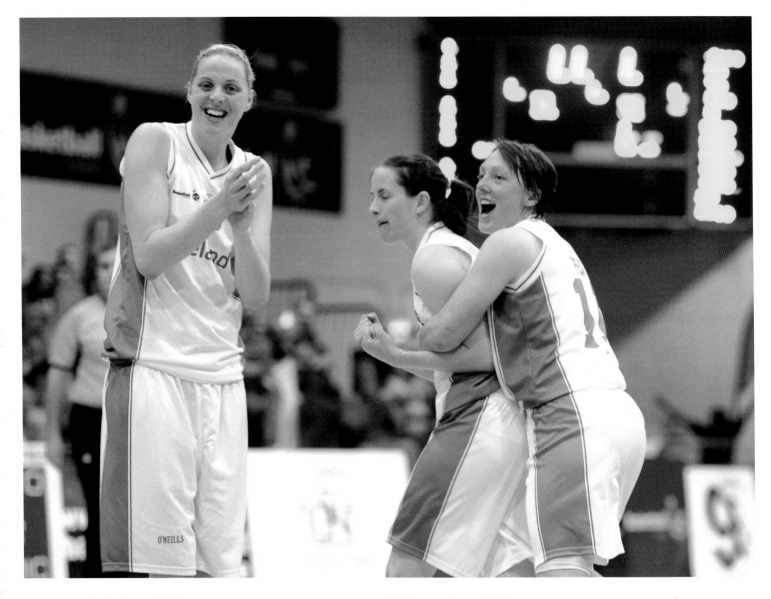

22 August 2009

Ireland players, from left, Ann-Marie Healy, Niamh Dwyer and Lindsay Peat celebrate at the final whistle. Senior Women's European Championship Qualifier, Ireland v Switzerland, National Basketball Arena, Tallaght, Dublin.

Brian Lawless / SPORTSFILE

05 September 2009

Jockey Mick Kinane with Sea the Stars after winning the Tattersalls Millions Irish Champion Stakes. Leopardstown Racecourse, Dublin. The climax of Sea the Stars' season would come in October when he won the Arc at Longchamp to complete six Group One wins on the bounce.

Ray McManus / SPORTSFILE

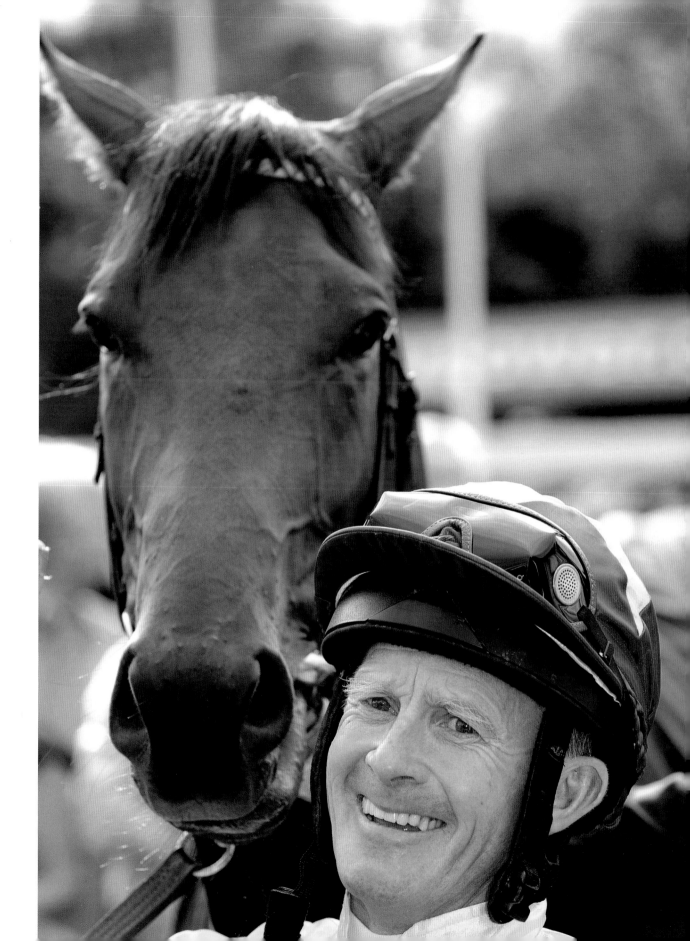

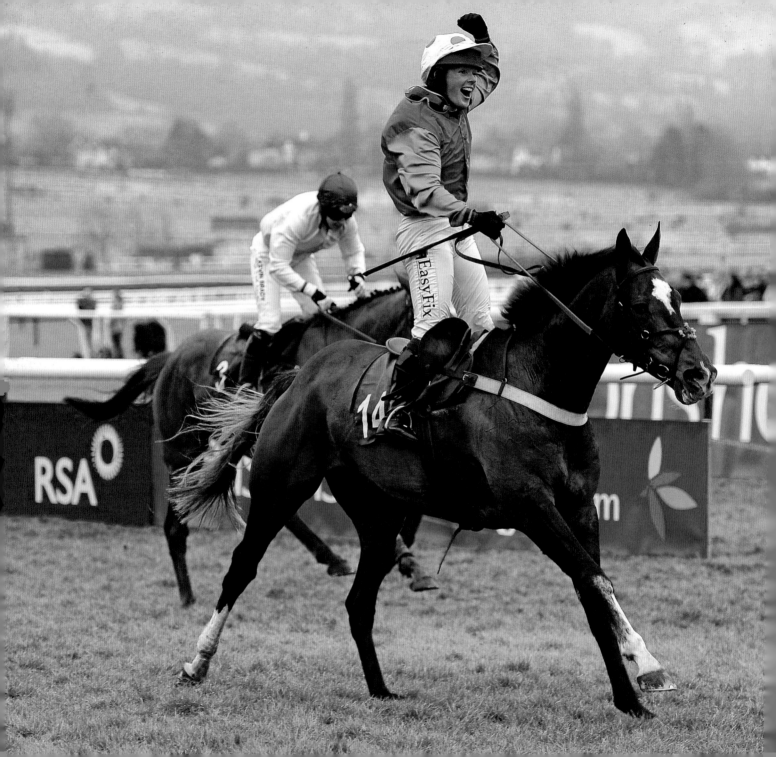

17 March 2010

Jockey Katie Walsh, on board Poker de Sivola, celebrates winning the 140th year of the National Hunt Chase Challenge Cup, from second placed Becauseicouldntsee, with Nina Carberry up. Cheltenham Racing Festival – Wednesday. Prestbury Park, Cheltenham, Gloucestershire, England.

2010s

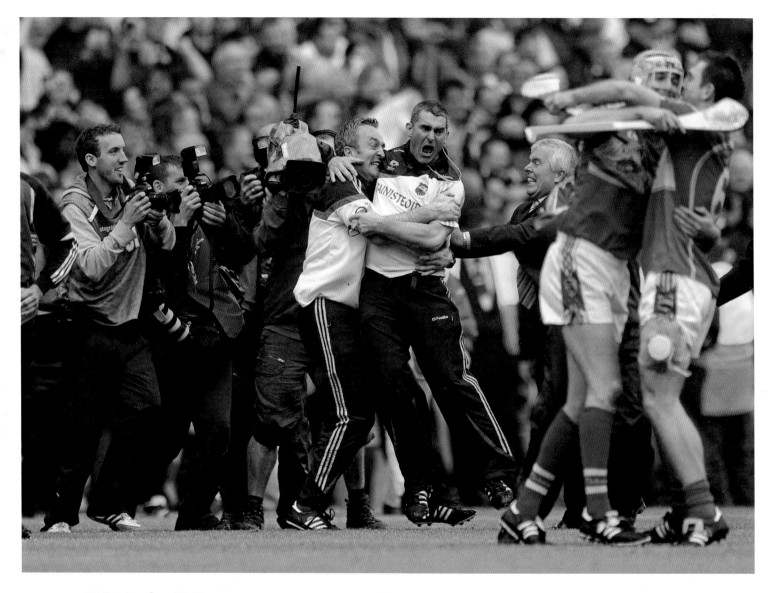

05 September 2010

Tipperary manager Liam Sheedy, centre,
celebrates with trainer Michael Ryan after the
final whistle. GAA Hurling All-Ireland Senior
Championship Final, Kilkenny v Tipperary,
Croke Park, Dublin.

Matt Browne / SPORTSFILE

12 September 2010

Wexford captain Una Leacy, left, and Michelle
O'Leary celebrate with the O'Duffy Cup. Gala
All-Ireland Senior Camogie Championship
Final, Galway v Wexford, Croke Park, Dublin.

Paul Mohan / SPORTSFILE

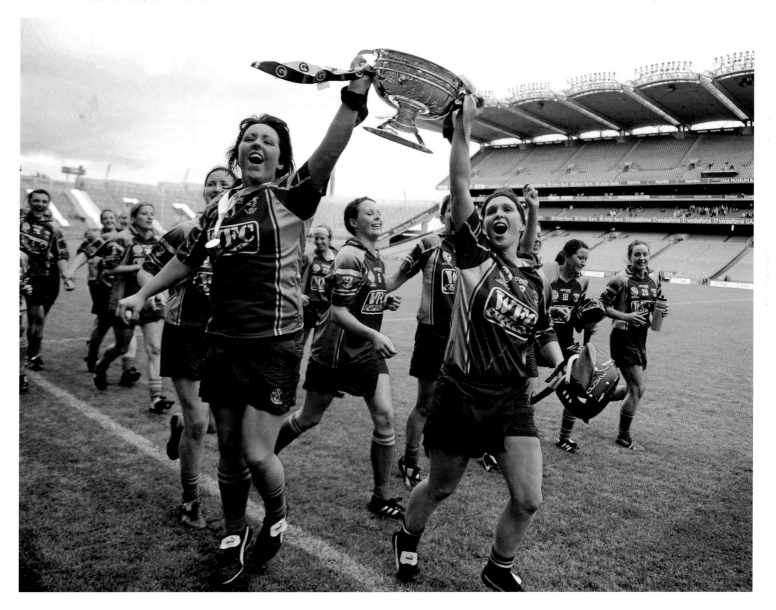

27 November 2010

Ireland's Grainne Murphy, from New Ross, Co. Wexford, in action during the final of the Women's 400m Freestyle event, where she finished 3rd, in a time of 4:02.86, and claimed the bronze medal at the European Short Course Swimming Championships in Eindhoven, Netherlands.

Frank Kliebisch / SPORTSFILE

02 July 2011

The Irish silver-medal winning 4x100m team (left to right, Martin Mahood, Bangor, Co. Down, Timothy Morahan, Rathmines, Dublin, Eileen O'Loughlin, Rathangan, Co. Kildare and Ciara O'Loughlin, Inagh, Co. Clare) celebrate at the 2011 Special Olympics World Summer Games, Athens, Greece.

Ray McManus / SPORTSFILE

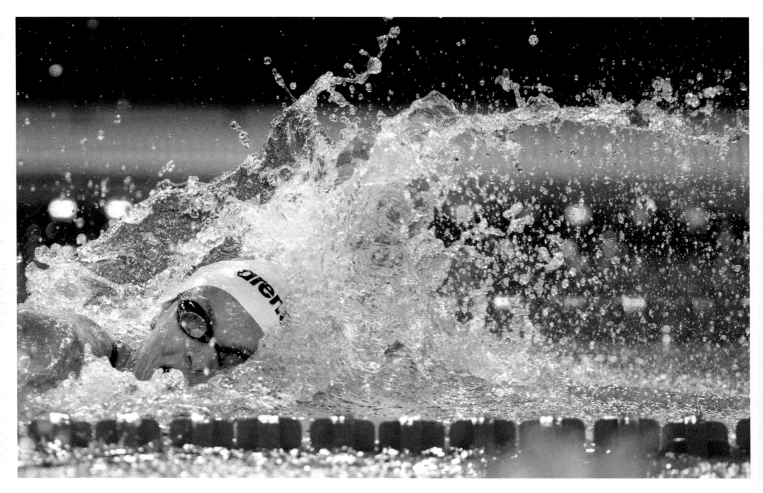

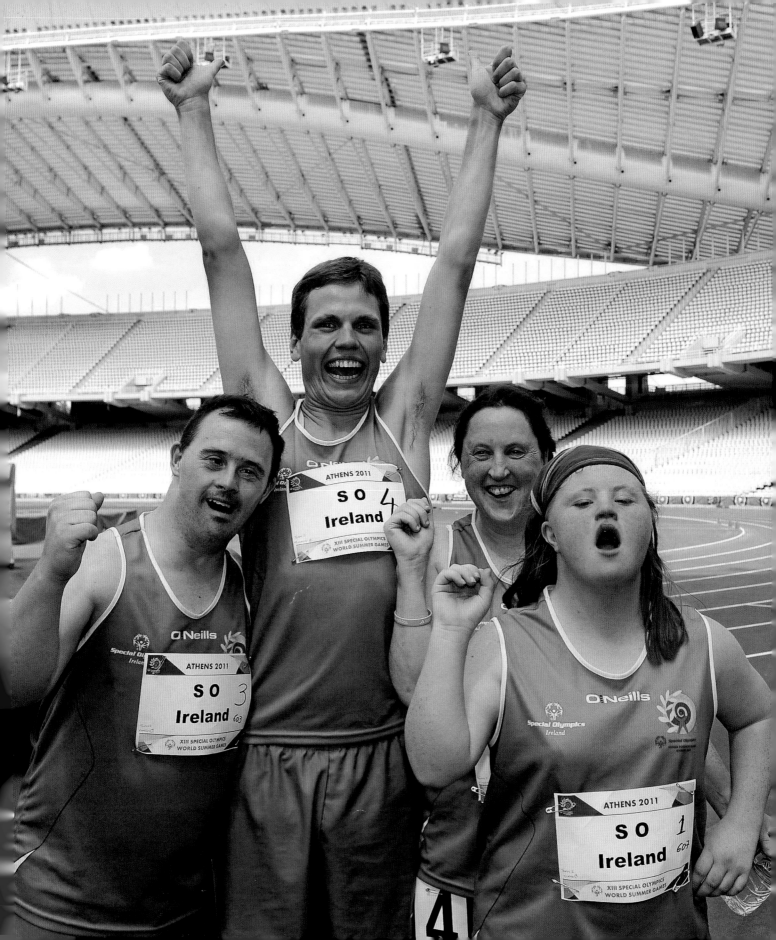

30 July 2011

Rory McIlroy watches his shot from the rough under a tree on the 9th hole during the third round of the 2011 Discover Ireland Irish Open Golf Championship, Killarney Golf & Fishing Club, Killarney, Co. Kerry.

Diarmuid Greene / SPORTSFILE

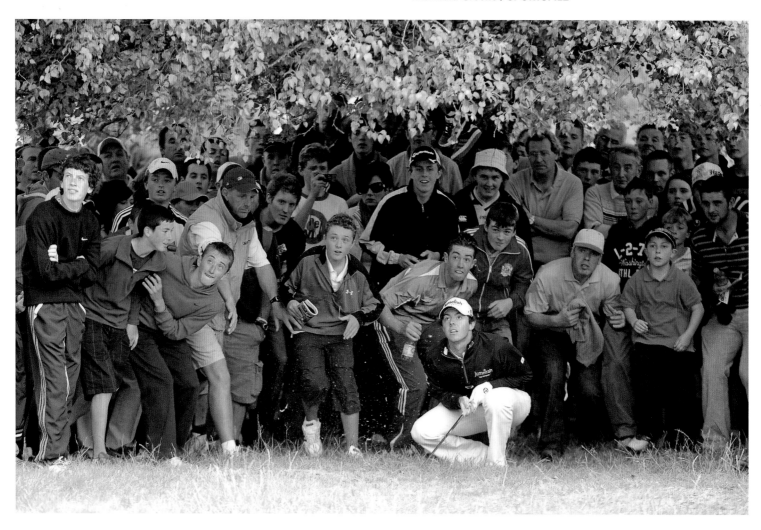

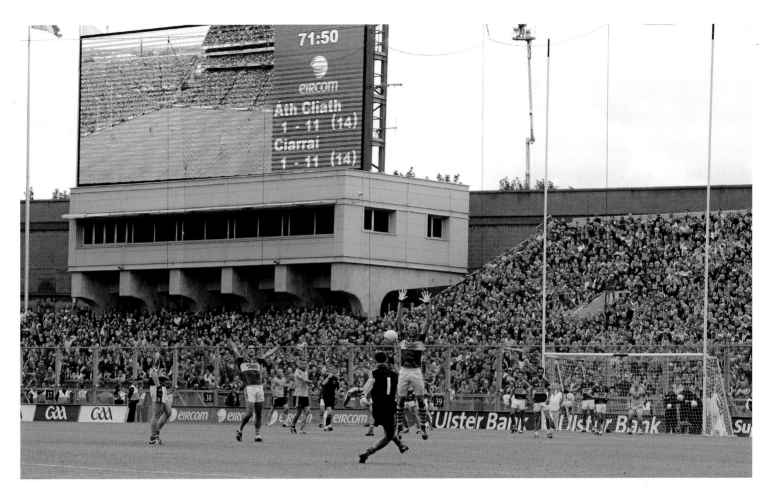

18 September 2011

Dublin versus Kerry: Dublin goalkeeper Stephen
Cluxton makes history as he kicks the winning
point in extra time from a free kick, giving
Dublin their first All-Ireland title since 1995. This
was the first time the winning point was scored
by a goalkeeper in an All-Ireland final.

Brian Lawless / SPORTSFILE

15 November 2011

Republic of Ireland captain Robbie Keane, left, and team-mate Damien Duff celebrate in the dressing room after securing qualification to Euro 2012. After fourteen years of service, the tournament in Poland and Ukraine would prove to be Duff's finale for Ireland. His last game came in the 2-0 loss to Italy in Ireland's final group match, which was also his 100th appearance. He announced his international retirement soon after Ireland's elimination. Keane would carry on until 2016. He retired from international football as a legend of the Irish game, holding the records for most appearances (146) and most goals (68) for the international team. He has also captained Ireland more times than any other player, having been handed the role by Steve Staunton in 2006. Euro 2012 Qualifying Play-off 2nd leg, Republic of Ireland v Estonia, Aviva Stadium, Dublin

David Maher / SPORTSFILE

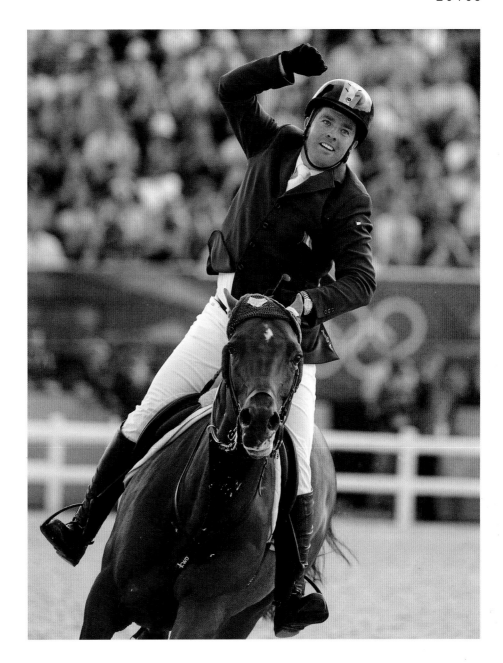

08 August 2012
Ireland's Cian O'Connor, on Blue Lloyd 12, celebrates after the final round in the individual showjumping final which he recorded only one time fault and won a bronze medal after a jump-off. London 2012 Olympic Games.
Brendan Moran /
SPORTSFILE

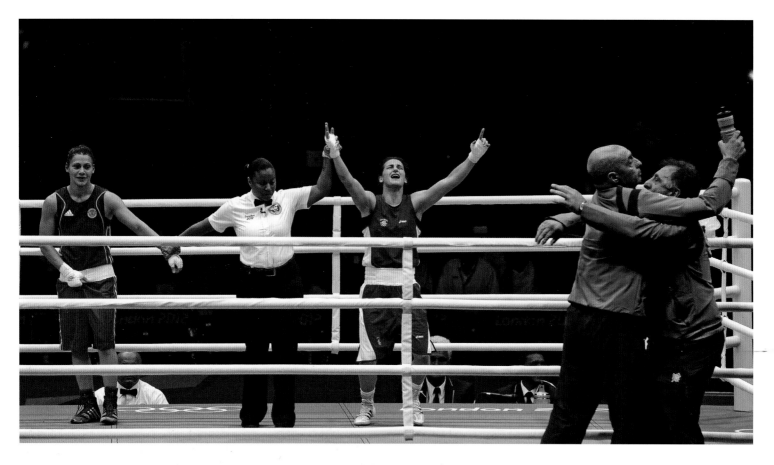

09 August 2012

The proudest moment! Katie Taylor is declared the winner over Sofya Ochigava of Russia in their women's 60kg final at the London 2012 Olympic Games, as Pete Taylor, her coach and father, and Team Ireland technical coach Zaur Antia celebrate the victory.

Ireland has won more Olympic medals in boxing than in any other sport; this win was arguably one of the most famous in Irish sport. 2012 was the first year that women's boxing was included in the Olympics, and it was a source of great national pride, as well as only fitting, that Katie Taylor, so long an ambassador and trailblazer for the sport, won gold.

David Maher / SPORTSFILE

12 August 2012

Team Ireland's Natalya Coyle competes in the modern pentathlon at the London 2012 Olympic Games. Coyle finished ninth in this event and went on to finish sixth at the 2016 Olympics in Rio.

Stephen McCarthy / SPORTSFILE

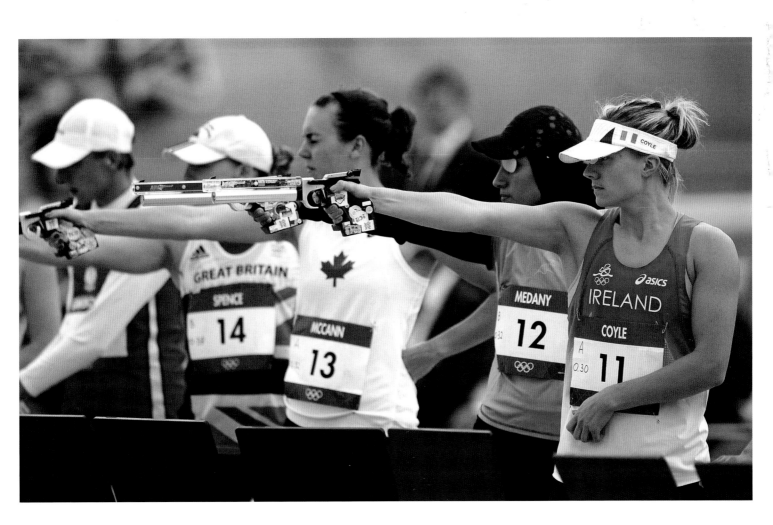

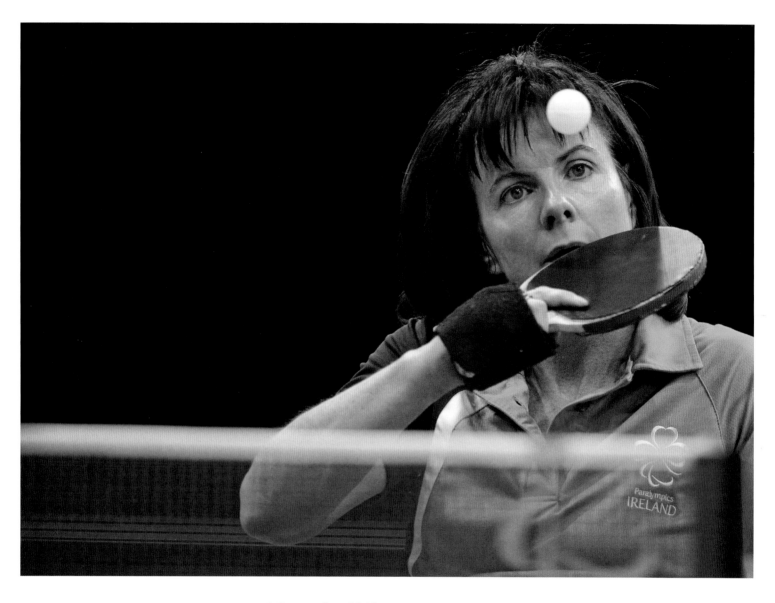

6 September 2012

Ireland's Rena McCarron Rooney, from Buncrana, Co. Donegal, in action during her women's team classes 1-3 quarter-final table tennis match against Pamela Pezzutto, Italy. London 2012 Paralympic Games. McCarron Rooney went on to compete at the 2014 World Championships in Beijing, and the 2016 Paralympic Games in Rio. In 2015 she won silver at the European para-table tennis championships in Denmark.

Brian Lawless / SPORTSFILE

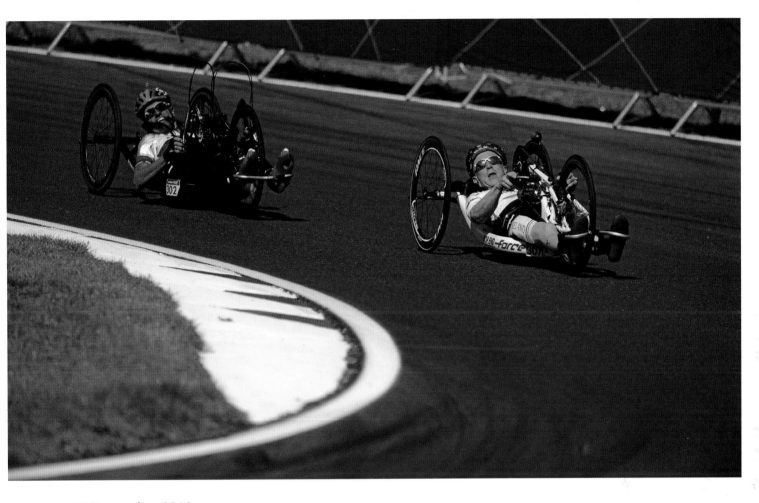

07 September 2012

Ireland's Mark Rohan, right, from Ballinahown, Co. Westmeath,
competes in the men's individual H1 road race. London 2012
Paralympic Games.

Brian Lawless / SPORTSFILE

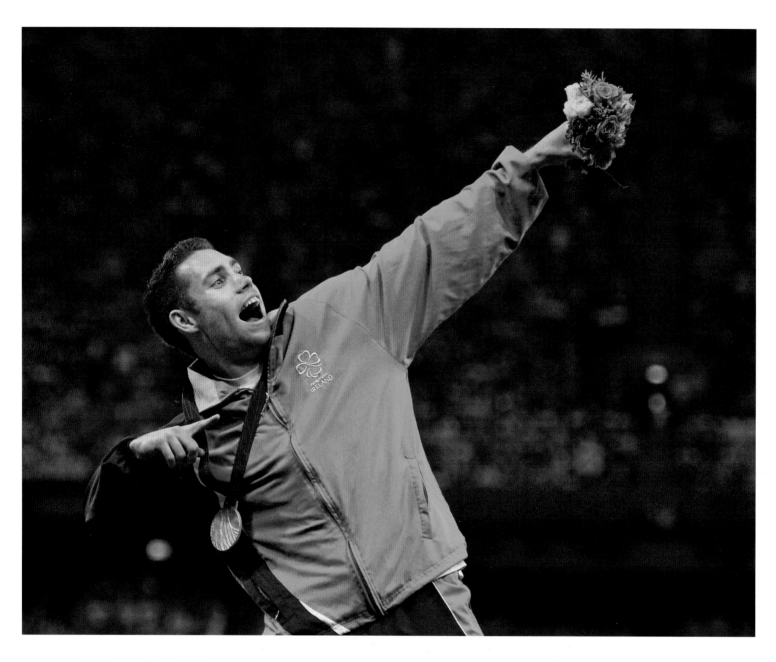

07 September 2012

Ireland's Jason Smyth, from Eglinton, Co. Derry, celebrates with
his gold medal after the men's 200m T13 final. London 2012
Paralympic Games. Smyth holds the world record for both 100m
and 200m in his category.

Brian Lawless / SPORTSFILE

23 September 2012

Donegal's Mark McHugh and his father Martin McHugh, TV pundit and All-Ireland winner in 1992 with Donegal, celebrate after the game. GAA Football All-Ireland Senior Championship Final, Donegal v Mayo, Croke Park, Dublin.

Oliver McVeigh / SPORTSFILE

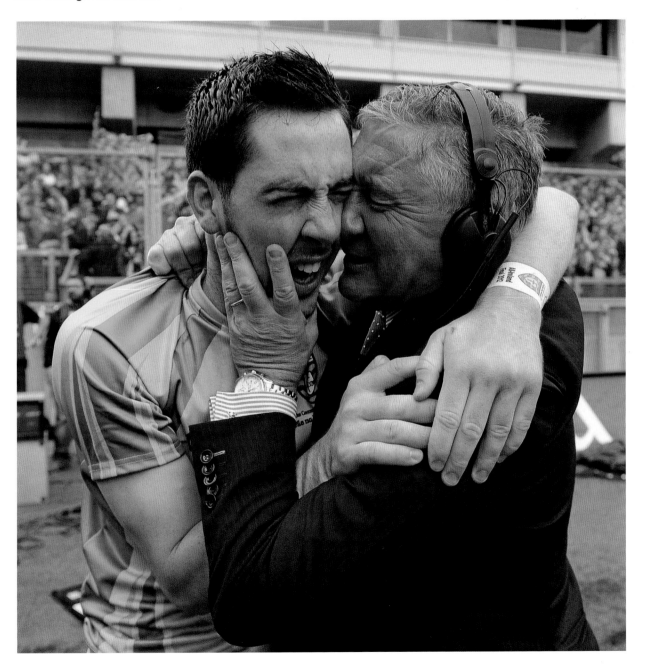

07 October 2012

Cork's Rena Buckley, left, and Briege Corkery celebrate their side's victory. TG4 All-Ireland Ladies Football Senior Championship Final, Cork v Kerry, Croke Park, Dublin.

Stephen McCarthy / SPORTSFILE

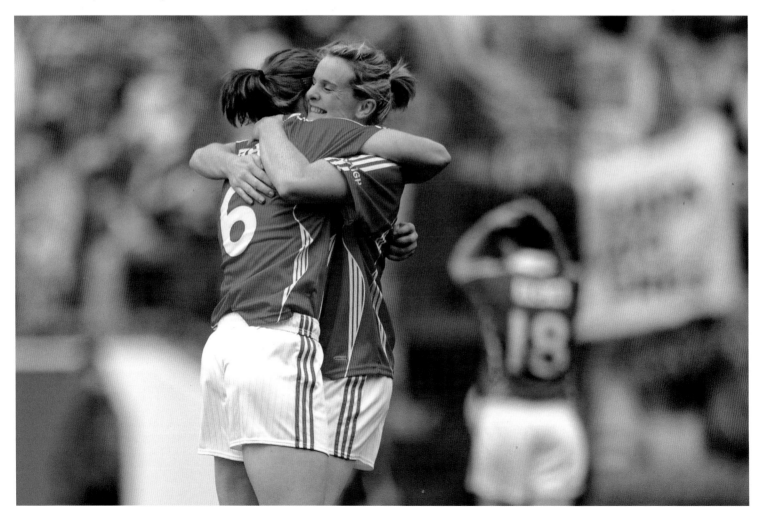

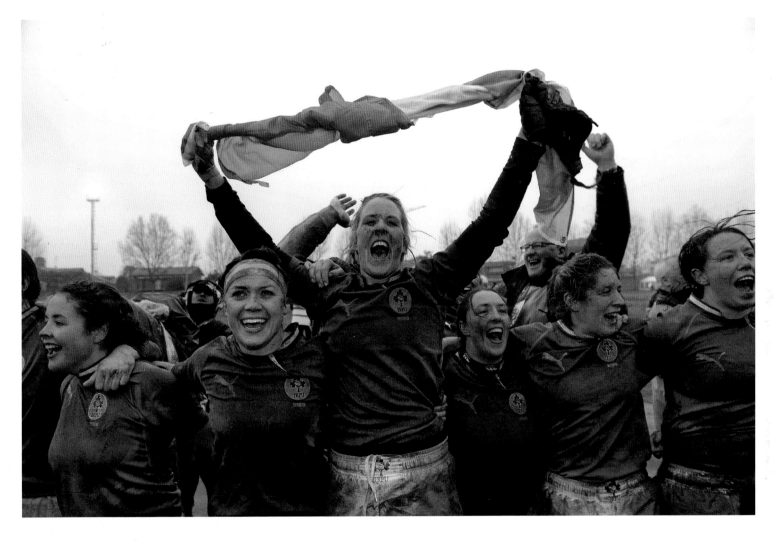

17 March 2013

The Ireland women's squad took their first Six Nations title and the Grand Slam after a hard-fought 6-3 win over Italy. Here, Joy Neville holds the Irish flag as her teammates celebrate, including, from left, Larissa Muldoon, Lynne Cantwell, Gillian Bourke, Alison Miller and Niamh Kavanagh. Women's Six Nations Rugby Championship, Italy v Ireland, Parabiago, Milan, Italy.

Matt Browne / SPORTSFILE

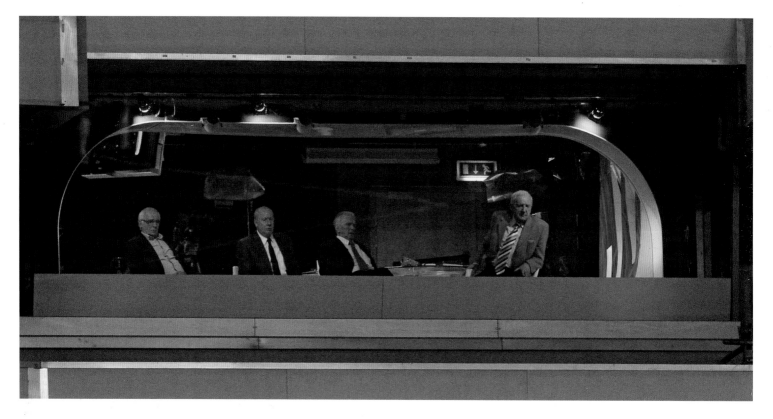

26 March 2013

The RTE panellists, from left, Eamon Dunphy, Liam Brady and John Giles, with anchor Bill O'Herlihy, look on during the game. Bill O'Herlihy and his 'three amigos' are about as iconic as sports broadcasters come in this country. Bill and Eamon Dunphy had worked together since the 1970s, with Giles joining the panel in the 80s and Brady in the 90s. As Bill so succinctly described in his farewell after the 2014 World Cup, the trio of pundits brought 'knowledge, insight, controversy' and 'a sense of fun' to RTÉ's football coverage, athough it was the inimitable way in which O'Herlihy reined in, and sometimes provoked, the three men to his left, that really elevated the coverage to such a high standard. O'Herlihy's departure in 2014 signalled the end of an era, with Giles following suit in 2016 and Dunphy also parting ways with the station in 2018. 2014 FIFA World Cup Qualifier, Group C, Republic of Ireland v Austria, Aviva Stadium, Lansdowne Road, Dublin.

Brian Lawless / SPORTSFILE

21 May 2013

Sam Bennett celebrates his first major win: Stage 3 of the An Post Rás in 2013 into Listowel, riding for Sean Kelly's An Post-Chain Reaction Cycles team; he also won stage 11 and a stage of the Tour of Britain that year. There were many ups and downs in his career, including when he rode the whole Tour de France in 2016 injured following an early crash, finishing in last place: 'the lanterne rouge'. His career swung dramatically upwards from October 2018 when he won four of six stages in the Tour of Turkey. Since then he has won stages in all three grand tours, winning the Green Jersey in the Tour de France in 2020 and finishing the season as the world's leading sprinter.

Paul Mohan / SPORTSFILE

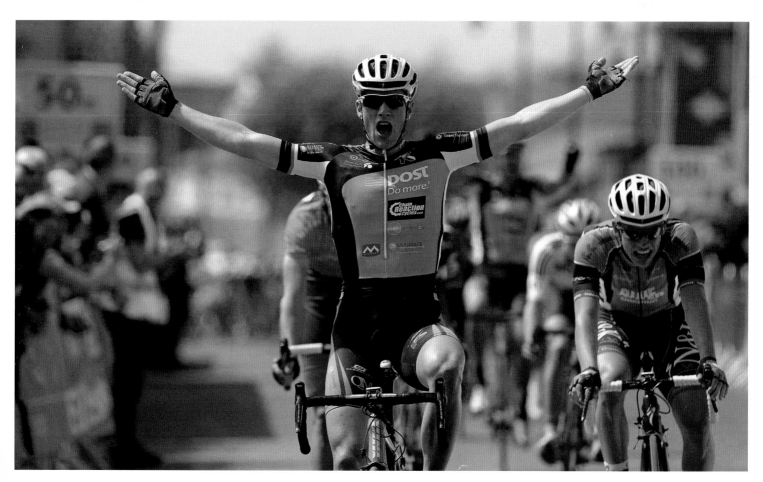

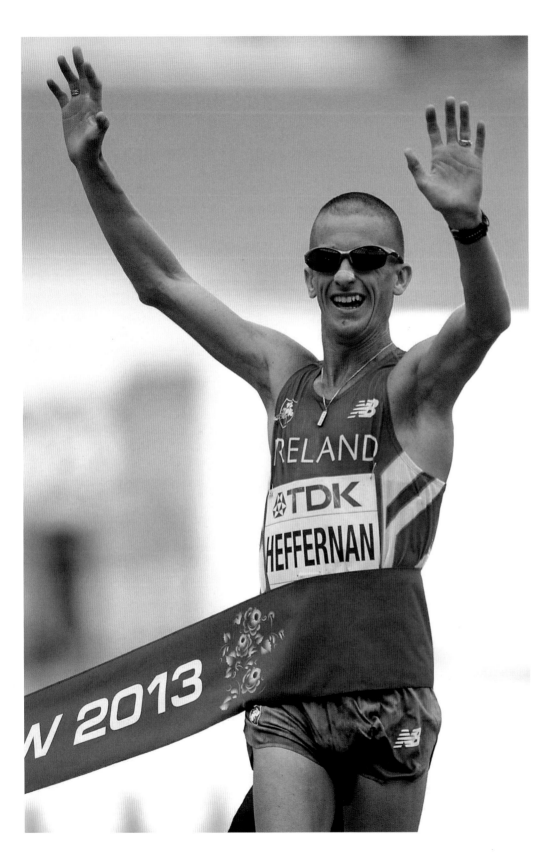

14 August 2013
Ireland's Robert Heffernan celebrates after winning the men's 50k walk in a time of 3:37.56. IAAF World Athletics Championships, Moscow. An evergreen athlete, Heffernan has competed in five Olympic games since 2000. He finished a heart-breaking fourth in the 50k walk at the London Olympics in in 2012; this was later upgraded to third place when the Russian race-winner, Sergei Kirdyapkin, was disqualified for doping. Heffernan was presented with his Olympic bronze medal at City Hall in Cork in 2016; he went on to finish sixth in the same event at the Rio Olympics in 2016.

Stephen McCarthy /

SPORTSFILE

05 August 2014

From left, Ashleigh Baxter, Ailis Egan and Vicky McGinn celebrate the Irish women's rugby team's historic win over world champions New Zealand in the World Cup in Paris on 5 August 2014. 2014 Women's Rugby World Cup Final, Pool B, Ireland v New Zealand, Marcoussis, Paris, France.

Aurélien Meunier /
SPORTSFILE

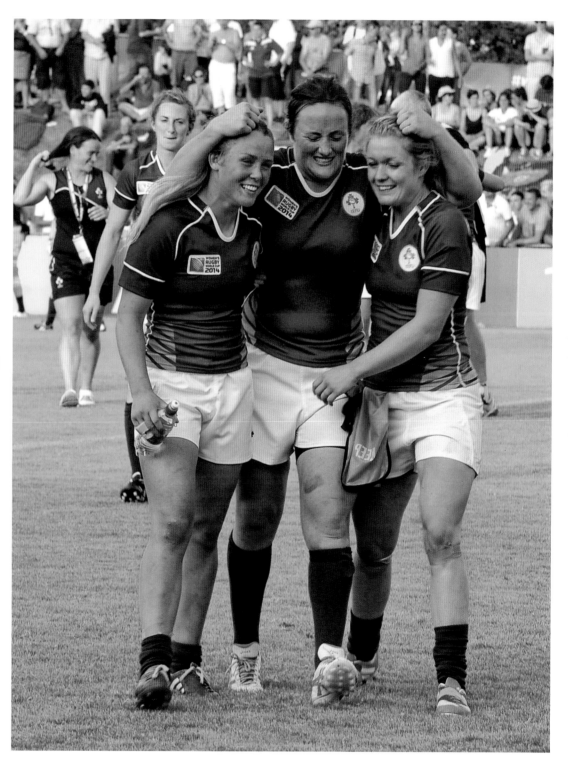

08 February 2015

Jockey Tony McCoy celebrates on Carlingford Lough, after winning the Hennessy Gold Cup.
Leopardstown, Co. Dublin. Carlingford Lough would go on to win the race again in 2016 under Mark
Walsh, coming from last to first in the last few furlongs.

Barry Cregg / SPORTSFILE

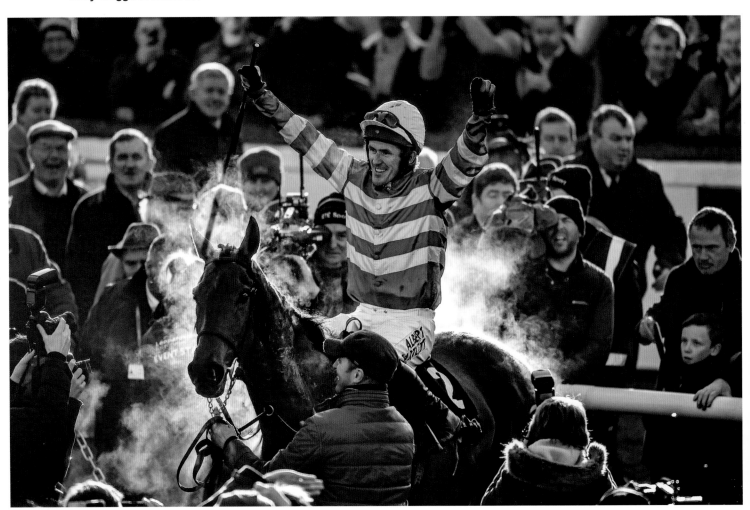

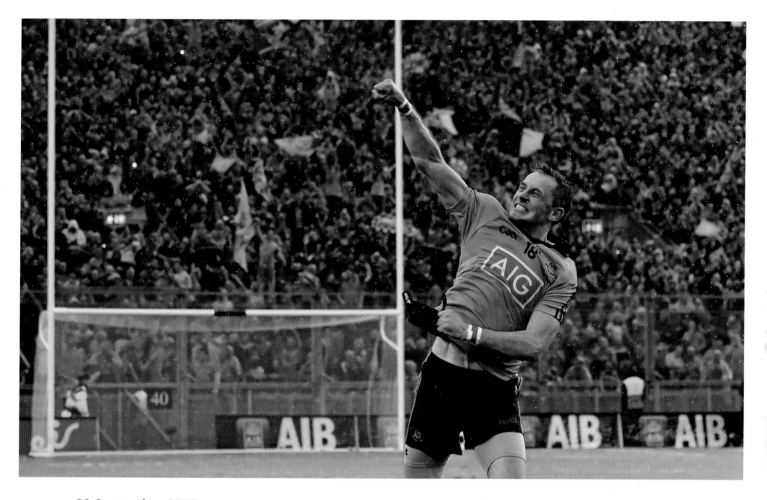

20 September 2015

Dublin's Alan Brogan celebrates in front of Hill 16 as Dublin take back the Sam Maguire Cup after being defeated by Donegal the previous year. GAA Football All-Ireland Senior Championship Final, Dublin v Kerry, Croke Park, Dublin.

Brendan Moran / SPORTSFILE

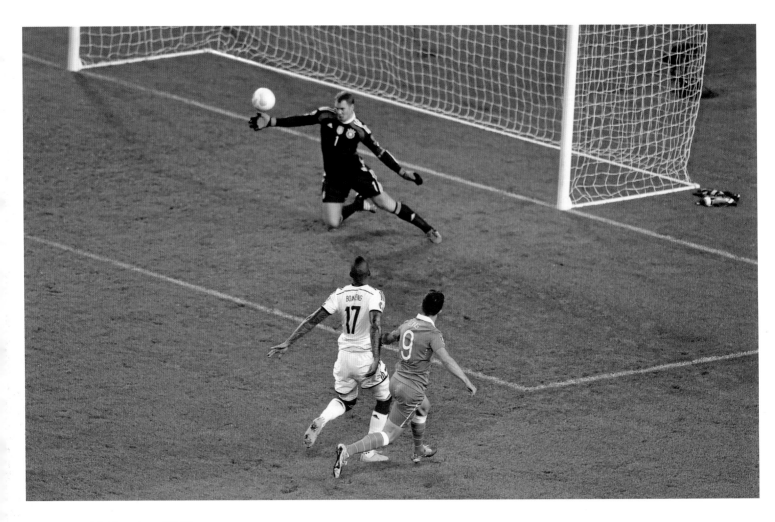

08 October 2015

Shane Long, Republic of Ireland, shoots to score past Manuel Neuer of Germany. Almost three years on from a humiliating 6-1 defeat, Ireland hosted Germany at the Aviva Stadium once again. This night was not to be as traumatic as Shane Long latched onto a long ball from goalkeeper Darren Randolph and emphatically finished past Neuer. Ireland held out for a 1-0 win. This meant they had secured four points from a possible six from the then-world champions after gaining a dramatic point away from home earlier in the qualifying campaign. UEFA Euro 2016 Championship Qualifier, Group D, Republic of Ireland v Germany. Aviva Stadium, Dublin.

Stephen McCarthy / SPORTSFILE

13 November 2015

Robbie Brady, Republic of Ireland, celebrates with team-mates after scoring. After a thick fog descended on the ground in the second half, the match became virtually impossible to view for both the crowd in Bosnia and Herzegovina and the television audience. Ireland's only goal of the game came through a well-struck effort from Robbie Brady. However, due to the poor visibility, for many watching at home, there was delayed celebration as it took a few seconds to realise what had happened. The away leg ended in a 1-1 draw, with qualification for the European Championships being secured in the return leg at the Aviva Stadium. UEFA EURO 2016 Championship Qualifier Play-off, 1st Leg, Bosnia and Herzegovina v Republic of Ireland. Stadion Bilino Pole, Zenica, Bosnia & Herzegovina.

David Maher / SPORTSFILE

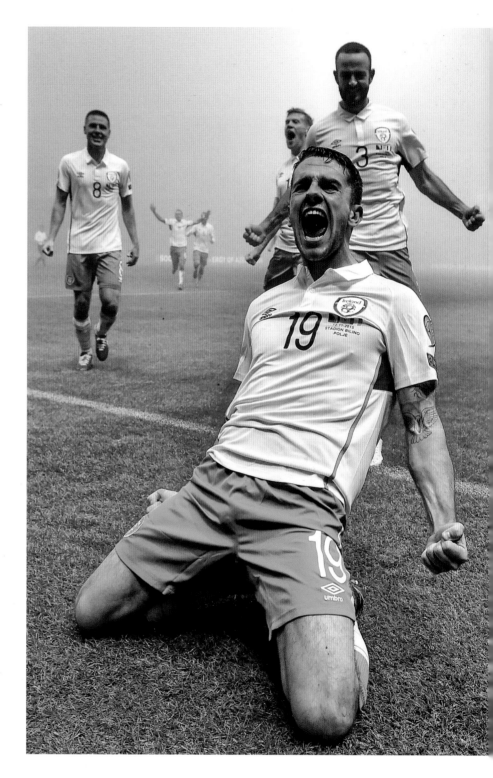

27 February 2016

Belfast boxer Carl Frampton celebrates after defeating Scott Quigg by a points decision in their IBF &

WBA Super-Bantamweight World Unification Title Fight at the Manchester Arena.

Ramsey Cardy / SPORTSFILE

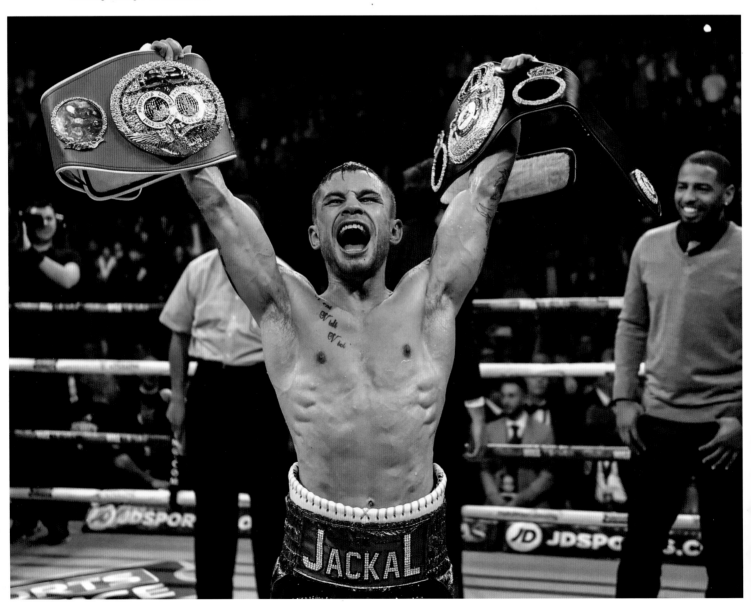

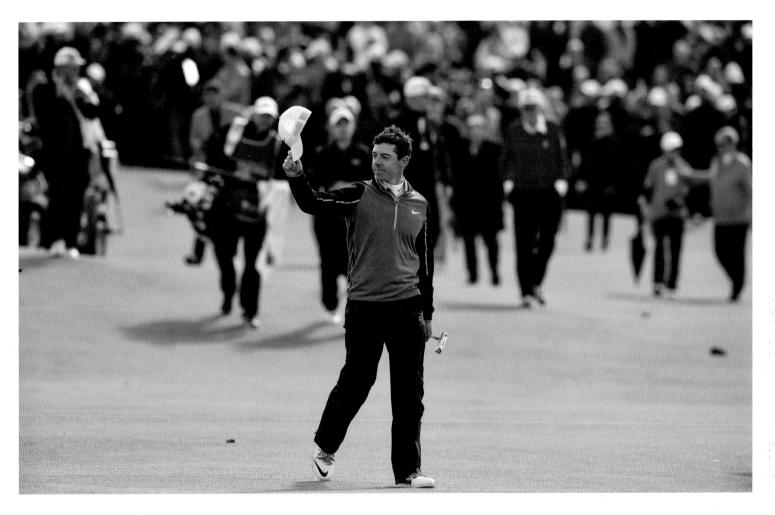

22 May 2016

Rory McIlroy of Northern Ireland acknowledges the crowd as he makes his way to the 18th green during the final round. 2016 marked the first Irish Open win for McIlroy. After the win, McIlroy said, 'I don't really get emotional when I win, but I was holding back the tears there. To play like that and finish like that, with all of my friends and family watching was just so special.' Irish Open Golf Championship, The K Club, Straffan, Co. Kildare.

Matt Browne / SPORTSFILE

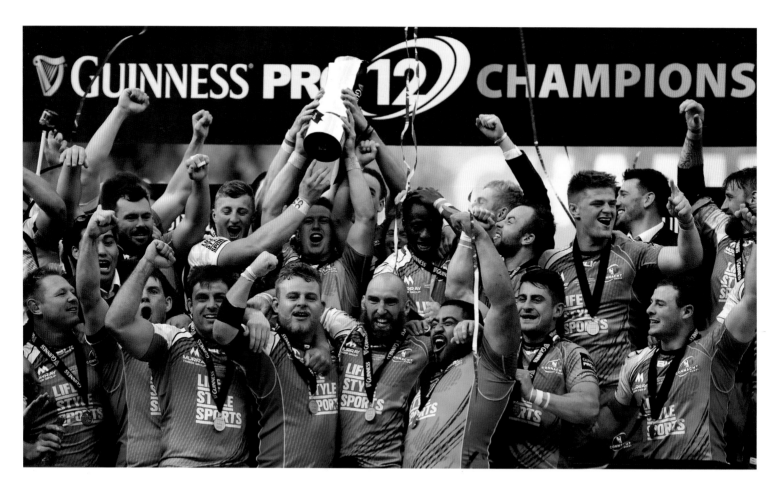

28 May 2016

Connacht players celebrate following the Guinness
PRO12 Final match between Leinster and Connacht
at BT Murrayfield Stadium in Edinburgh, Scotland.

Stephen McCarthy / SPORTSFILE

22 June 2016

Republic of Ireland players, left to right, Robbie Brady, James McClean and Stephen Ward, run towards the supporters after securing progression to the last 16 of the Euros. Brady was the hero that night as he scored the only goal of the game against the Italians. Going into the game, Ireland knew that if they failed to win, they would be going home. Ireland had put in a spirited display, but had failed to break the deadlock. With the clock running down, Brady made a surging run through the middle. Wes Hoolahan produced a moment of magic, curling a stunning cross right onto Brady's head, which he converted past Salvatore Sirigu with just five minutes left on the clock. Brady would score again in the Round of 16 against France, but an Antoine Griezmann double would send Ireland home. UEFA Euro 2016 Group E match between Italy and Republic of Ireland at Stade Pierre-Mauroy in Lille, France.

Ray McManus / SPORTSFILE

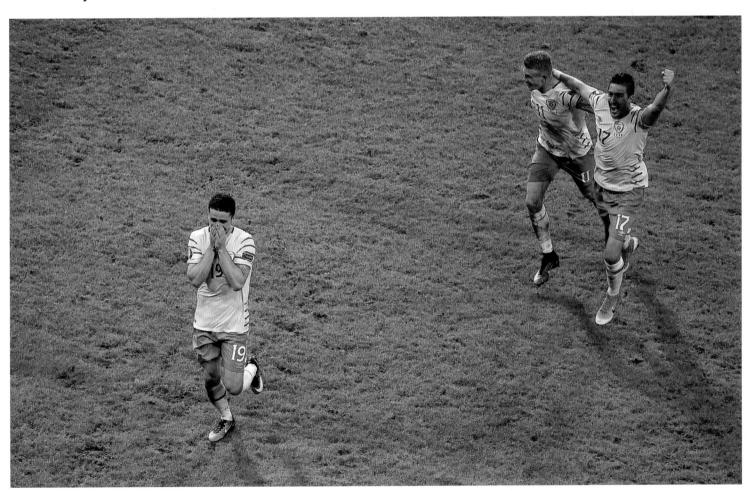

10 July 2016

Ciara Mageean holds the tricolour aloft after winning a bronze medal in the Women's 1500m Final at the European Athletics Championships in Amsterdam. This race marked Mageean's real breakthrough to the senior ranks: the Portaferry runner had a dazzling junior career, medalling at both the world junior and world youth championships, before she was stalled for several years by an ankle injury. Mageean went on to represent Ireland at the Olympics in Rio in 2016. She continued her successful trajectory, becoming the first Irish woman to run under 2 minutes for 800m in 2020, breaking Sonia O'Sullivan's long-held Irish record for the 1,000m later the same year, and representing Ireland in the Tokyo Olympics in 2021.

Brendan Moran / SPORTSFILE

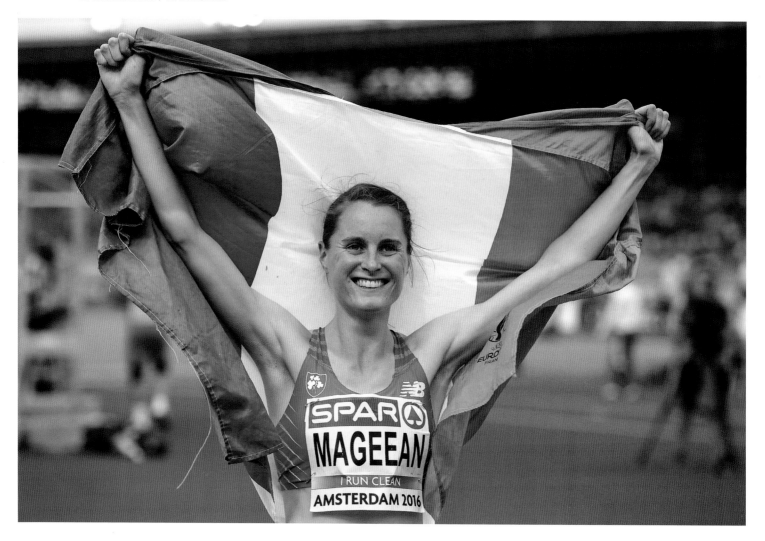

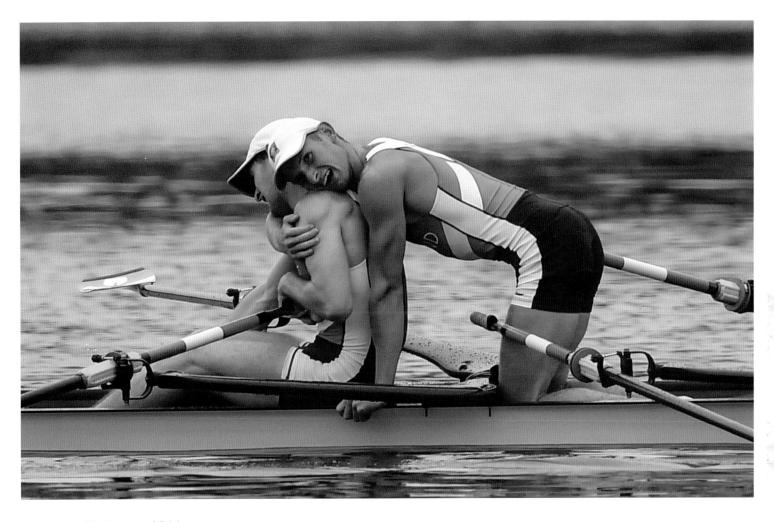

12 August 2016

Paul and Gary O'Donovan of Ireland celebrate after winning silver in the Men's Lightweight Double Sculls in the 2016 Rio Olympic Games in Brazil. The brothers from Skibbereen made rowing the most popular sport in Ireland for a time in the summer of 2016, thanks to their performance on the water and their lively and irrepressible interview style off it. They famously explained their tactics as: 'Close your eyes and pull like a dog'.

Stephen McCarthy / SPORTSFILE

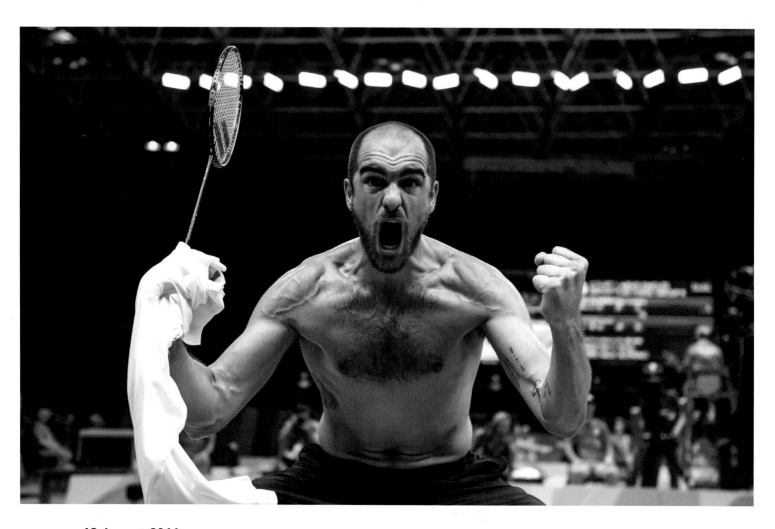

13 August 2016

Scott Evans of Ireland celebrates his victory in the Men's Singles Group Play Stage match against Ygor Coelho de Oliveira at Riocentro Pavillion 4 Arena during the 2016 Summer Olympic Games in Rio de Janeiro, Brazil.

Stephen McCarthy / SPORTSFILE

16 August 2016

Michael Conlan of Ireland vents his feelings after his controversial loss to Russian Vladimir Nikitin in the bantamweight quarter-final at the Rio Olympic Games. His result set off a chain of events which ultimately led to the International Olympic Committee stripping the IABA (International Boxing Association) of responsibility for organising the boxing tournament at the Tokyo Olympics, where all the Rio boxing referees and judges were banned as well. Conlan subsequently went professional and beat Nikitin in a pro boxing match in Madison Square garden in 2019.

Stephen McCarthy / SPORTSFILE

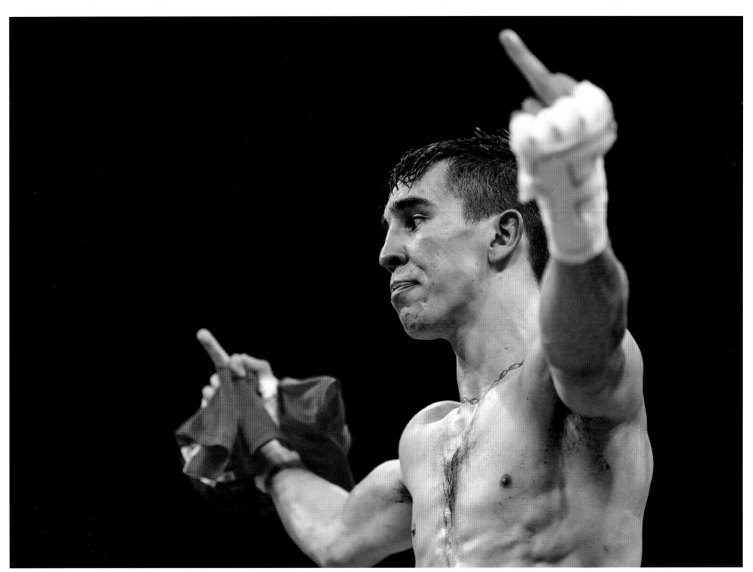

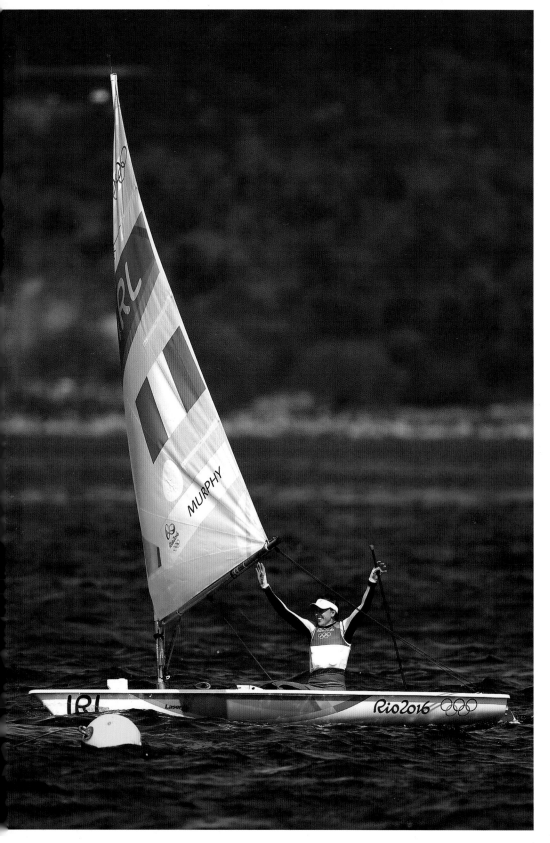

16 August 2016

Annalise Murphy of Ireland celebrates after winning silver in the Women's Laser Radial Medal race during the 2016 Rio Olympic Games, becoming the first Irish woman to win a medal in sailing.

Brendan Moran /

SPORTSFILE

18 August 2016

Arthur Lanigan O'Keeffe of Ireland in action during the Men's Individual Fencing Ranking round of the Modern Pentathlon during the 2016 Rio Summer Olympic Games in Rio de Janeiro, Brazil.

Ramsey Cardy /

SPORTSFILE

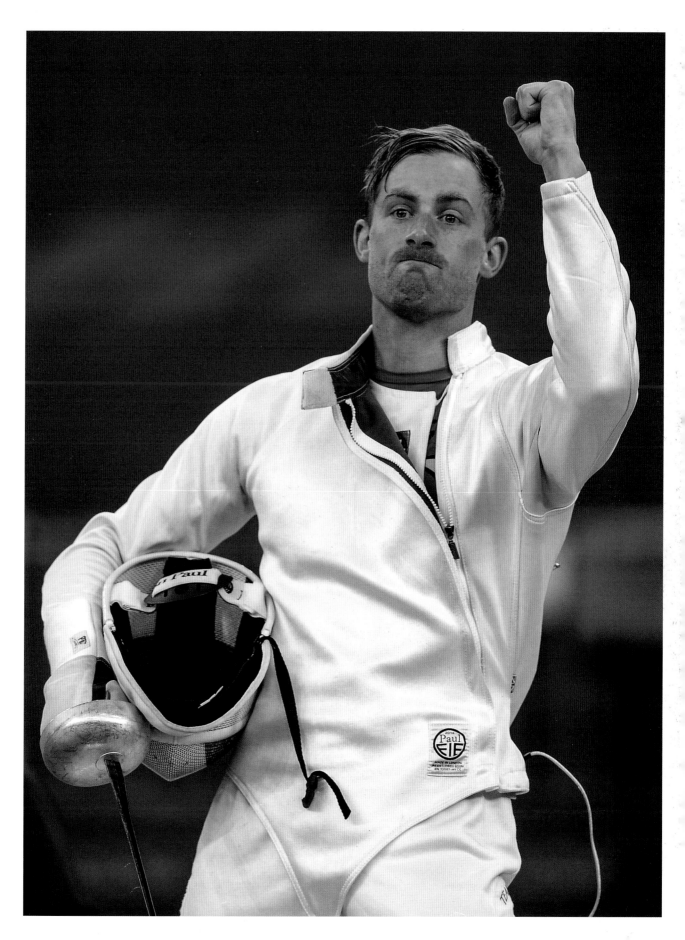

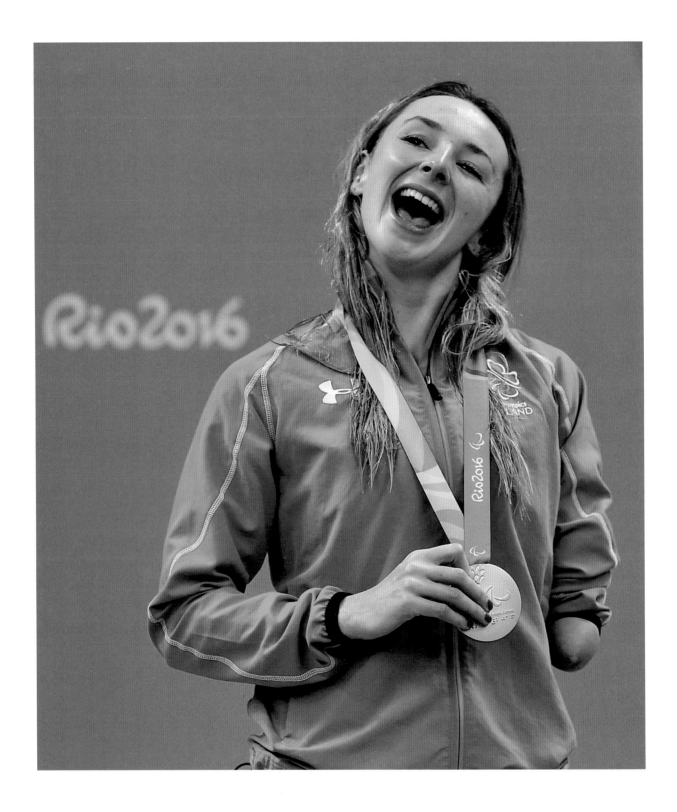

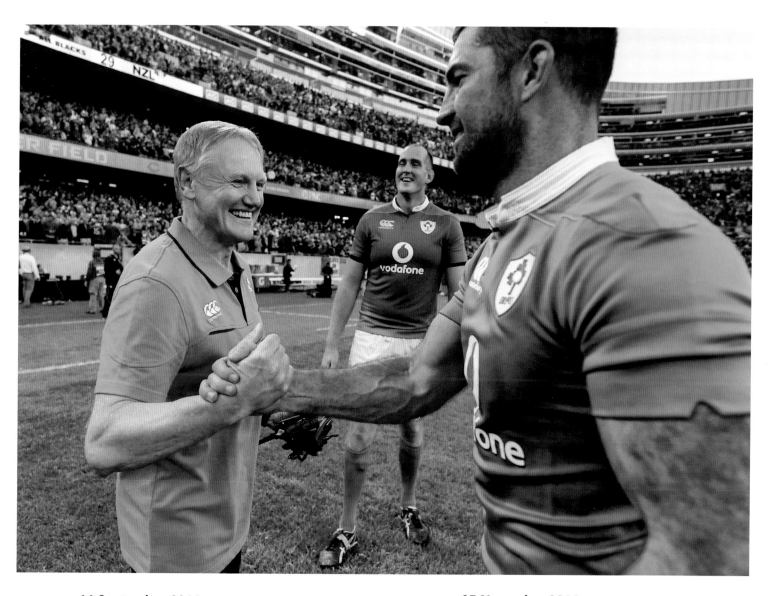

14 September 2016

Ellen Keane of Ireland with her bronze medal
following the Women's 100m Breaststroke SB8 Final
at the Olympic Aquatics Stadium during the 2016
Paralympic Games in Rio de Janeiro, Brazil. Keane was
Ireland's youngest ever Paralympian when she swam
for Ireland, aged thirteen, at the 2008 Paralympics
in Beijing. She also represented Ireland in London,
before going on to medal in Rio and represent Ireland
in Tokyo in 2021.

Paul Mohan / SPORTSFILE

05 November 2016

Head coach Joe Schmidt, left, and
Rob Kearney, after Ireland's first-ever
victory over New Zealand at Soldier
Field in Chicago, on 5 November
2016.

Brendan Moran / SPORTSFILE

12 November 2016

Conor McGregor celebrates with his featherweight and lightweight belts after defeating Eddie Alvarez during their lightweight title bout at UFC 205 in Madison Square Garden, New York.

Adam Hunger / SPORTSFILE

17 February 2017

Lightweight amateur boxer Kellie Harrington celebrates after defeating Shauna O'Keeffe of Clonmel during their 60kg bout at the 2017 IABA Elite Boxing Championship finals in the National Stadium, Dublin. Harrington, from Portland Row in Dublin 1, is a double world medallist and double European medallist. In June 2021 – after a year of training curtailed by the Covid-19 pandemic – she became the second Irish female boxer, after Katie Taylor, to qualify for the Olympics when she beat world champion, Maiva Hamadouche of France in Paris to book her place in the 60kg division in Tokyo.

Eoin Noonan / SPORTSFILE

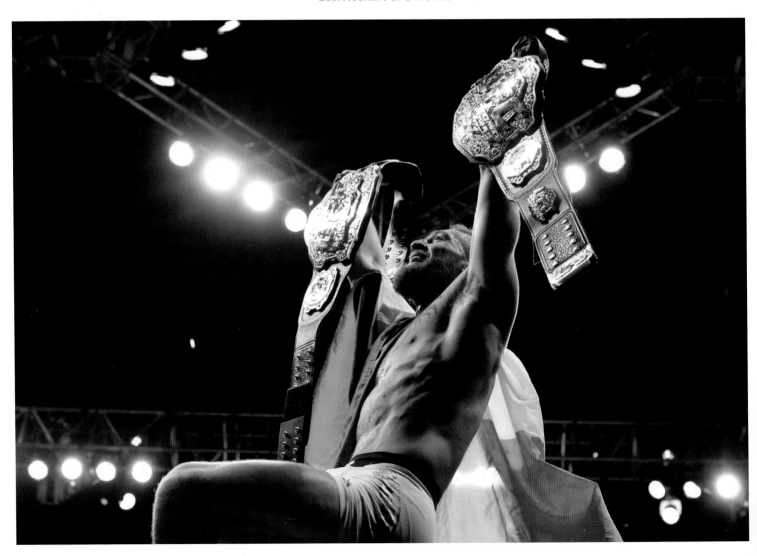

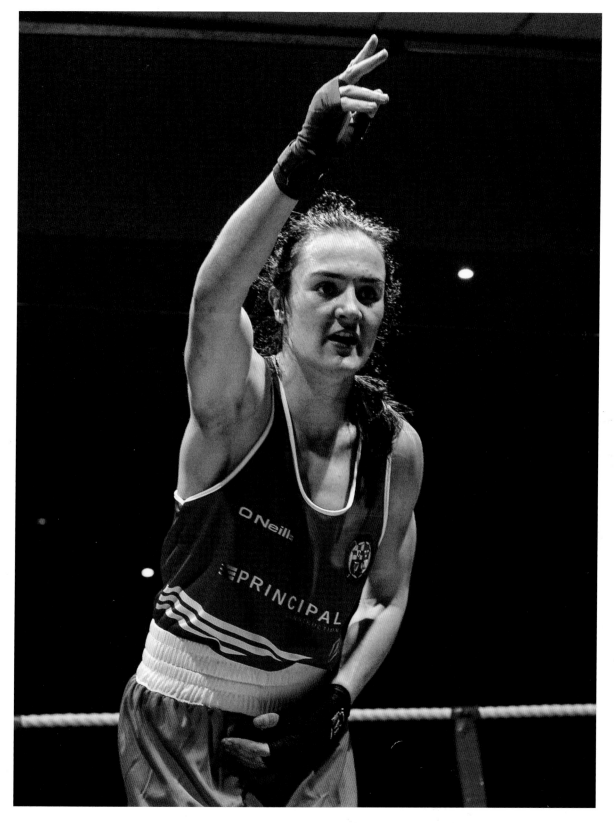

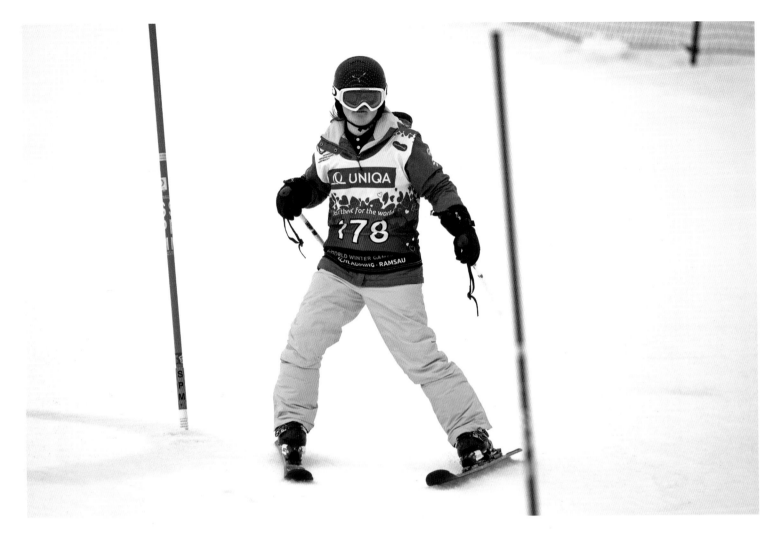

23 March 2017

Team Ireland's Laoise Kenny, a member of Kilternan Karvers
Special Olympics Club, from Monkstown, Co. Dublin, competing in
the Alpine Slalom Final at the 2017 Special Olympics World Winter
Games at Schladming-Rohrmoos, Stadthalle Graz, in Graz, Austria.

Ray McManus / SPORTSFILE

25 July 2017

Team Ireland's Lara Gillespie, from Enniskerry, Co. Wicklow, after being presented with her silver medal for second place in the women's cycling time trial, during the European Youth Olympic Festival 2017 in Gyor, Hungary.

Eoin Noonan / SPORTSFILE

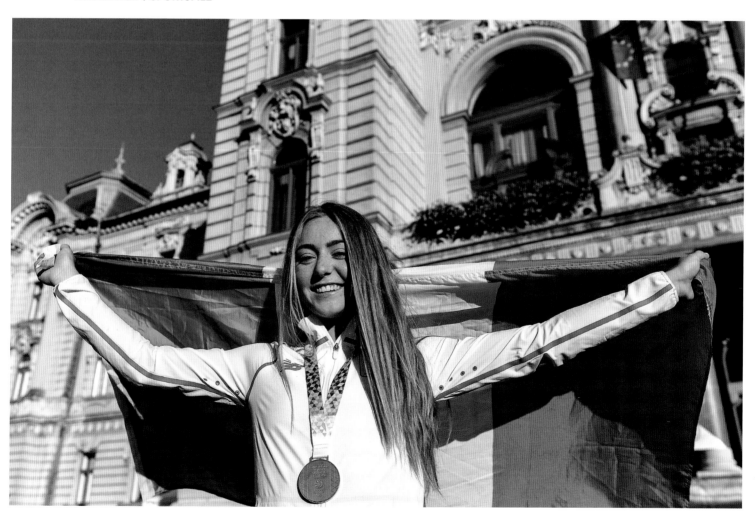

19 September 2017

Stephanie Roche of the Republic of Ireland in action against Ashley Hutton of Northern Ireland. Roche is arguably best known for her sensational goal for Peamount United that saw her nominated for the FIFA Puskás Award in 2014. She earned a place among the finalists, alongside James Rodríguez and Robin Van Persie, making her the first woman to ever make the final three. On the night, Roche finished in second place, receiving 33% of the vote. 2019 FIFA Women's World Cup Qualifier Group 3 match between Northern Ireland and Republic of Ireland at Mourneview Park in Lurgan, Co. Armagh.

Stephen McCarthy / SPORTSFILE

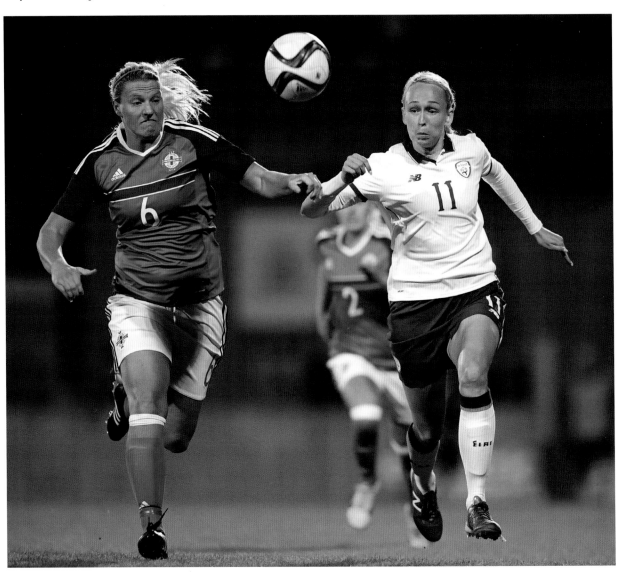

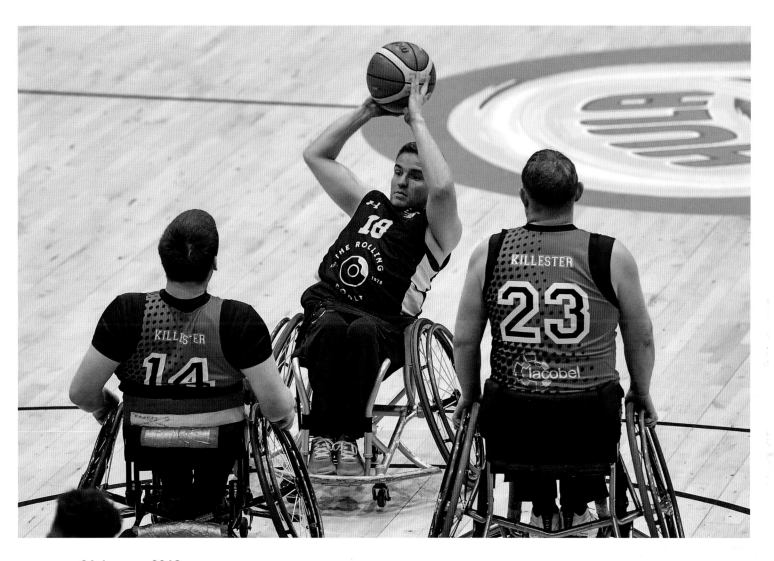

26 January 2018

Jason Ryan of Ballybrack Bulls WBC in action against Michael O'Cearra, left, and Paddy Forbes of Killester WBC during the Hula Hoops IWA Wheelchair Basketball Final at the National Basketball Arena in Tallaght, Dublin.

Brendan Moran / SPORTSFILE

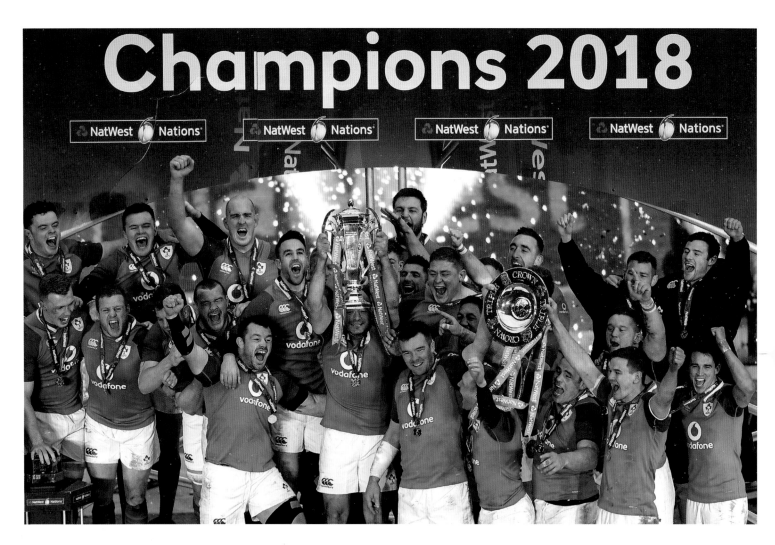

17 March 2018

The Ireland team celebrate with the Six Nations and Triple Crown trophies after beating England at Twickenham on 17 March 2018.

Harry Murphy / SPORTSFILE

12 May 2018

Ireland captain William Porterfield, left, leads his
side out prior to play on day two of the International
Cricket Test match between Ireland and Pakistan at
Malahide, Co. Dublin.

Seb Daly / SPORTSFILE

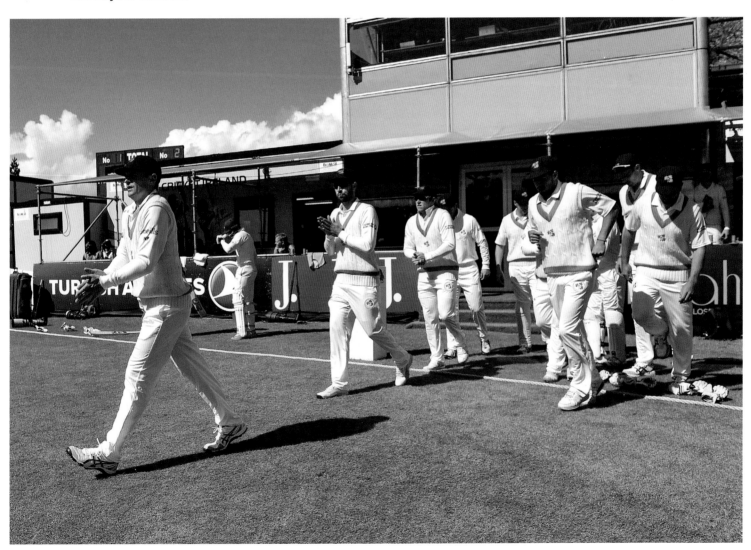

16 July 2018

Ireland's silver medal winners in the women's 4x100m relay team event, from left, Molly Scott of St Laurence O'Toole AC, Co. Carlow, Patience Jumbo-Gula of St Gerard's AC, Dundalk, Co. Louth, Gina Akpe-Moses of Blackrock AC, Co. Louth, and Ciara Neville of Emerald AC, C.o Limerick, during the Team Ireland homecoming from the IAAF World U20 Athletics Championships in Tampere, Finland, at Dublin Airport. The young team were bringing home Ireland's third ever medal at a World Under-20 Championships.

Piaras Ó Mídheach / SPORTSFILE

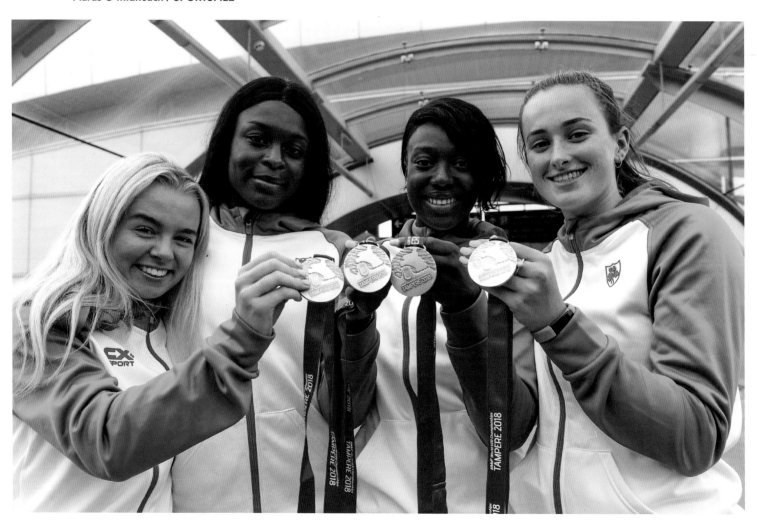

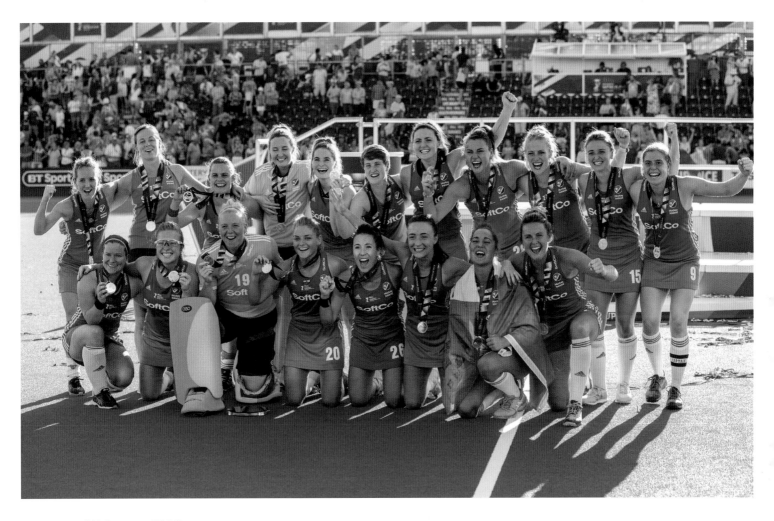

05 August 2018

The Ireland team celebrate with their medals after the Women's Hockey World Cup Final match between Ireland and Netherlands at the Lee Valley Hockey Centre in QE Olympic Park, London, England.

Ireland entered the competition ranked sixteenth in the world – the lowest-ranked team in the tournament – but went on an unprecedented run of play. The team of part-time players beat the USA and India in the group phase, going on to win their quarter-final against India and semi-final against Spain, with Ireland goalkeeper Ayeisha McFerran stopping shot after shot in penalty shoot outs.

Though Ireland lost 6-0 to the number-one ranked Netherlands, they had put Irish hockey firmly on the world stage.

Craig Mercer / SPORTSFILE

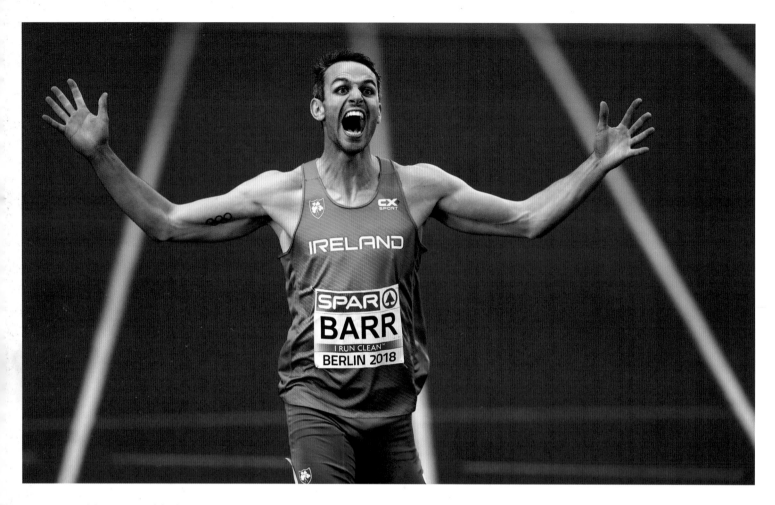

09 August 2018

Thomas Barr of Ireland celebrates after winning a bronze medal in the 400m hurdles at the 2018 European Athletics Championships in Berlin. Two year earlier, the Déise man ran the race of his life to place a 'bittersweet' fourth in the Olympic final in Rio.

Sam Barnes / SPORTSFILE

19 August 2018

Goalkeeper Nickie Quaid, left, and player of the year Cian Lynch of Limerick celebrate as Limerick end a forty-five year drought, beating reigning champions Galway in the GAA Hurling All-Ireland Senior Championship Final at Croke Park in Dublin.

Ramsey Cardy / SPORTSFILE

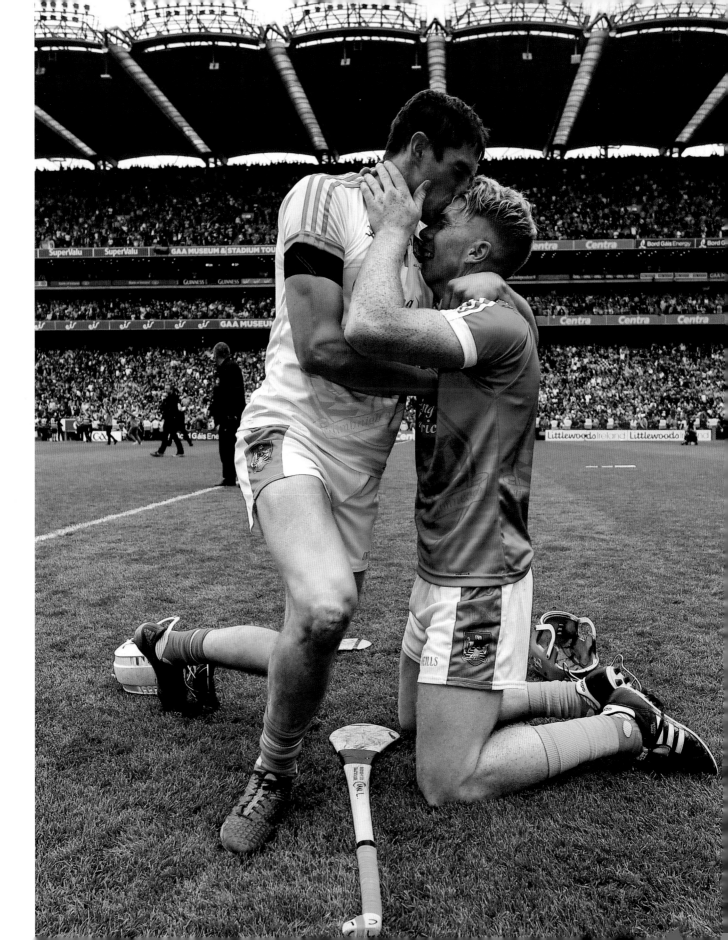

31 August 2018

Republic of Ireland players celebrate after Katie McCabe scored her side's second goal during the 2019 FIFA Women's World Cup Qualifier match between Republic of Ireland and Northern Ireland at Tallaght Stadium in Dublin. Despite winning 4-0, Ireland would fail to qualify for the Women's World Cup as they finished third in their qualifying group.

Stephen McCarthy / SPORTSFILE

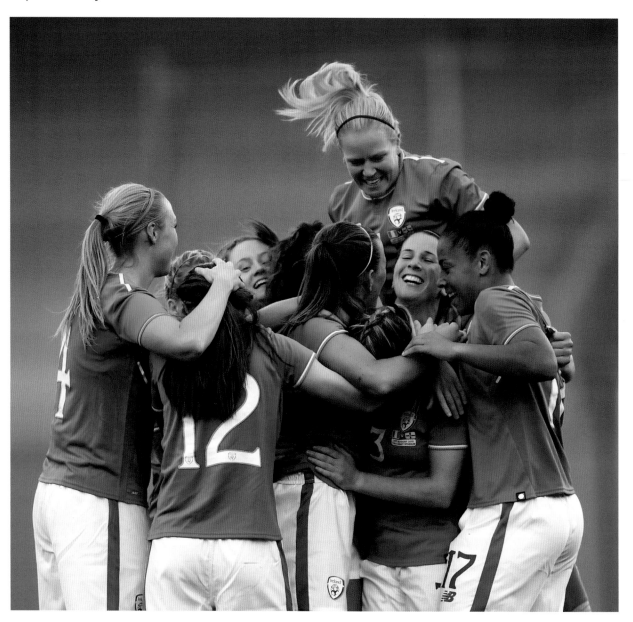

19 March 2019

Team Ireland's James Hunter, left, a member of Mallow Utd, from Co. Cork, Stephen Lee, centre, a member of the Cabra Lions Special Olympics Club, from Dublin 7 and William McGrath, a member of Waterford SO Clubs, celebrate after beating SO Estonia 7-2 to take the Bronze medal at the 2019 Special Olympics World Games in Abu Dhabi, United Arab Emirates.

Ray McManus / SPORTSFILE

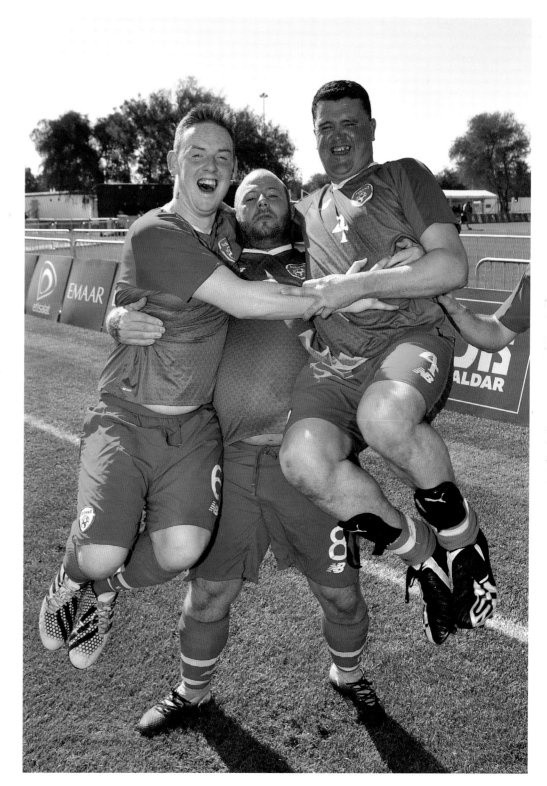

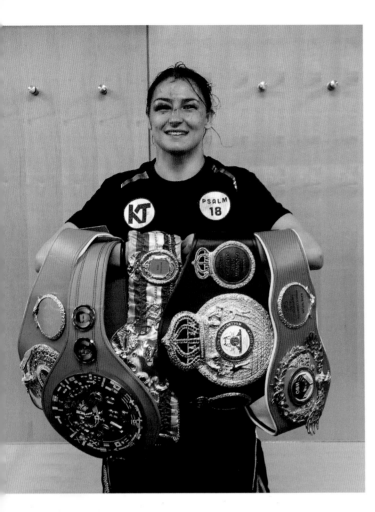

01 June 2019

Katie Taylor celebrates with her belts after her Undisputed Female World Lightweight Championship fight with Delfine Persoon at Madison Square Garden in New York, USA.

Stephen McCarthy / SPORTSFILE

21 July 2019

Shane Lowry of Ireland celebrates as he walks onto the 18th green on Day Four of the 148th Open Championship at Royal Portrush in Portrush, Co Antrim. Amateur winner Lowry would not take home the €500,000 winner's prize, but the victory was to be the start of a great career for the Clara native.

Brendan Moran / SPORTSFILE

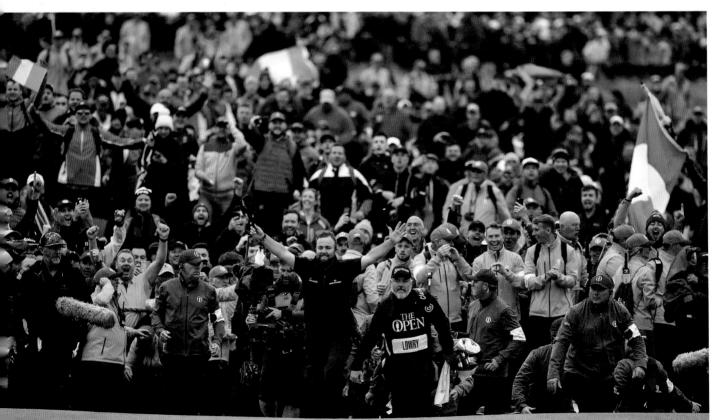

18 August 2019

Sometimes called 'Tipp's Iron Curtain', brothers Ronan (4) and Padraic Maher (6), along with Brendan Maher (second from left), make a formidable half-back partnership; along with Cathal Barrett they hold off Kilkenny players, left to right, Billy Ryan, TJ Reid and Walter Walsh to win 3-25 to 0-20. Hurling All-Ireland Senior Championship Final, Croke Park, Dublin.

Dáire Brennan / SPORTSFILE

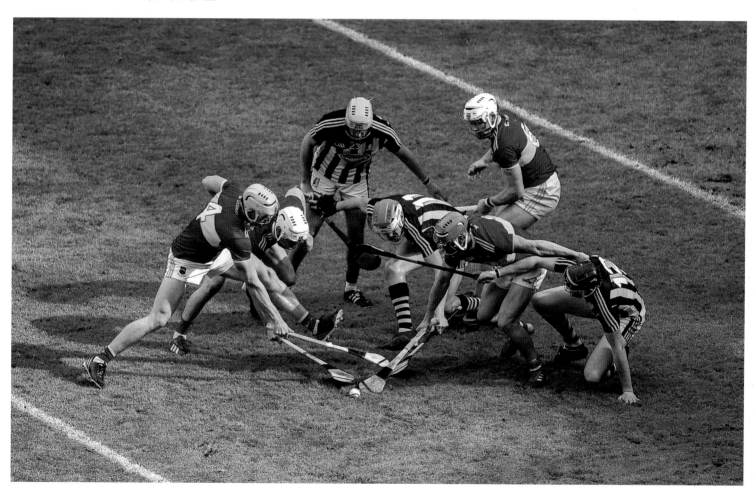

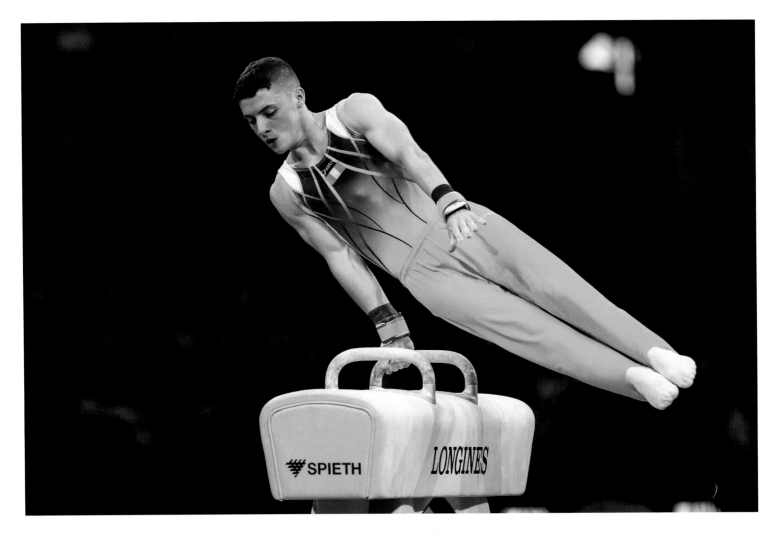

12 October 2019

County Down gymnast Rhys McClenaghan competing in the pommel-horse final during the Artistic Gymnastics World Championships at Stuttgart before winning the silver medal. Although Ireland has very little history with the sport of gymnastics, McCleneghan seems destined for greatness.

Ricardo Bufolin / SPORTSFILE

03 November 2019

Irish hockey players, from left, Nicola Daly, Roisin Upton, Bethany Barr, Chloe Watkins and Gillian Pinder, celebrate winning the penalty strokes and qualifying for the Tokyo Olympic Games during the FIH Women's Olympic Qualifier match between Ireland and Canada at Energia Park in Dublin.

Brendan Moran / SPORTSFILE

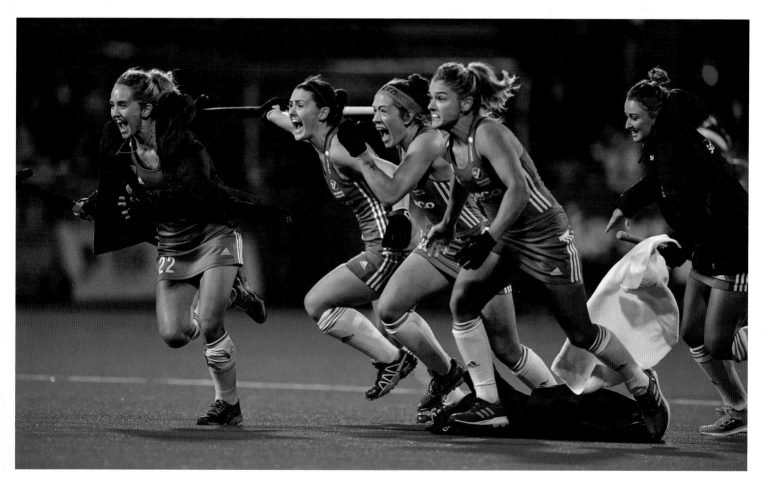

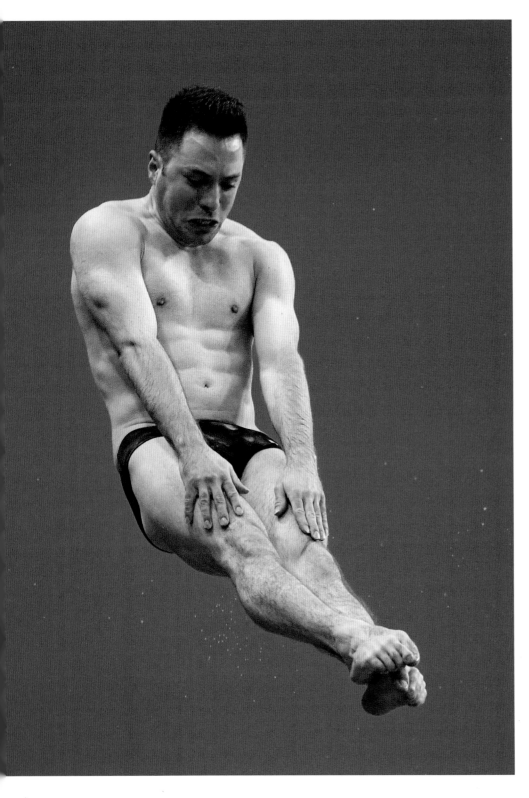

24 November 2019
Oliver Dingley competing in the Men's 3m final at the 2019 Irish Open Diving Championships at the National Aquatic Centre in Abbotstown, Dublin.

Ramsey Cardy / SPORTSFILE

24 November 2019

Fionnuala McCormack, right, congratulates her sister Una Britton, both of Kilcoole A.C., Co. Wicklow, after winning gold and bronze medals in the Senior Women event during the National Cross Country Championships at the National Sports Campus, Abbotstown. It was the first time in the long history of Irish cross country running that two siblings made the podium in a senior race. Fionnuala McCormack is one of Ireland's finest distance runners; her marathon best of 2:26.43 puts her second on the Irish all-time list, she's represented Ireland at the 2008, 2012, 2016 and 2021 Olympics. She's been the linchpin of the successful Irish women's team at several European cross country championships, and in 2012 was the first woman to successfully defend her European cross country title.

Sam Barnes / SPORTSFILE

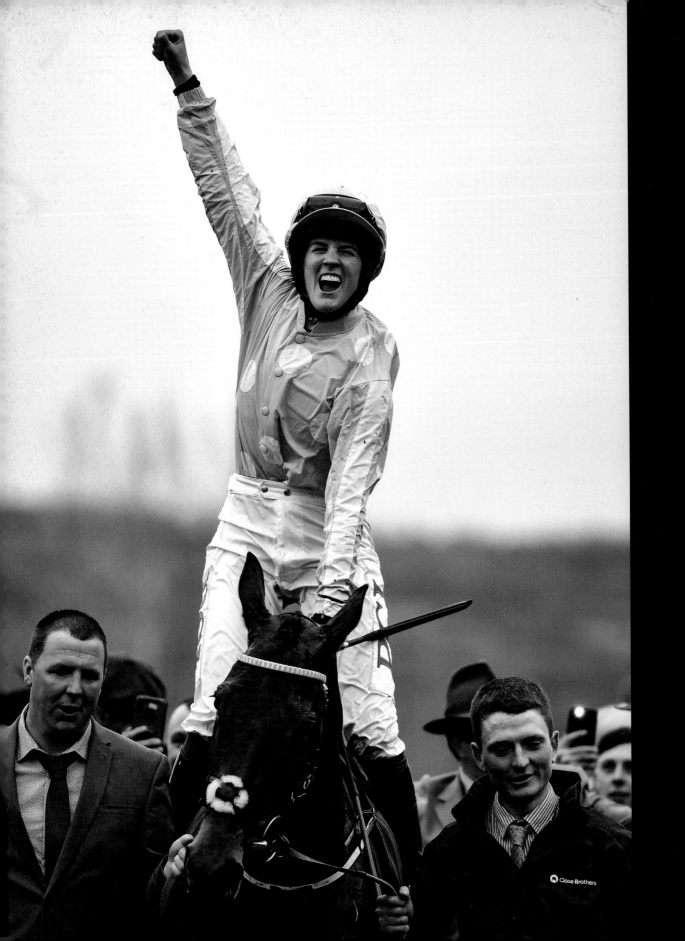

10 March 2020

Jockey Rachael Blackmore on Honeysuckle
celebrates after winning the Close Brothers
Mares' Hurdle on Day One of the Cheltenham
Racing Festival at Prestbury Park in Cheltenham,
England. Honeysuckle has been unbeaten in her
twelve National Hunt races so far.

David Fitzgerald / SPORTSFILE

2020s

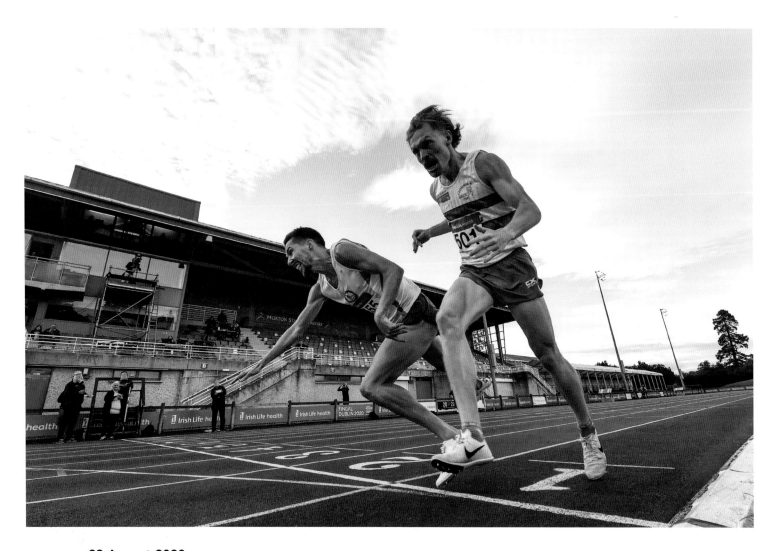

23 August 2020

Two hundredths of a second separated training partners Paul Robinson of St Coca's AC and Sean Tobin of Clonmel AC in the Men's 1500m at the National Athletics Championships in Morton Stadium, Robinson just edging across the line first. For Robinson, it was a moment of redemption after a long cycle of injuries; it had been six years since he ran at the nationals, nine since he last won the 1500m. Their epic battle played out in front of an empty stadium due to Covid-19 restrictions, but was no less scintillating for that.

Sam Barnes / SPORTSFILE

12 December 2020

Kilkenny players Michelle Teehan, left, and Meighan Farrell celebrate after
the Liberty Insurance All-Ireland Senior Camogie Championship Final match
between Galway and Kilkenny at Croke Park in Dublin.

Piaras Ó Mídheach / SPORTSFILE

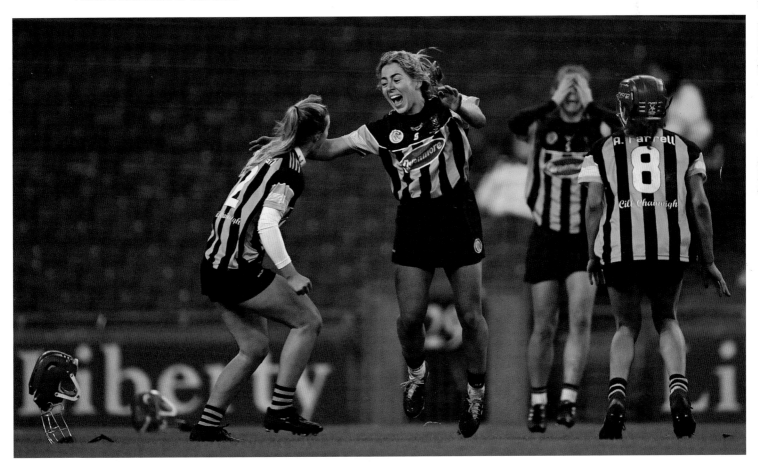

13 December 2020

Happy to be back! Limerick players and officials celebrate with the Liam MacCarthy Cup following the GAA Hurling All-Ireland Senior Championship Final match between Limerick and Waterford at Croke Park in Dublin. The championship was originally scheduled to start on 9 May 2020, but due to the Covid-19 pandemic public health measures the competition didn't begin until 24 October 2020, with the long-awaited final held on 13 December 2020.

Stephen McCarthy / SPORTSFILE

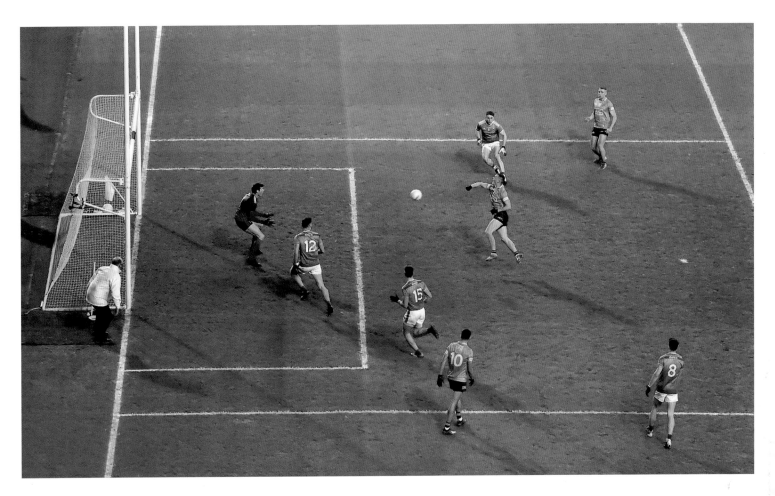

19 December 2020

Con O'Callaghan of Dublin scores his side's second goal past David Clarke of Mayo. Mayo were determined to win their first title since 1951, but it was not to be; Dublin won an unprecedented sixth All-Ireland in a row in front of the empty stands, necessitated by the Covid-19 public health measures.

Dáire Brennan / SPORTSFILE

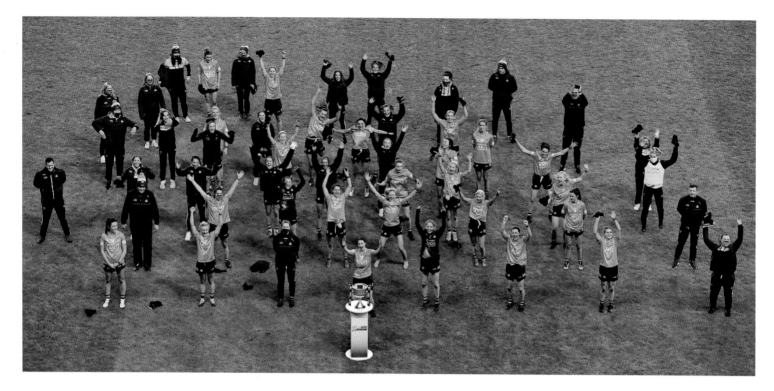

20 December 2020

A year like no other; a rivalry like no other. Dublin face Cork in the Ladies Football Final. Due to the Covid-19 pandemic, the final could not be staged until December. This year the Jackies prevailed, beating the Rebelettes 1-10 to 1-5. All-Ireland Senior Ladies Football Championship Final match between Cork and Dublin at Croke Park in Dublin.

Sam Barnes / SPORTSFILE

16 March 2021

Honeysuckle, with Rachael Blackmore up, jumps the last on the way to winning the Unibet Champion Hurdle Challenge Trophy on day 1 of the Cheltenham Racing Festival at Prestbury Park in Cheltenham, England.

Hugh Routledge / SPORTSFILE

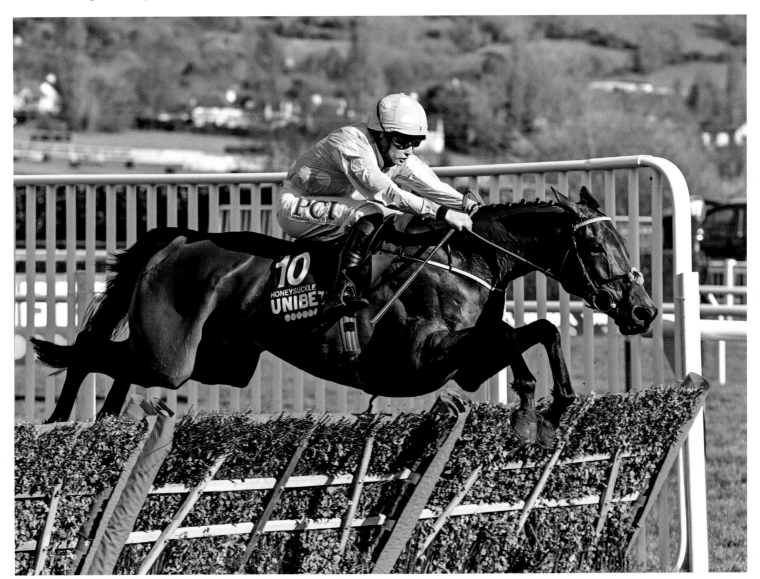

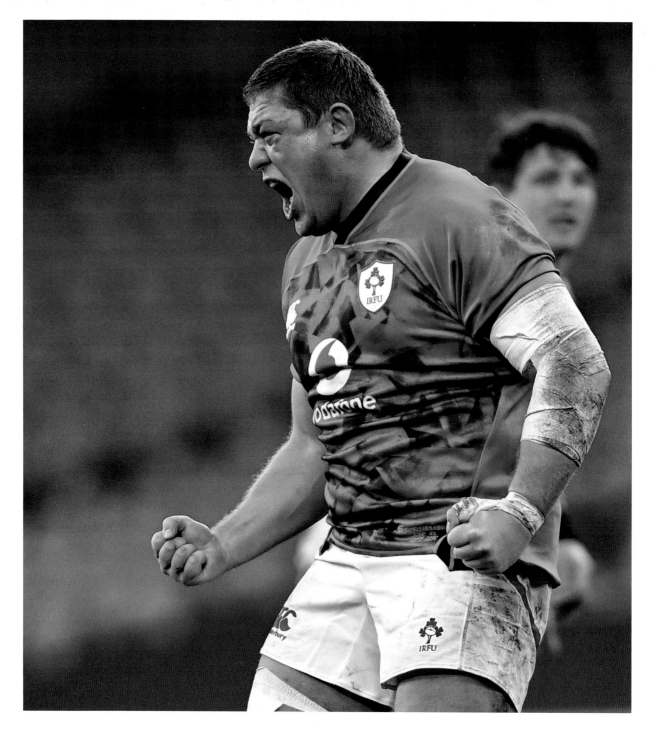

20 March 2021

Tadhg Furlong after winning a scrum penalty during the Six Nations clash between Ireland and England at the Aviva Stadium on 20 March 2021. Ireland delivered a decisive performance in their final match of the tournament, which was played behind closed doors, dominating England by 32-18.

Ramsey Cardy / SPORTSFILE

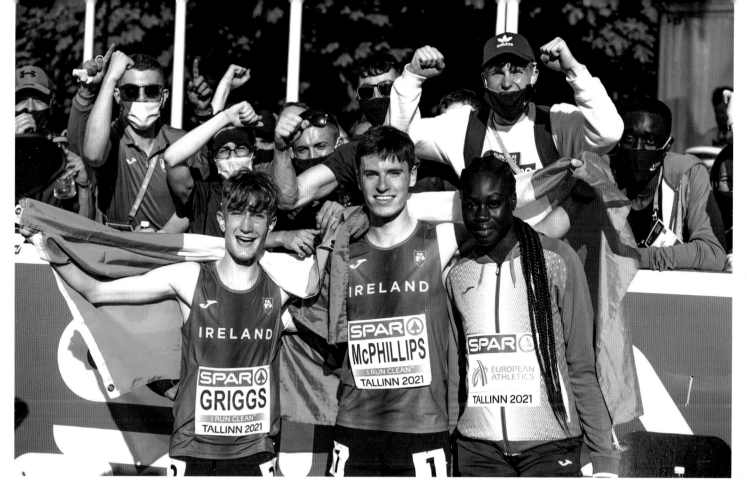

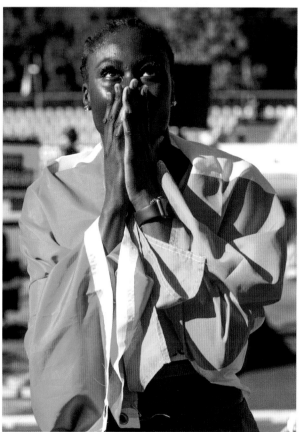

17 July 2021

Gold rush! Young Irish athletes had an amazing championship at the European Under 20 championships in Tallinn, winning four gold medals in just over twenty-four hours. First Rhasidat Adeleke (left) became the first woman in a decade to win the 100m and 200m, then Cian McPhillips took gold in the 1500m in a time of 3:46.55, and the day was rounded off by sixteen-year-old Nicholas Griggs winning the 3,000m.

Gold medalists, from left, Nicholas Griggs, Cian McPhillips and Rhasidat Adeleke with their team-mates during day three of the European Athletics U20 Championships at the Kadriorg Stadium in Tallinn, Estonia.

Marko Mumm / SPORTSFILE

27 July 2021

Mona McSharry from Sligo before the women's 100 metre breaststroke final at the Tokyo Olympics. The twenty-year-old made history by becoming only the second Irish swimmer ever to compete in an Olympic final.

Ian MacNicol / SPORTSFILE

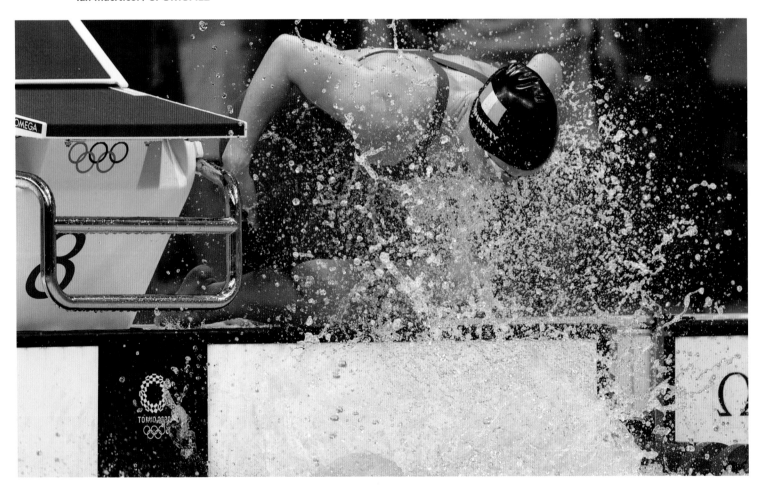

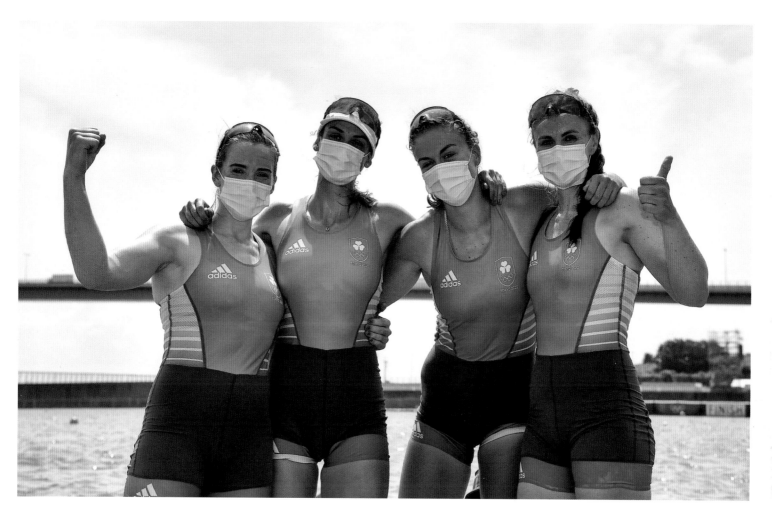

28 July 2021

Ireland rowers, from left, Emily Hegarty, Fiona Murtagh, Eimear Lambe and Aifric Keogh celebrate after finishing third in the Women's Four final at the Tokyo Olympics Games. The quartet were assembled as a crew in the year running up to the Olympics and became the first Irishwomen to win an Olympic medal in rowing.

Seb Daly / SPORTSFILE

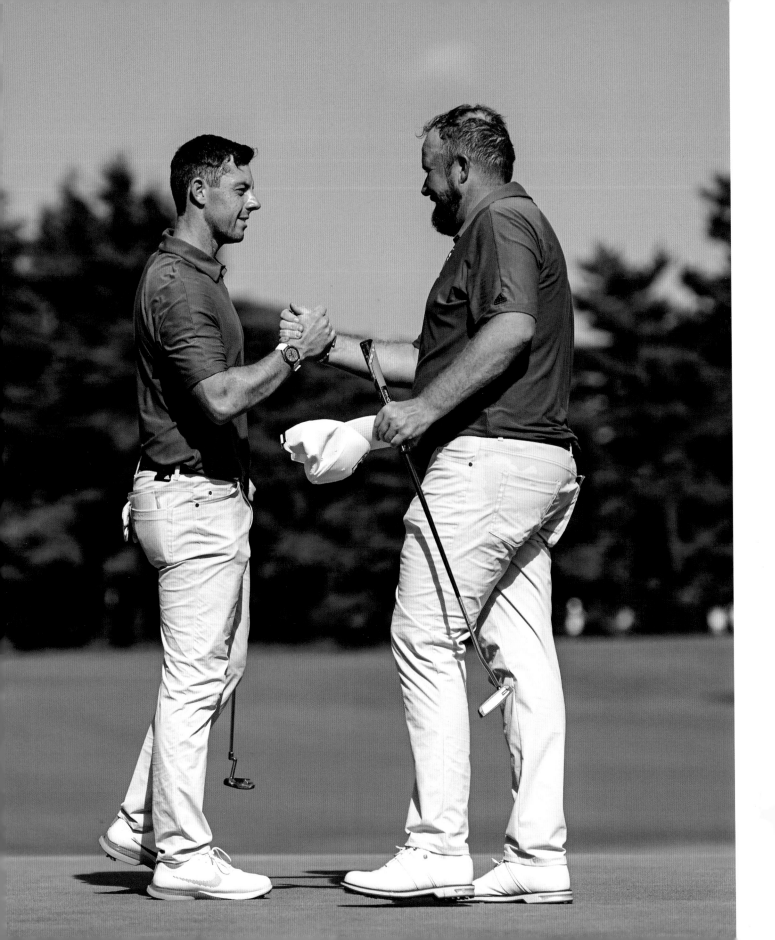

28 July 2021

Rory McIlroy and Shane Lowry exchange a handshake after both golfers put in impressive third rounds at the Tokyo Olympics. McIlroy eventually reached a seven-man play-off for a bronze medal, but finished outside the medals.

Ramsey Cardy / SPORTSFILE

29 July 2021

Paul O'Donovan and Fintan McCarthy of Ireland celebrate after winning the Men's Lightweight Double Sculls, ahead of Germany and Italy. The Skibbereen duo won Ireland's first gold medal of the Tokyo Olympics – and made history by winning the country's first ever gold medal in rowing. O'Donovan and his brother Gary won the silver in the same event at the Rio Olympics in 2016.

Brendan Moran / SPORTSFILE

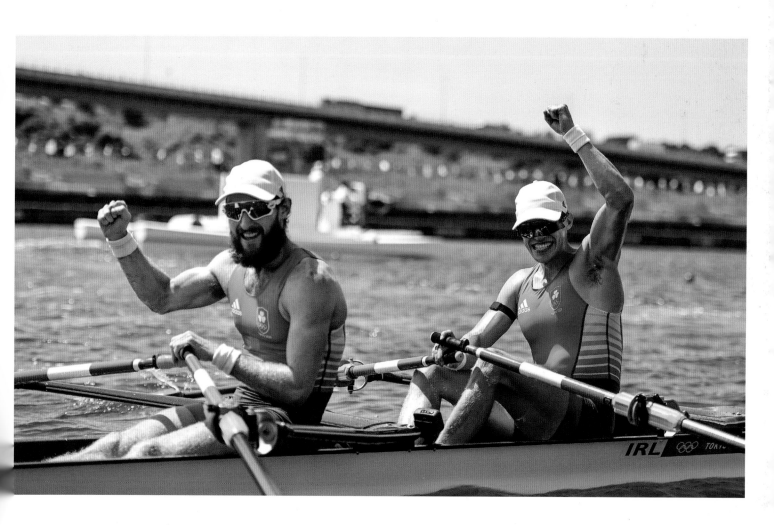

30 July 2021

The 4x400m mixed relay – where teams are made up of two women and two men – was a new event at the Tokyo Olympics. The Irish team (from left) Phil Healy, Sophie Becker, Christopher O'Donnell and Cillin Greene, ran a National record in their semi-final to advance to the final round where they finished eighth.

Stephen McCarthy / SPORTSFILE

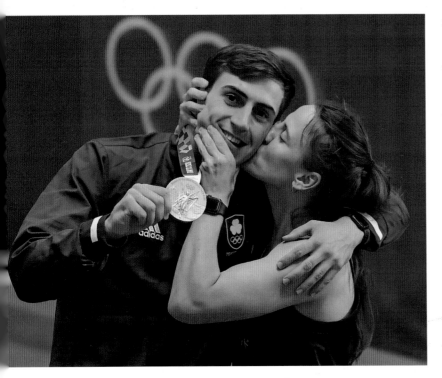

3 August 2021

Belfast boxing siblings Michaela and Aidan Walsh celebrate with Aidan's bronze medal in the men's welterweight division at the Tokyo Olympics. Due to an injury sustained after he won his quarter final, Aidan Walsh was not fit to fight Great Britain's Pat McCormack in the semi-final, and finished the Games as a bronze medallist. Michaela also represented Ireland in Tokyo, bowing out after her defeat to Italy's Irma Testa in the women's 57kg featherweight last sixteen.

Brendan Moran / SPORTSFILE

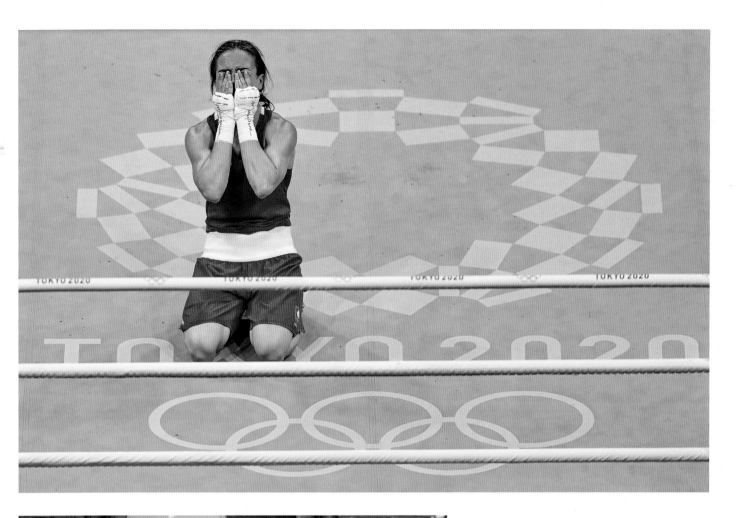

8 August 2021

Golden girl! Kellie Harrington collapses to her knees after defeating Beatriz Ferreira of Brazil in the women's lightweight final (above). The country held its breath as she went into the final on the last day of the Games – it was a fitting finish as Harrington prevailed and went down in history as the third Irish boxer to win gold at the Olympics. Left, Harrington's mother Yvonne is congratulated outside her Portland Row home after the fight.

Above: Brendan Moran / SPORTSFILE

Left: Ray McManus / SPORTSFILE

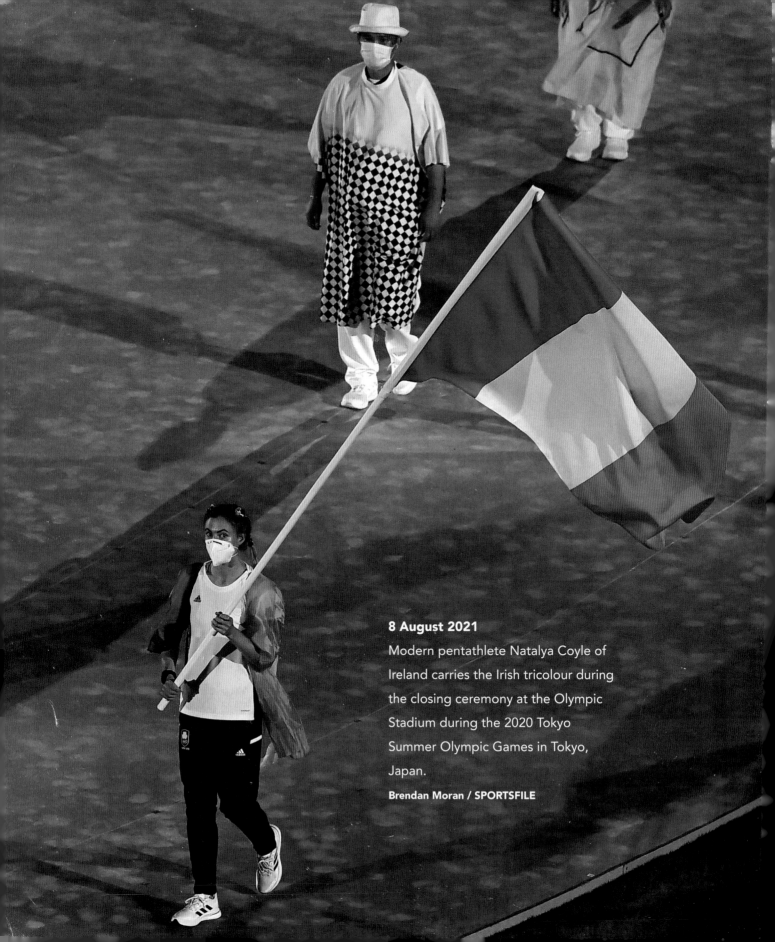

8 August 2021

Modern pentathlete Natalya Coyle of
Ireland carries the Irish tricolour during
the closing ceremony at the Olympic
Stadium during the 2020 Tokyo
Summer Olympic Games in Tokyo,
Japan.

Brendan Moran / SPORTSFILE